Nikon
SYSTEM HANDBOOK

REVISED AND UPDATED

B. "MOOSE" PETERSON

images
PRESS INC.

Nikon System Handbook

Revised and Updated.
Library of Congress Catalog Card Number:
90-084933
B. Moose Peterson
(Softcover) ISBN: 0-929667-03-4
(Hardcover) ISBN: 0-929667-09-3

Published by Images Press, 7 East 17th Street,
New York, NY 10003

Printed and bound in the United States of America

Cover and Original Book Design by Jennifer Lawson
Typography and Additional Graphic Design by
 Ray Noonan, ParaGraphic Artists, New York City
Edited by Norris H. Williams
Cover Photos: Nature, Bird Photos by B. Moose Peterson
 Technical Photos: Courtesy of Nikon, Inc.
Photos Throughout Book Reprinted Courtesy of Nikon, Inc.
Photo Portfolio: B. Moose Peterson, Michael Pliskin

1 2 3 4 5 6 7 8 9 10

To Pop:
for opening up the experiences of a lifetime

Acknowledgments

This book would not have been possible without the help of many people in its preparation. I want to especially thank the folks at Nikon, Inc: Victor Borod for his endless support, Steve Jarmon and Richard LoPinto for their generous contributions, Maurice Benchimol for his endless support of me and my photography with equipment and friendship, and Mr. K. Shioiri of Nikon, Japan for all of his information and contributions. My technical advisors, Michael Pliskin and Geoff Keller, have been of great assistance for years leading to the production on this book. My sincere thanks go to James Ridgway for his hours of editing. And I would not have made it this far without the years of constant prodding from my good friend Peter Gould, or without help from David Van Middlesworth who made the writing of this book possible. To all of you, a special thanks!

TABLE OF CONTENTS

INTRODUCTION

Nikon, as we know it today, started as an optical company almost a century ago. The Japan Optical Company (English for Nippon Kogaku, K.K.) was formed on July 25, 1917 by the merger of three small optical firms, the oldest one dating back to the 1880's. They started with just 200 employees and with German technicians who became part of the company by invitation in 1919 (but arrived in 1921). It's important to understand that they only produced optics for other camera manufactures and no camera bodies of their own at the start. They began to manufacture microscopes, transits, surveying equipment, optical measuring devices (they are still the leader in todays market of these devices) and telescopes. The early optics they produced paralleled those of Leitz and Zeiss, companies that also started as optical firms.

Because of the line of optical products they were manufacturing, they became extremely well known in the scientific and industrial communities but not by general consumers. By the thirties, they were manufacturing a series of photographic lenses from 50mm to 700mm, mostly for plate back cameras. With these lenses came a new name for their optics "NIKKOR" which was derived from "NIKKO" which was used on their early microscopes.

In the summer of 1937, they completed the design of 50mm f/4.5, f/3.5 and f/2 lenses as original equipment on the famous Hansa Canon introduced that same year. Nippon Kogaku actually manufactured all of Canon's lenses for their rangefinder models up to mid 1947. These lenses first incorporated the Canon bayonet mount and were later switched to the Leica screw mount. All prewar and early postwar Canons came with NIKKOR lenses. With World War Two, Nikon was selected by the government to be the largest supplier of optical ordnance and grew to 23,000 employees and 19 factories. All that they produced during this period is sought after by today's collectors and is rare to find.

The end of the war saw the company reorganized under the occupational forces for civilian production. They were left with only 1400 employees and one factory. They went back to optical production, but their legendary status was limited to Japan, as the world had yet to hear of their products. Sometime in 1945-46 they decided to produce a camera body of their own with interchangeable lenses and coupled rangefinder. A Twins Lens Reflex (TLR) and a 35mm design were considered but the TLR was soon dropped. On April 15, 1946 a production order was issued for twenty experimental "miniature cameras". Some time after that the name "NIKON" first appeared on a body, short for **NI**ppon **KO**gaku. The first rangefinder came out in 1948, and the rest is history.

NIKON BODIES:
THE EVOLUTION

Nikon bodies have evolved over the decades from the original all mechanical body to today's all electronic models. Many of the design features utilized in today's cameras have their origins with those original mechanical models. We'll delve into this evolution of Nikon bodies highlighting the major advances and technological innovations that made each particular body unique. The instruction manual for the older models have not been rewritten, but the current production cameras will have greater depth concerning their operation and problem solving capabilities since they are what most photographers use today. I have used the majority of these cameras over the last decade and have seen them evolve to the incredible machines we use today.

Nikon's first bodies were rangefinders, discovered by the first photojournalists and soldiers going to the Korean conflict. The history of the different models is extremely well illustrated in the highly recommended *Nikon Rangefinder Camera* by Robert Rotoloni. We'll start with Nikon's introduction of their first SLR (single lens reflex) camera, the start of the modern Nikon line.

The Nikon F

The revolution and evolution in the Nikon SLR that we know today started with the "F" body. It began many of the standards still used by the company, the main one being the "planned absence of obsolescence in models to come." The most important design feature to be developed for the Nikon F was the Nikon "F" Bayonet lens mount. This mount is still employed today even with the introduction of autofocus bodies.

The **Nikon F** is the first "Professional" model whose basic construction and design can be traced back to the Nikon rangefinders: interchangeability of lenses, focal plane shutter curtain made from titanium foil, slip down camera back and motorized conversion, shutter speed dial and shutter release. The F was the first Nikon to have interchangeable prisms and screens. It also had many other new accessories and features which made it the most advanced SLR of the day.

Users of the Nikon F soon became accustomed to its durability and dependability. The F did not significantly change over the years of its manufacture (1959-1974 with 1 million cameras manufactured) other than changes in internal parts. These were improved with the advance of new materials and technologies that came from constant research and a desire to improve the product. The main features of the F were:

1. 35mm SLR rendering a true 24mmx36mm final image on film.
2. Interchangeable prisms.
3. Interchangeable viewing screens.
4. Automatic lens diaphragm operation for maximum aperture viewing with lens preselected on any f/stop.
5. Standardized lens bayonet mounting flange.
6. Standardized shutter speed settings.
7. Titanium foil shutter curtain, focal plane type.
8. Vibration free mirror and mirror box with lock-up mirror capability.
9. Built-in self timer, 3-10 seconds.
10. Flash sync up to 1/1000 with bulbs, 1/60 with electronic flash.

11. Depth-of-field preview button.
12. Self-resetting film counter.
13. Single stroke film advance in a 136 degree stroke.
14. Removeable film back for easy access to film reloading.
15. Acceptance of metered prism.
16. Virtual 100% viewing.
17. Film-winding and pressure plate arrangement ensuring film held absolutely flat.

This is the basic F body without any prism attached. The first F's came with a standard eye-level prism, but that's all. The **Eyelevel Prism** has no metered components and provides corrected viewing, letting the photographer see through the lens just as the scene appears before him. The eyelevel finder originally came with a square viewing port which requires an attachment (called **Eyecup Adapter for Nikon F**) in order for eyecups and other prism accessories to be attached. Late in the production of the F, when the F2 was about to appear on the market, the viewing port was changed from square to round.

The finder is removed by depressing the small button on the top-back left of the body (same button for changing the screens). Metering is only possible with a clip-on external meter (**Model 3** came with a booster and incident light opal plate) which couples with both the camera's shutter speed dial and lens aperture ring. The top of the meter provides exposure information. Matching the two needles by turning the shutter speed dial or aperture ring is required to derive correct exposure. It wasn't until 1962 the first metered prism was introduced for the F.

The first metered prism was the **Photomic Prism**. It combined the basics of the eyelevel prism with an external meter using a CdS (Cadmium Sulfide) exposure meter. This metered prism was coupled to the shutter speed dial and aperture ring. Correct exposure is set by centering the meter needle appearing in the viewfinder. This information is also provided on the outside, back-topside of the prism. The light meter reading is obtained from small attachments on the side of the meter which are interchangeable. A **light acceptance converter tube** and **incident light opal plate** were provided with the prism and, depending on the lens and/or lighting present, were changed to obtain the correct meter reading. The

meter worked with ASA 12 to 1600 films, quite a range for its day.

The Photomic was replaced with the **Photomic T Finder** in 1965 which provided TTL (through-the-lens) metering. It used a match-needle system for correct exposure, and still required turning either the shutter speed dial or aperture ring to obtain the correct exposure. All of this information is provided while viewing through the prism. The TTL prism could now take into account any exposure factors such filters, etc., which previously had to be manually calculated. Its ASA rating is 12 to 1600.

Built-in condenser lenses in front of the two CdS cells in the prism minimizes the influence of backlight entering from the behind the eyepiece. This was improved in 1967 with the **Photomic Tn**, the first Nikon meterhead to have center-weighted exposure metering. This meter, like the rest, is removed by depressing the release button on the top-back left of the body. The meter is turned on by pressing a button on the front-right side of the prism, and turned off by pressing a button on top, next to the turn-on button.

Up to this point, all of the photomic finders require the maximum aperture manually matched to the ASA dial on the prism for correct exposure. This requires changing each time a lens with different maximum aperture is attached for proper indexing.

In 1968 that system was replaced with the introduction of the **Photomic FTn** which provides semi-automatic maximum aperture indexing. This is accomplished when mounting the lens to the body. First set the aperture ring on the lens to f/5.6, then mount the lens onto the body. Once the lens is attached, turn the lens to the minimum aperture, then back to the maximum, indexing the lens to the meter. Meter compensation now surrounds the ASA dial, providing the first meter compensation setting on a camera not physically connected to the ASA dial.

To change the FTn prism on the F, depress the button on the top-back left of the camera body while pressing in on the lever on the front-right of the prism. For older F bodies, serial number 6900001 or below, a small modification needs to be performed in order for the meter to attach to the body correctly. The ASA of the FTn was boosted up to work with 6 to 6400. This was the first meter to display the shutter speed setting inside the prism.

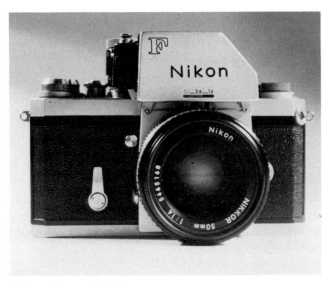

Nikon Photomic FTn.

Turn on the meter by pressing the ON button on the front-right of the meter. This pops up the OFF button and exposes a red line on the OFF button which shows the meter is on. Turn off the meter by pressing the OFF button on the top of the prism directly above the ON button. To check the battery, press down on the OFF button when the meter is switched off. A good battery is indicated by the meter needle centering in the meter display on top of the prism.

In its day the F shutter and mirror box were quite advanced. Its available shutter speeds are: 1sec, 1/2, 1/4, 1/8, 1/15, 1/30, 1/60, 1/125, 1/500, 1/1000, B (bulb) and T (time). These integrated actions are performed in approximately 71 milliseconds when the shutter speed is set at 1/1000.

The F was in production in the days of the flash bulb. Electronic flash was just starting to be developed and be used commercially. The F is designed to synchronize completely at all shutter speeds with flash bulbs by raising and rotating the synchro-selector ring located around the shutter speed dial. This switch in time can be adjusted to the particular type of flash bulb in use. The four settings are: FP class, green dot=1/125 to 1/1000, red dot=1/60, white dot=1/30, white dot w/red F=1/15 or slower, FX=electronic flash. The F has a PC socket located top-front left where either flash bulb or electronic flash accessories can be connected to the camera.

The F has a mirror lock-up mechanism to lock the mirror up, minimizing vibration during an exposure. The switch for this is at the lower-right of the lens mounting assembly on the front of the body. To activate this button (it has a ridge in the center to facilitate operation) push it towards the red dot. To return the mirror to its original position, turn downwards until the black dot meets the black dot on the body. This should be done after the shutter is released or the mirror will not return for viewing until the next exposure is made. Losing one exposure of film during this process cannot be prevented. There were many special production F bodies, one of which had a red dot on the back of the top plate. It was unique in that it could lock up the mirror and not lose a frame of film. It was believed to be made for astronomers for use on large telescopes.

Nikon designed several optional finders (which had no metering capability) for special applications for the F. This was a first. These optional finders replaced the meter finder. The **Waistlevel Finder** permits direct viewing from the top of the camera. The principal reasons behind its manufacture were as an aid in photographing a subject at ground level or for use on copy stands or microscopes. The first waistlevel came out in a three sided model, the missing side being at the rear when looking down through the finder. All models had a built-in magnifier (3x) that popped-up upon pressing a button on the top of the finder. The last model of waistlevel finder had four sides (during the period the **DW-1** for the F2 was being produced) and is the rarest and most sought after model. The waistlevel finder, when purchased new, came with a small leather case and was wrapped in a small piece of green material, a special touch that Nikon soon ended.

The **Prism Reflex Sportsfinder** (commonly called **Sportfinder F**) was an innovation designed to be used by photographers who had to wear safety glasses or goggles, or required greater clearance for viewing. The **Standard Penta Prism** (an eyelevel or meter finder) finder requires a normal eyepoint of 15-18mm to view the entire screen, the sportfinder provides as much as 60mm, with 20mm distance providing complete screen viewing. Today, the F in combination with the sportfinder is extremely popular with underwater photographers. It can be used inside an underwater housing, and still provide the photographer complete screen viewing.

One other finder for the F was the **6x Magnifier**. This finder is extremely rare and looks just like

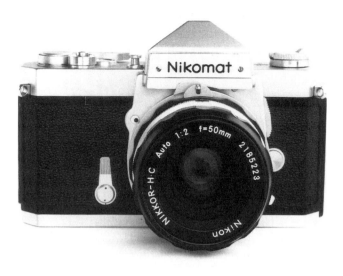

Nikomat FTn.

the **DW-2** finder for the F2. The 6x finder has a built-in diopter, which must be focused on the rangefinder split on the viewing screen in the camera before attempting to focus on a subject. This finder has the same angle of viewing as the waistlevel but provides critical focus, especially for high magnification work. Like the four-sided waistlevel, the F 6x finder came out near the end of the F production line when the F2 and its accessories were beginning to be manufactured.

The F's interchangeable viewing screens were another major innovation of the day which most photographers found indispensable. The F came with the **"A"** screen as standard equipment. The **"A"** is a split-prism rangefinder, (3mm in size) dead center in the screen surrounded by an all matte fresnel field. A 12mm concentric circle surrounds the split to delineate the favored metering area of the meter finder. Twenty-one screens were developed for the F, many with very specific purposes while others were more generic. Direct applications for each screen as well as general descriptions follow in the accessories chapter.

The F went through some cosmetic changes near the end of its production as the F2 came on line and some of its parts were adapted to the F. The most obvious change was in the film advance lever which originally was all metal, and was changed to the plastic-tip style adopted for the F2.

The serial number of the last F's manufactured started with 74.... They were manufactured until the end of 1972. The camera was introduced in 1959, but the earliest serial number recorded is

64.... Many believe serial numbers indicate manufacturing dates. The first two digits do not directly correspond to date of manufacture although that system is widely used to no harm.

There were many special versions of the F manufactured by Nikon, many known only to Nikon. An **F High Speed** was made for a limited time. It has a pellicle mirror and is capable of 9.5FPS (frames per second). Two other versions were a NATO green version believed to have been made for NATO forces and an all white version, for what purpose never known. Many F's had other modifications, special symbols, and notations that now make them quite collectable.

The Nikkormats

In 1965 when Nikon introduced the F Photomic T, they also introduced their first Nikkormats. A less sophisticated line of camera bodies, the Nikkormats were the first in a long line of bodies with non-interchangeable prisms and lacking certain features and accessories found in the "professional" bodies. Two Nikkormats were brought on the market in 1965, the first being the **Nikkormat FT**. The FT was a moderately priced SLR with a fixed pentaprism accepting all Nikkor lenses and Nikon system accessories. The metering in the FT is center-weighted, using two regular condenser lenses in front of the two cells (on either side of the viewfinder eyepiece) to project an image of the entire screen onto the surface of the CdS cells.

Nikkormats have only 97% viewing whereas the F has 100%. The Nikkormat has the faster "swing open" film back and not the slip-down model of the F's. This is a style change that will hold for all models to come. Opening the back is done by pulling down on a small tab at the base of the left end of the body below the flash sync socket.

Shutter speeds are set by turning a ring that encircles the lens mount. They are white numbers, the selected speed being the one in the middle (three shutter speeds appear at one time). The shutter speed selected can be seen in the viewfinder on the lower edge. It is also indicated on the outside of the body at the top right of the lens mount. Correct exposure is determined by centering the needle between the brackets inside the viewfinder or by centering it in the circle on top of the prism. The same ring that sets the shutter speed

also has the ASA setting which goes from 12 to 1600.

Like the "T" and "Tn" finders, the lens maximum aperture needs to be indexed to the film ASA for correct exposure readings. This must be changed every time a lens with a different maximum f/stop is used. The viewing screen is not interchangeable, but is an all matte fresnel with a 12mm central grid circle. It has depth-of-field capability by pressing a button on top of the body to the right of the pentaprism.

The Nikkormats have a mirror that can be locked-up. This is done via a flat-sliding tang to the left of the lens mount just above the lens release button. Although it is hard to push, this feature is unique and allows the use of lenses, such as the 21mm f/4, which requires the mirror to be locked up. The camera also has a self-timer of ten seconds but has no flash mounting shoe. Attaching a flash is accomplished via the **Nikkormat Accessory Shoe** with the PC cord having to be plugged into either the M or X socket.

The film advance on the right-top of the body is a single stroke 120 degree advance. The film advance lever needs to be out from the body 35 degrees (there is a detente for this) to activate the meter. The meter remains on the entire time the lever is left out. The shutter release button and frame counter are located adjacent to the advance lever.

Later in 1965 Nikon introduced the **Nikkormat FS**, a simplified version of the FT minus the exposure meter and mirror lock-up. The popularity of this model was brief and production lasted only six years.

The big break-through came in 1967 in the newest model of the Nikkormat line, the **Nikkormat FTn**. The reception of this camera was so great that one photo magazine of the day said, "the danger of building a better and more economical mousetrap is that it can be too successful, thereby making a liability of your more expensive models...this may appear to be the case with the Nikkormat camera vs. the Nikon F." What made the FTn so hot? The FTn with so many new improvements was priced the same as the FT, probably the only time in photographic history that this happened. Keep in perspective that electronics such as pocket calculators and other electronics we take for granted today were not even on the market yet.

Housed in the same body as the FT, the FTn's biggest new feature was its center weighted meter. The CdS meter behind the lens reads the finder screen at full aperture with the emphasis on the central area. This minimizes exposure error caused by backlight, long lenses, and extraneous light surrounding the subject. The FTn has plastic, aspherically convex, fresnel grooved lenses which form an image from the central 12mm diameter circle of the viewing screen to achieve its central weighted metering.

The new ASA indexing system of the Nikkormat FTn was also revolutionary. In the FT or even in the Nikon Tn, lenses are indexed by setting the maximum aperture opposite the ASA of the film in the camera, a time consuming procedure when trying to photograph action. Other manufacturers obsoleted their lenses in order to accomplish a system of semi-automatic indexing. Nikon's commitment to planned non-obsolescences held true with this semi-automatic system. The ASA is indexed on a ring on the lens mount that is indexed by a unique spring-loaded connecting ring when the lens is mounted on the body (the lens aperture is set at f/5.6). A twist of the aperture ring to the smallest aperture then back to the largest and indexing is completed.

Other improvements on the FTn are inside the viewfinder. The meter brackets for the match needle (center the needle for correct exposure) has been given a minus sign at the top and a plus sign at the bottom to ease indication of exposure. One drawback, the movement of the needle up or down is nonlinear, the same amount of movement up does not equal a comparable movement downward. The shutter speed readout at the bottom of the screen on the FTn changed from that of the FT. The selected shutter speed is white with the other two in yellow.

The Copal Square-S vertical shutter provides a 1/125th flash sync. The FTn has the same screen as the FT except that the outside fresnel rings are slightly closer (50mm lines per mm compared to the original 25mm) to enhance picture brightness. Later, an FTn came out with the option of a Rangefinder Screen which has a split-image rangefinder (4mm in center of screen) surrounded by a matte fresnel field. All of these improvements added only 1oz to the overall weight of the FTn (39oz) over the FT.

The Nikkormat line of bodies did not change

for five years until 1972 when the **Nikkormat EL** was introduced. Its contribution to today's Nikon cameras was "aperture priority" and exposure memory lock with full manual control.

Although the EL continued with many of the design elements of the FTn, it had all new cosmetics. The shutter speed dial was no longer around the lens mount but was brought topside to the right of the prism (the prism is not interchangeable). It has 15 shutter speeds from 4 seconds to 1/1000 as well as "B" and "A" for aperture priority. By pulling up on the outer ring of the shutter speed dial, flash sync can be changed to work with either electronic flash or flash bulbs. The difficult FTn mirror up latch has also been changed to an easy throw switch located on the lens mount. The EL came with the same style viewing screen as on the FTn, but they can often be found with a split rangefinder screen which may be a factory or custom installation.

The meter has CdS cells concentrating 60% of their reading from the center of the bright matte (not the same as today's bright matte) fresnel screen. This is center-weighted metering. The meter readings are displayed on the inside of the prism along the left, vertical edge of the display, starting with 4 seconds on the bottom and going up to 1/1000. A solid green bar moves as the shutter speed is changed, indicating the manual speed selected. In manual mode, the black needle moves in reaction to light. This must be matched to the green bar by either adjusting shutter speed or aperture to get correct exposure.

When in aperture priority mode, the green bar covers the "A". With the green bar on the "A", the black needle will move to indicate the shutter speed the camera has chosen in accordance to the f/stop selected. When in aperture priority, the shutter speeds are stepless. The camera can pick a shutter speed such as 1/67, 1/467 or hundreds of other shutter speeds not listed on the shutter speed dial. The camera will only indicate those speeds listed on the scale although selecting a slightly different shutter speed, so as not to confuse the photographer.

Selecting the ASA is new on the EL, on the far-left topside of the prism. It is by a ring located under the film rewind lever. The semi-automatic indexing of the FTn is still employed on the EL, but the maximum aperture is displayed on the left of the lens mount ring. Mounting a lens onto the EL

still requires setting the lens at f/5.6 and, after mounting the lens, rotating the aperture ring to the minimum aperture then back to the maximum. This indexes the meter. The traditional bayonet F lens mount is still employed as on all previous Nikon bodies.

The EL's self-timer provides up to ten seconds when turned counter-clockwise. Pushed in towards the lens mount ring, this becomes the memory lock button when the camera is in aperture priority. The EL still employs a depth-of-field button that is found right above the self timer lever. The battery for the camera, which runs the meter and the electronic circuitry of the shutter, is located under the mirror inside the mirror box. Use the mirror-up lever and lock up the mirror to get into the battery box. It uses a 6 volt battery. The EL has a battery check located on the left-top back cover. It is operated by pressing in on the button which lights up an LED to the left if the battery is good. The EL film back opens by pulling up the film rewind knob, a feature retained in Nikon bodies for more than two decades.

The Nikkormats did not radically change after the introduction of the EL. In 1975 the **Nikkormat FT2**, a modified FTn, came on the market. The biggest change is that the FT2 has a built-on flash hot shoe for direct mounting of a flash onto the body. In conjunction with this, it has an automatic M-X switchover via shutter speed selection. This works with either electronic flash or flash bulb. For bigger flash units, there is a standard PC plug on the top-left end of the body. All other features and operating procedures remain the same as those of the FTn.

1976 saw the introduction of the **Nikkormat ELw**, "w" standing for winder compatible. Other than a modification to accept the winder, there were no other changes to the body design or features. The **AW-1**, a very simple motorized film advancer, attaches to the bottom of the ELw and advances the film when the shutter release button is pushed. The AW-1 is extremely noisy and prone to breakdown because of a nylon gear on one of the main drive shafts that is easily stripped. A gear from the MD-3 repairs the stripped gear, but it too is difficult to obtain.

In 1977, the next in the line, the **Nikkormat FT3** was introduced. The FT3 is a direct copy of the FT2, with one exception, but it now works with the newly introduced "AI" indexing system (intro-

duced in 1977). Later that same year, the **Nikon EL2** came on the market. It was an exact copy of the ELw except that it also worked with the "AI" indexing system. These last few Nikkormats were produced for only a short period (production numbers unknown) and few were ever on the US market. The EL2 and FT3 are still in use today by many photographers and are mechanically extremely reliable. With the passing of the EL2 went the era known as the Nikkormats.

Nikkormat cameras with a *"Nikkomat"* name plate were originally sold in foreign markets. The *Nikkormat* nameplate was on cameras imported into the US, much like the *F801* is the *N8008* but sold in markets outside the USA.

There was one camera that Nikon brought on the market for a brief time that should be mentioned. In 1961 Nikon introduced the **Nikkorex F**, a low-priced SLR that would accept the Nikkor F lenses. It had an accessory shoe located in the front for an external meter, but otherwise it was bare of features. Not many were manufactured so it was not on the market long. Occasionally these cameras come on the used market and are mistakenly purchased as collectable, but their real value is about $30.

The F2

In the fall of 1971, Nikon introduced their first major addition to the pro series body. The **F2** was a big departure from the F. It was given a cold reception at first (which happens anytime a new pro body is introduced) by the thousands of loyal, die hard F owners. In a short time, the F2 became the workhorse of photographers around the world. Some of the concepts in the F were carried through to the F2. Items such as interchangeable prisms, screens (the F2 utilized the exact same screens), and the bayonet F lens mount remained the same. The F2 was the beneficiary of many of the Nikkormat's innovative designs. Things such as hinged film back and other cosmetic features were incorporated into the F2s design. But the F2 had many of its own, new innovations to introduce.

When first released, the F2 was available with a straight pentaprism finder, the **DE-1**, or the **DP-1** TTL meter finder. The combination of the F2 with the DP-1 is referred to as the **F2 Photomic**. The F2

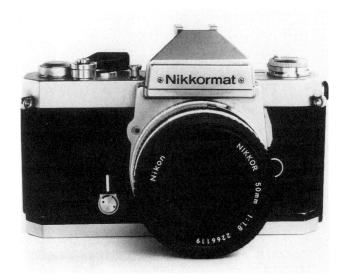

Nikkormat FT3.

body remains an F2 (though there were hundreds of internal changes over the years of production) no matter what prism is attached to it.

The basic F2 controls are designed and placed for optimum ease of operation. On the top-right is the film advance lever (with plastic tip) that has a short, single stroke action of 120 degrees. Film advance can also be performed in a number of shorter strokes. The film advance lever pulled out from the body 30 degrees activates the power to the meter. The meter's power remains on as long as the advance lever is left out in this position. Directly above the film advance lever is the additive frame counter. This indicates how many frames have been fired. The shutter release, next to the advance lever, is protected by the T-L ring. The ring has two functions: protecting the accidental firing of the camera and setting the camera either on "T" for time exposure or "L" to lock the shutter release from firing. Lift up the ring and turn until the notch is either on the "T" or "L" to use those functions. Leave the notch in the center for general shooting. The **AR-2** cable release threads around the shutter release button for hands off firing.

The shutter speed dial is adjacent to the prism. Its settings are "B", 1 second through 1/2000. The F2 was the first Nikon with a top shutter speed of 1/2000th of a second. The red line on the shutter speed dial between 60 and 125 indicates the top flash sync of 1/80 (though 80 is not written) and can be set at that line for flash sync.

The F2 provides stepless shutter speeds when working between 1/80 and 1/2000. Fine tuning the

Screens

Any one screen must, by necessity, be a compromise, and good though our type K screen is in terms of focusing accuracy and convenience, it is not the perfect answer to every photographic situation. The same is true for cameras without interchangeable screens. There will be some jobs that just cannot be handled with speed and accuracy by their fixed screen.

With the F2's, you not only have a range of 13 basic types of screens to choose from but there are also subgroups within this range, giving a total of 19 screens in all. All just to ensure that whatever the situation or, whatever the lens in use, there is a focusing screen to match. This is important as both maximum aperture and focal length influence focusing, sometimes even causing the central range-finder spot to black out. Indeed, some photographers are so conscious of the suitability of one screen or another for their work that they permanently reserve one F2 body/screen combination for use with specific lenses. This assures them of very fast handling in actual shooting situations, with maximum focusing accuracy.

Each screen, too, is much more than just the piece of plastic used in other systems. Instead, each Nikon screen comprises a precision optical system in itself, securely locked into a metal retaining frame that serves to both mount the screen in the camera and to protect it from damage when handling. Once in place, the screen is positively locked in position by powerful spring-loaded clamps which ensure that it cannot move out of position and degrade focusing accuracy.

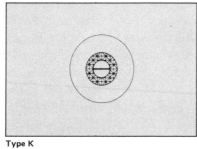

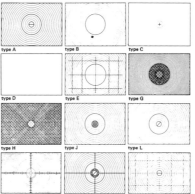

Type K

type A	type B	type C
type D	type E	type G
type H	type J	type L
type M	type P	type R

type A: Matte/Fresnel field with a 12mm-diameter reference circle and a split-image rangefinder spot. Ideal for quick and accurate focusing in general photography.

type B: Matte/Fresnel field with a 12mm-diameter circle. For viewing and focusing without distraction in the center. Also recommended for lenses with small maximum aperture, such as 200mm f/5.6 Medical-Nikkor, 500mm f/8 and 1000mm f/11 Reflex Nikkors, etc.

type C: Fine matte field with a crosshair reticle in a clear 4mm-diameter center spot. For photomicrography and astrophotography, and other applications involving high magnifications, for parallax or aerial-image focusing. Requires viewfinder with focusing control. (6X finder or 2X magnifier, both with variable diopter eyepiece)

type D: Overall, fine matte field ensures unobstructed viewing. Used especially with long telephoto lenses or for close-up work.

type E: Matte/Fresnel field with a 12mm-diameter circle and etched vertical and horizontal reference lines. For picture taking that requires accurate image placement or alignment such as architectural photography with PC-Nikkor, and copying work.

type G: Clear Fresnel field with a 12mm-diameter microprism focusing spot. Provides an extremely brilliant image for focusing in low light. Available in 4 models to match various focal length lenses.

type H: Clear Fresnel field with microprism pattern over entire screen area. Permits rapid focusing with optimum brightness. Suitable for use in low light and with moving subjects. Available in 4 models.

type J: Matte/Fresnel field with a 4mm-diameter microprism focusing spot within the 12mm-diameter circle. Covers most general purposes.

type K: A combination of Types A (split-image) and J (microprism) screens. Rapid and accurate focusing. Suitable for general photography. Supplied with the Nikon F2 as standard screen.

type L: Similar to Type A screen, but with the split-image rangefinder line at a 45° angle. Especially effective when focusing on an object with horizontal lines.

type M: With a double cross-hair reticle and scales on a clear surface. Recommended for photomicrography, close-ups and other work involving high magnification. Requires viewfinder with focusing control. (6X finder or 2X magnifier with variable diopter eyepiece)

type P: Matte/Fresnel field with a central 3mm-diameter split-image rangefinder at a 45° angle. A 1mm-wide microprism band and a 12mm-diameter reference circle surround the rangefinder. Has etched horizontal and vertical lines to facilitate composition. Suitable for general photography.

type R: Matte/Fresnel field with a central 3mm-diameter circular split-image rangefinder and etched horizontal and vertical lines. No image darkening in the rangefinder even with the lenses having maximum apertures between f/3.5 and f/5.6. Ideal for architectural and commercial photography.

11

exposure when using a meter prism in conjunction with the shutter speed dial as opposed to the aperture ring is possible. Controls for turning the shutter speed dial are different depending on whether a metered prism is attached to the body. Directly in the center of the shutter speed dial is a small line that turns as the film advances and indicates whether the next frame of film has completely advanced. This cannot be seen if there is a meter prism attached to the camera.

The top-left side of the F2 is bare with just the film rewind knob and accessory shoe present. To rewind the film manually on the F2, first depress the small button located on the bottom of the body (on back side below self-timer). Then turn the rewind knob in the direction the arrow points until the film is back in the cassette. The accessory shoe that surrounds the rewind knob accepts only the Nikon special flash shoe which is not an ISO shoe. The **AS-1** Accessory Shoe Attachment permits attachment of any ISO foot flash unit, and provides hot shoe connections. There is a standard PC plug right in front of this on the front of the camera for bigger flash units.

The button on the back side directly behind the film rewind knob permits removal of prisms and screens. It is activated by pressing in (a strong, pointed object is recommended) while pressing in the lever on the meter prism. The DE-1 requires pressing in only the one button on the body for removal. This same button is used to remove the screen from the body when no prism is attached. This is performed by continuously pressing in the button, carefully turning the body until the screen drops free. Without a prism attached to the F2, note the two posts on either side of the prism mount. The post on the film rewind side is surrounded in plastic, the other is bare. These posts bring the power up from the battery box to the meter powering it.

The depth-of-field, mirror-up, and the self timer are on the front right panel of the F2. The depth-of-field and mirror-up buttons are part of the same assembly which is at the top of the body near the shutter release button. Depressing in the button activates the depth-of-field (DOF); turning the dial around the DOF button locks the mirror up. Below this is the self-timer which delays firing for up to ten seconds.

On the base of the camera is the **O/C** (Open/Close) **Key** which folds out and when turned in the direction of the arrow, pops open the film back (must be manually reset after closing the back). Next to this is the battery chamber which powers the meter. Next to this is the film rewind release button. Two motor drive connecting sockets are also found here.

The prisms first released with the F2 in 1972 were a standard pentaprism **DE-1** and metered prism **DP-1 Photomic**. The DE-1 and all other prisms for the F2 provide virtually 100% viewing for complete viewing screen composition. This is aided by the newly designed mirror in the F2 which is larger to prevent cutoff, especially when using a telephoto lens. The compact DE-1 was manufactured for photojournalists (PJs) who at this time relied more on hand held meters rather than the newer TTL meters. The DE-1 has a post on the back-left side which, when connected with the right flash or accessory, lights up a flash ready light at the inside top of the prism finder eyepiece.

In its day the DP-1 Photomic finder was quite a meter. As a testament to its durability, many are still in use today. It employs high quality CdS cells along with improvements in other related parts that let it function from EV1 to EV17 at ASA 100. The center-weighted metering concentrates 60% of its reading from the 12mm circle on the screen (appx 1/8th of the total area of the screen) with sensitivity falling off gradually towards the edges.

The ASA settings are an amazing 6 to 6400! The meter couples with the lens for semi-automatic indexing. Mount the lens at f/5.6, then rotate the aperture ring from minimum back to maximum aperture to index the meter. A window on the front of the prism above the lens displays the maximum aperture indexed. With an f/2 lens and a properly indexed meter, f/2 appears in the window. The viewfinder information provides the photographer with the shutter speed and aperture in use as well as the match needle meter readout.

On the top of the DP-1 is a window that is split in half. The top half is a plastic diffuser that illuminates the meter needle inside the prism, and the bottom half is the same match needle meter reading found inside the prism. For correct exposure, the needle must be centered in the squared off box at the top of the circle. When the needle is to the right point of the box, exposure is approximately 1/3 stop underexposed, to the left and the exposure is 1/3 stop overexposed. If the needle is

anywhere past these points, exposure is more than 1/3 stop over or underexposed.

The shutter speed readout is to the right of the needle, the aperture to the left. Both numbers are on a wheel inside the prism that turn with either the shutter speed dial or aperture ring. These can sometimes get out of alignment or stuck between numbers, but this can be easily repaired.

On the front-right of the DP-1 is a silver button which performs the battery check. Depress it and the needle in the meter readout should center, indicating a good battery. The lever right beside the battery check button is for removal of the meter. While pressing in the prism release button on the back of the body, press in and turn the lever on the prism to remove it. To remount, press the meter back onto the body, spinning the shutter speed dial to make sure it is aligned with the dial on the body.

The serial number located on the top-left body cover has been mistakenly believed to indicate the year of camera manufacture. For example, a camera with serial number 7100001 is called a '71 body and assumed to have been manufactured in 1971. This does not hold true at all, but does help identify the earlier models with problems. Some early model F2's with serial numbers 71.. and 72.. had a problem with the film transport system. The drive cam on the take up spool has a slight kickback to it when advancing the film and can give a ghosting effect in the photograph. This problem can really be seen when a motor drive is used. There is no easy or inexpensive fix. Throughout the years of F2 production, many internal changes were made to perfect the camera's operation.

Nikon introduced its first new meter prism for the F2 in 1973, the **DP-2** meter head. The combination of the F2 body and DP-2 meter is referred to as the **F2S** (long version is F2S Photomic). The DP-2's main new feature is in the way it relays the exposure information to the photographer. Instead of a needle to match up, there are diodes that display either a plus or minus arrow. These diodes are also visible in the window on the top of the prism. The arrow on the right indicates underexposure, on the left, overexposure. When both are lit simultaneously, the exposure is correct. The DP-2 with its CdS cells has increased sensitivity over the DP-1 (but CdS cells are not very sensitive), from EV-2 to EV17. It still employs the same meter coupling system as the DP-1.

The DP-2 can meter down to 8 seconds, a new

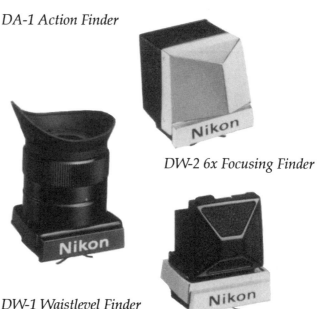

DA-1 Action Finder

DW-2 6x Focusing Finder

DW-1 Waistlevel Finder

feature. First, turn the shutter speed dial to "B" (bulb). Then press the button located in the center of the ASA dial. The ASA dial will now spin, showing 2, 4, 6 and 8 second markings directly above the "B" setting. The number set above the "B" permits metering for that shutter speed.

The window on the front of the DP-2 indicates the maximum aperture setting. The lens must be properly mounted and indexed for correct operation. There are a new set of contacts under a ledge near the front-left of the meter. These hook the DP-2 up to the **DS-1**, EE Aperture-Control Unit. This attachment provides shutter priority operation.

Working off its own internal battery (the Nicad **DN-1** charged with the **DH-1**), the DS-1 mounts by first removing the lens and PC cap from the body. The DS-1 has a ring that fits around the lens mount. This ring has a squared off tang on a track that connects to a small tang on the lens mount. This track assembly slips over the lens mount as the knob on the DS-1 is turned, screwing it into the PC socket.

This permits the DS-1 to change the aperture ring for correct exposure. The chosen shutter speed causes the electric information in the finder to light up either the plus or minus diodes to indicate correct exposure. At the same time the DS-1 receives the information which instructs it to turn the aperture ring until both diodes indicating correct exposure are on. Any external lighting changes cause the DP-2 to automatically change the DS-1 to

the right exposure. Though extremely accurate, operation of the DS-1 is very slow. A later introduction, the **DS-2**, is the same as the DS-1 except that it has a PC socket.

The F2 has updated versions of the F prisms which are designed for specialized applications. The **DA-1 Action Finder** (also called sportfinder) is an updated version of the Sportfinder with slight cosmetic changes. The **DW-1 Waistlevel Finder** is the four-sided version introduced late with the **F Waistlevel**. The **DW-2 6x Focusing Finder** is the critical focusing aid finder. None of these finders produces a corrected view of the image, everything being reversed. These prisms can work on the F with modification. The metered prisms for the F2 cannot, the main reason being that the F has no battery posts on top of the body near the screen. These meters remained the same throughout the time the F2 was manufactured.

In 1976, Nikon introduced another new prism, the **DP-3**. When attached to F2, the combo is referred to the **F2SB**. The DP-3 turned out to be a fantastic finder. This was the first meter to come out with Silicon Blue Cells (which have stood the test of time), a very sensitive light gathering system. The cells are coupled with a 5-stage, LED display to indicate correct exposure.

Inside the finder are a plus, circle and minus sign (from right to left). The circle lit by itself indicates correct exposure. A lighted circle with either the plus or minus sign denotes either under or overexposure by 1/3 stop. If only the plus or minus is lit up, exposure is off by 1 stop or more. For remote use, the DP-3 has an eyepiece curtain which can be closed to block out ambient light. The DP-3 will also work with either the DS-1 or DS-2 for shutter priority.

The F2 system marched on for three years without any changes until 1977. This was when the AI (automatic indexing) coupling was introduced in the **DP-11** and **DP-12** meter finders. The F2/DP-11 is referred to as the **F2A** and F2/DP-12 as the **F2AS**. The DP-11 is an exact copy of the DP-1 with all of its features with the addition of AI meter coupling. It lost the maximum aperture window in the front. The DP-12 is a DP-3 with AI coupling and is also missing the maximum aperture window.

The DP-12 has a new EE aperture-control, the **DS-12**. It works the same as the DS-2 but has slightly different couplings between it and the

lenses aperture ring. Both DP-11 and DP-12 can lock up their AI prong so non-AI lenses can be used. Just press up on the prong and it snaps up out of the way. Pressing the button under the letters "A" or "AS" on the front of the finders releases the prong back to AI meter coupling.

There were other models of F2 introduced in 1976 in limited quantity. The first was the **F2T**, identical to the F2 except it had a back, top and bottom plate made of titanium. This is a light weight metal with the strength of a heavier metal. In conjunction was the **DE-1T**, a DE-1 prism with a titanium top cover. Serial numbers of the F2T start with 92... and can also be distinguished from other F2's by the textured finish and flat black color. The F2T accepts all accessories available for the F2 body without modifications. Nikon made special F2T's for the space program named **"TITAN"** which is inscribed on its face. These cameras are now very rare.

The **F2H** came out the same year and is a titanium body with a special pellicle mirror. Connected to the motor drive **MD-100**, it can fire up to 10 frames per second. The pellicle mirror does not go up and down like a normal mirror. Rather, it

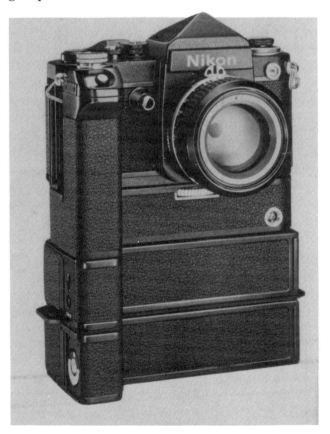

F2 high-speed motor-driven camera.

stays in one place, permitting viewing through the lens while taking a picture. The photograph itself is taken right through the mirror. Screens cannot be interchange in the F2H; a "B" screen is permanently mounted. The body has been stripped of "T", "B", 1/2000 shutter speed and self-timer. The MD-100 is powered by a permanently attached, double stacked MB-1 battery pack that is loaded with four MN-1 nicads. It comes with a special charger that charges all four nicads at once. The F2H was produced in very limited numbers and is collectable as well as being extremely sought after by photographers for use today.

The FM/FE Series

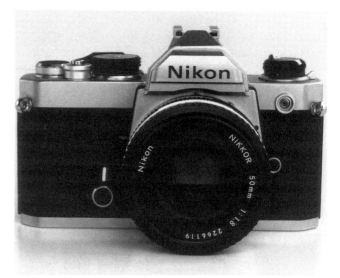

Nikon FM.

In 1977 Nikon embarked on a whole new line of compact bodies. The **FM** was the first to be introduced with basic, functional features which soon made it quite popular. It was significantly smaller and lighter than the Nikkormat or EL series but maintained full-sized operating controls. Like all Nikons to come, the FM meter coupled with the new AI system.

The FM had completely new metering cells, radically different from all other models. Gallium Photo Diode (GPD) metering responds to light changes with incredible speed, especially at low light levels. Its increased sensitivity (EV1 to 18) quickly caught on with users. The center-weighted TTL meter has the standard 60% bias in the center 12mm circle on the screen. The FM has a fixed Nikon type "K" screen, a split rangefinder 3mm in diameter surrounded by an overall matte fresnel.

The viewfinder readout is clean and simple. On the left is the meter with a plus, circle and minus. Next to them, a red light indicates the exposure. The shutter speeds are on the left hand side and the aperture is located in the center on top. The **Aperture Direct Reading** (ADR) method is new and occurs in conjunction with the new AI lenses. The aperture ring has two sets of numbers, the smaller set are used by the ADR. These are read through a mirror on the outside-top of the prism then seen inside the finder. Like most Nikons, the finder has a built-in –1 diopter correction.

The FM has only 93% viewing of the screen unlike the Nikkormats. The FM has an oversize instant-return mirror for full frame viewing with telephotos. This has a special damping mecha-

nism. Unlike the Nikkormat, the FM has no mirror lock-up capability. Mirror lock-up utilizes quite a bit of space inside the mirror box, adds weight and increases production costs which is why it was left out.

Its unique shutter travels vertically rather than horizontally. This minimizes noise and vibration during exposure while increasing durability. The shutter speeds on the FM are "B", 1 second to 1/1000 with a flash sync of 1/125. A simple double exposure control is available by pushing a small lever next to the film advance lever, allowing the shutter to be cocked but preventing the film from advancing. This works with a motor drive attached as well. After firing the camera, advancing the film resumes normal operation.

The FM still accepts all Nikon lenses (except those requiring mirror up) and meter couples with the newer AI lenses. For those lenses that are not AI coupled, the AI meter prong folds out of the way by pressing the button next to it. Once accomplished, stop-down metering is required. The FM has a depth-of-field feature activated by pressing the lever to the right of the lens mount towards the body. The FM also has a 10 second, cancellable, self timer.

A state-of-the-art film transport system is also featured. Typical of the current design, the FM has an oversized pressure plate plus extra-long film rails, cassette stabilizer, anti-bellying roller and emulsion-side-out winding on the take-up spool to assure superior film flatness for optimum edge-to-edge sharpness. The film single stroke advance is

135 degrees. The meter activates at 30 degrees. It is also a hinged film back which has become standard equipment. The FM has a hot shoe attached to the prism with an automatic safety switch. A standard PC socket on the body permits off camera PC cord use.

The FM has a standard threaded cable release socket surrounded by a rotating collar. This collar must be turned in order to use the camera with the optional motor drive. With a black FM, turn the collar to the red mark for use with the motor drive or to the white mark for manual advance. With a chrome FM, turn the ring to the red for motor drive use and black for manual advance. In later models this feature was dropped, in favor of a system that did not need to be changed for motor drive operation.

The **MD-11** Motor Drive was the motor drive designed for use with the FM. It easily connects to the base of the FM with a simple turn of the thumb wheels. It can provide up to 3.5 frames per second. It has a socket for remote firing via the MC-10 cord or MR-1 button.

In 1978 the **FE** came on line. Although the body looks exactly like the FM, the FE (E stands for electronic) shutter and meter are completely powered by the batteries. The FE has aperture priority while maintaining complete manual setting control with match needle metering.

The FE has three interchangeable screens, the "K" (standard) which has a split rangefinder, "B" (plain matte) with 12mm circle and "E" (same as B but with two horizontal and 3 vertical lines) known as the architectural screen. It has dual Silicon Photo Diodes (SPDs) cells with metering monolithic IC circuit for 60% center-weighted metering. Exposure information inside the prism is similar to that in the EL series (which was still on the market at the time). The shutter speeds are displayed on the left, a green bar indicating the chosen shutter speed and a black bar indicating correct exposure. The ADR is at the top of the finder displaying the aperture in use. Using Nikon system flash units, a flash ready light appears in the prism when the flash is charged and ready. If the shutter speed is above 1/125 when the flash is attached, the ready light will flash a warning.

Shutter speeds available are 8 seconds to 1/1000, with a "B" and "Auto" provided. A new setting appears on the FE, M90. In case of dead batteries causing system failure, turn to M90. This provides a manual 1/90 shutter speed, but meter functions are still lost. On the back left-top of the FE is an LED battery check. Utilizing this feature prevents accidental loss of shutter speeds from battery failure.

The FE has no mirror lock up. It does have the FM style depth-of-field preview lever, enabling stop down metering with non-AI lenses. The FE also features the lock-up AI prong on the aperture ring. The ASA setting is around the film rewind with a new meter compensation system. The meter setting may be biased by plus or minus 2 stops in 1/3 stop increments. The camera has a detachable hinged film back that can be replaced with an **MF-12** Data Back. This back can imprint simple numbers such as year/month/day on the lower right corner of the image. It is connected to the camera via a cord (repl cord prod #4418) to the PC socket. The back is triggered just the same as a flash would be, imprinting at that instant. The FE can also use the newer MD-12 or older MD-11 motor drive.

In 1979, a year after the introduction of the FE, Nikon entered the consumer market with the introduction of the **EM**. This ultra compact camera was stripped of most of the basic features: depth-of-field, PC terminal, interchangeable screens, and shutter speed control. A fully automatic camera with aperture priority, it picks the correct shutter speed according to the chosen f/stop.

The EM was the first of many Nikons to come with an all plastic aperture ring. Only AI/AIS lenses can be attached, non-AI lenses can no longer be mounted to the body. The shutter speed readout in the viewfinder (same as the FE) is a needle indicating the selected shutter speed. The shutter speed is stepless, so the nearest shutter speed to the one selected by the camera will be indicated by the needle. If the shutter speed should fall below 1/30, a "**sonic**" warning signals a slow speed. If the batteries fail (battery check is right next to the film advance lever) almost all operation is lost. Like the FE, the EM has an M90 setting for a manual 1/90 shutter speed. The EM also has an electronic "B" setting which uses battery power during the entire exposure.

Even the flash is semi-automatic (a first) on the EM. When used with the **SB-E** flash, the camera's hot shoe transmits ASA and aperture information from camera to flash. When switched on, the flash sets the camera shutter speed to 1/90

for proper flash sync and activates the LED in the viewfinder. The LED blinks when an incorrect f/stop is used. Another advanced feature on this economical camera is backlight control. A button located on the front-left of the body near the film rewind activates the backlight control. When this button is pressed, the camera, though lacking an exposure compensation dial, automatically increases exposure by two stops. The meter is center-weighted, metered by one SPD cell with a sensitivity of EV2 to 18. The EM provides only 92% viewing.

The EM has no mirror up mechanism or depth-of-field button. On this or any such camera lacking a manual DOF button, depth-of-field can be seen through the lens by partially dismounting the lens. Press the lens release button and turn the lens as if removing it from the body. As the lens turns, at one point it will be disconnected from the lens diaphragm lever in the body which keeps the lens opened to the maximum aperture. Once disengaged, the lens will stop down and depth-of-field can be seen. Be careful not to forget the lens is only partially engaged to the lens mount.

The F3

1980 was a very exciting year. True to tradition (a new pro model every ten years), Nikon introduced its third and newest addition to the "Pro" camera line, the **F3**. As with the release of the F2, the fully electronic F3 was at first given the cold shoulder. This reluctance lasted for over a year but slowly the F3 became one of Nikon's best selling cameras in the US. The F3 was the first, truly all electronic, pro camera for Nikon. It served as a test for many of the new features and innovations that Nikon developed with an eye towards the future.

The F3 has a totally new look coming from the incorporation of these new features. The shutter speed dial is still located to the right of the prism. It has a new rubber ring around it for easy turning even in cold weather. A button in the center locks the shutter speed dial in the "A" (aperture priority), "X" and "T" slots. Its shutter speeds range is 8 seconds to 1/2000 with the 1/60 in red for flash sync speed. Turning to "X" provides a 1/80 sync speed (the F3's flash sync), but metering is lost.

The shutter release button is located in the middle of the film advance lever. It is an electro-

magnetically activated release requiring battery power rather than a mechanical one. The shutter release button also activates the meter, turning itself off after 16 seconds once the button is released. The small lever below the advance lever (toward the front) must be turned and the red dot exposed in order to power the camera. If the MD-4 motor drive is attached, its batteries power the F3 and the switch on the body does not need to be activated. A very convenient double exposure lever is also located here.

On the front of the camera, right below the shutter release is the molded handgrip. Permanently fixed, this rubber coated grip is well designed and placed for maximum comfort and security. Next to the handgrip near the top is the self-timer light that flashes at an even pace until the last three seconds when its flashing speeds up. Next to the lens mount are the depth-of-field button and mirror up lever. These work just like those on the F2. Below this, next to the lens mount ring, is the memory lock button which is in the center of the manual shutter release lever. Pressing in on this button and holding it in during the exposure will lock in the shutter speed selected by he camera while in aperture priority. The manual shutter release lever provides a 1/60 shutter speed if the batteries die. The F3 is all-electronic. If the batteries go dead, the whole camera is dead except for the 1/60 manual speed and film advance.

On the top-left side of the camera are the film rewind knob, ASA dial, and the meter compensation dial with plus or minus 2 stop compensation. The special F3 flash foot is part of the assembly and covers the film rewind knob when attached. Lifting up on the film rewind is required to open the camera back for film changing. The flash must be removed before rewinding film if no motor drive is attached or opening the film back.

All three, the F, F2 and F3 have removable prisms requiring them to incorporate special flash foots on the body instead of on the prism. The strain on the prisms and prism mounts of a top-mounted flash is too much, so these pro cameras were designed with the side mount. The F3 has TTL flash capability when using Nikon system flash units connected to this foot. The **AS-4** permits the F3 to accept an ISO flash, but all TTL connections are lost. The system frustrates photographers still.

When the F3 was first introduced it came with

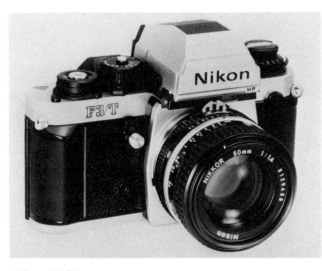

Nikon F3/T.

the standard finder, the **DE-2**. In 1982 this was replaced by the **DE-3** and the F3 has since been known as the F3HP. With the HP (High Eyepoint) finder, the eyepiece is bigger in diameter enabling those wearing glasses to see the whole screen. The information in the finder is simple and permits 100% viewing. Top-dead center is the ADR window with the flash diode for TTL exposure/ready light indication to the right. To the left is the LCD (Liquid Crystal Display) window which displays the shutter speed.

This same window contains meter information when in manual mode. Correct exposure is indicated by the plus and minus sign being lit simultaneously. When one or the other is lit, over or underexposure is indicated. An "M" will also be displayed when in manual mode. In "A" mode, the camera will display the shutter speed closest to the one selected by the camera, in a stepless range. The aperture ring is AI and has the fold back AI prong permitting non-AI lenses to be mounted to the body, but requires stop-down metering.

The F3 has interchangeable prisms along the same lines as those of the F and F2. The **DW-3 Waistlevel**, the **DW-4 6x Magnifier**, **DA-2 Sportfinder** and the **DX-1** provide focus assist when mounted to a regular F3. Metering is not lost when these finders are used since the meter is in the body. The DW-3, DW-4 and DA-2 are the exact same as the older prisms for the F/F2; only the cosmetics are updated. There are two levers on the side of the prism which must be pushed forward to remove a prism from the body. When attaching,

press until a click signals the prism has locked to the body.

The **DE-4** is a special prism packaged with the F3P. It has an ISO hot shoe on the top and when removed from the camera, a number of contacts on the base of the prism are exposed. This finder will work only on the F3P body and is not interchangeable with other F3 bodies. The F3P can accept all F3 system prisms with no problems (but you lose that expensive hot shoe). The F3 has interchangeable screens. These are not interchangeable with those of the F/F2 but they do share the same nomenclature.

One feature of the F3 confuses photographers because they are not aware of its existence. When the back of the camera is opened (done by lifting up the film rewind knob), the film counter automatically resets to -2 frames. Until advanced to frame 1, the meter in the camera is not operable. To avoid having long exposure times while trying to get to frame one, the camera will automatically set to 1/80 a second. If one looks inside the finder before the counter is at frame 1, 1/80 will be displayed in the LCD. The counter must be on frame 1 before any metering function is achieved. With the film back open, the meter is also inoperable.

The F3 meter was unlike any that Nikon had previously manufactured. As the meter is in the camera body, any prism used on the F3 could utilize the metering functions. The SPD cell is located at the bottom of the mirror box and can work in two modes, both separate from each other. When working with ambient light, the SPD cell takes a reading off a 4-piece secondary mirror. This gets its light through the mirror used to focus the camera. A very close inspection of the mirror reveals a rectangle made up of thousands (Pinhole Mirror) of small holes. The light passes through the lens, the aperture, and then to the mirror which bounces it to the second mirror to a cell at the bottom of the mirror box.

The same cell works the TTL (through-the-lens) flash exposure. The flash goes off and lights the subject. That light comes back through the lens, through the aperture and hits the film (the mirror and secondary mirror have swung up for the exposure). Then it is bounced directly off the film to the cell. Once the film has been correctly exposed, the cell tells the camera's computer to shut off the flash. All of these calculations are happening at the speed of light and with incredible accuracy. This

gives the F3 a very sensitive 80% center-weighted flash meter. Added to these capabilities, the mirror box has air-dampened shock absorbers. These reduce mirror vibration during the first phase of exposure.

Among the many innovations, the completely quartz-timed shutter speed is the most radical. Whether in manual or aperture priority, it is in use. The mirror box combination-magnet and the sequential operation of the shutter release are also quartz-timed. Over time this system has proved extremely accurate, providing the user true shutter speeds for years without loss of timing. The F3 retained the same titanium horizontal shutter curtain as the F/F2, precluding a high sync speed for flash.

The F3 has state-of-the-art microelectronics. These include 6 IC's, SPD metering cell, quartz oscillator and LCD block. There is also a Functional Resistance Element (FRE) integrated on a rigid substrate and then bonded to a flexible printed circuit (FPC) board. The F3 is cold tested to -20 degrees with an MD-4 attached to assure all these electronics live up to the Nikon name.

The F3 has more different versions than any other pro model offered by Nikon. The first was the F3HP in 1982. That same year the **F3T** came on the market. The first model of the "T" is natural titanium color, referred to by many as "champagne". It is exactly the same camera as the basic F3 except that it has a titanium top, bottom, back and prism cover (though the nameplate on the prism is plastic). This chrome F3T did not sell well and was discontinued for a black finish model in 1984. In 1983, Nikon took a very daring leap into autofocus with the introduction of the F3AF. An extremely fine working camera system, the F3AF did not last long simply because it was ahead of the time.

The **F3AF** is the basic F3 body, but with the addition of the DX-1 finder. The screen is built into the DX-1, so no screen is needed in the body. This body can be used as a regular F3 by adding a prism and screen and removing the DX-1. To autofocus, the DX-1 reads the right and left halves of the image-forming light rays from the subject. These pass through the lens and converge at the finder screen, located at the geometric equivalent of the focal plane distance. The travelling direction of the two halves becomes reversed as the light rays pass through the finder screen. Those are then split by

Top - Nikon F3HP, bottom - Nikon F3/T.

a half-mirror beam divider which transmits a portion of the image-forming light rays towards two relay lenses.

The internal relay lenses redirect each half to its respective SPD sensor. The sensors electronically detect the degree of focus shift and its direction from the optical axis. Focus detection is virtually instantaneous, within 0.5 milliseconds. With this information the finder tells the lens (80f2.8 or 200f3.5 ED are all that were made for the camera) which way to focus. The motor to do this is in the lens itself. It is a good and accurate system, but never caught on with the public, so more lenses

were never developed and Nikon soon dropped the camera.

In 1983 another F3 was secretly introduced. The **F3P** was not released to the general public at first, but only to Nikon Professional Services members (NPS). An NPS member could order the camera from his local dealer, but the dealer could not get them for open stock. In 1987 it became open stock for dealers. The poor sales of the F3P probably reflect the need of professionals for a high flash sync speed which no version of the F3 offered.

The F3P is a stripped down F3 with the addition of an ISO flash, non-TTL hot shoe on top of the prism. The F3P lacks the film back opening lock, self-timer and double exposure lever but has added to it a higher shutter speed dial and battery switch (with special pin) with a gasket fitted shutter release button. These improvements facilitate the use of the camera with gloves, making the controls bigger and easier to use. The F3P also comes with an **MF-6B** back (leaves the film leader out after rewinding film with MD-4) and "B" screen. The literature that came with a new F3P claims that the camera may be better sealed against moisture than a normal F3, but this doesn't mean it is waterproof.

The FM2/FE2/FA

1982 saw the introduction of the "World's Fastest 35mm SLR" (for its day), the **FM2**. The centerpiece of this claim lies in the completely new shutter. It is a vertically travelling, focal plane mechanical shutter made of titanium curtains that give an incredible 1/4000 top end and a flash sync of 1/200. Still in the same basic body as the FM/FE, the FM2 has a number of incredible new features. The ASA setting is located in the shutter speed dial at the top of the body and is set by lifting up the outer dial and turning it to the appropriate ASA setting. The FM2 is also the first in the series with an energy saving switch. Once the shutter release button is touched, the camera will automatically turn off the meter within 30 seconds.

The shutter speeds range from "B" to 1/4000, with a special 1/200. The 1/125 is red to indicate that it is the top speed for flash sync except when the shutter speed dial is turned to the 1/200. One problem occurs when the shutter speed is set to 1/200: the meter does not function. The viewfinder

information is the same as in the FM except for the addition of the ready light that works in conjunction with Nikon system speedlights. Other FM features retained in the FM2 are: depth-of-field preview lever, self timer, multiple exposure, single stroke film advance, mirror size and drive and interchangeable screens. It incorporates the AI coupling but the AI prong on the body aperture ring does not fold back, so non-AI lenses cannot be used.

1982 was a good year for new designs from Nikon. Not only did they introduce the new FM2, but also the FG. The **FG** is the next step in the EM line but vastly improved with some new features that would be used for the next decade. The revolutionary new features of the FG are TTL flash exposure and Program and Aperture Mode with manual settings. All these features were compacted into the smaller FG body.

The meter in the FG is a single SPD cell, 60% center-weighted. The metering range is from EV1 to 18 with an exposure compensation of plus or minus 2 stops. The FG also has the same backlighting button found in the EM for instant two stop over exposure. With program mode, set the lens aperture ring to the minimum aperture and the shutter speed dial to "P". The camera will pick the correct shutter speed/aperture combination. In aperture mode, set the shutter speed dial to "A", then select the desired aperture. The camera will use the correct, stepless shutter speed providing a correct exposure. In manual mode, both the shutter speed and aperture setting are picked by the photographer. The FG's aperture ring is AI coupled, but its AI prong does not fold up so non-AI lenses cannot mount to the body.

The viewfinder information in the FG was radically changed from previous models. The shutter speeds are displayed on the right, 1 second on the bottom and 1/1000 at the top. Directly to the right is a red LED column providing exposure information. When film is first loaded, both the 60 and 125 lights will blink to indicate 1/90 until frame 1. In the Program Mode (having set the aperture at the lens minimum f/stop with camera picking the aperture), the LED opposite the shutter speed the camera has selected lights up. When two lights are present, it means the camera has selected an intermediate shutter speed (remember it's a stepless system). In Aperture Priority, the LED lights opposite the shutter speed the camera has

selected as in Program Mode. In Manual Mode the LED lights up at the speed dialed while the camera's recommended speed displays blinking lights. In either mode, the aperture is not displayed at all in the finder.

Directly below the shutter speed numbers is a lightning bolt. This bolt indicates the correct exposure for the flash when in TTL mode. If under-exposure occurs, it will blink rapidly, indicating a need to either get closer to the subject or open up the f/stop. If the bolt goes off and then comes back on after a few seconds, correct exposure is indicated. To determine when flash is required, the FG has a "**sonic**" alarm when the shutter speed falls below 1/30 of a second. The meter is activated by touching the shutter release button, and turns itself off after 16 seconds. The standard K screen in the camera is non-removable.

The FG is the first Nikon that has an additional small handgrip on the front right of the camera. This provides extra security when holding the camera and is removed when the **MD-14** motor drive is attached. It is capable of 3.2FPS when set on High and 2FPS on Low setting. The MD-14 attaches directly to the base of the camera via a simple thumb screw and is powered by eight AA batteries.

Although not a fancy unit, the MD-14 is small and compact, fitting quite well with the FG, and provides outstanding service. The FG also has a data back available, the **MF-15**, which imprints the day/time/year on the lower right hand corner of the frame. Though the FG was considered an amateur camera body, many of the technological designs used in current cameras were put into practice by its introduction.

1983 brought in the best in the FE/FM series, the FE2. The **FE2** has the same basic body as the FE with many of the same features. The main new addition to the FE2 was the electronically-controlled, vertical-travelling, focal plane shutter with titanium curtains (like that in the FM2). This affords the FE2 shutter speeds from 8 seconds to 1/4000 with a flash sync of 1/250 (the fastest available). Nikon coupled this fast flash sync with TTL flash capability, thus making the camera an instant hit with most photographers. The FE2 has a standard ISO hot shoe on the prism that accepts Nikon system TTL speedlights as well as many off brand units. The shutter speed dial has a new setting, M250. This is a manual 1/250 that can be used if

the batteries go dead. The 1/250 in red on the dial is the flash sync speed. The meter is fully operational at this setting. The FE2 meter couples to the AI system but the AI prong does not fold up, so non-AI lenses cannot be mounted.

FE2 metering is 60% center-weighted, controlled by a pair of Silicon Diodes which provides a metering range of EV1 to 18. The viewfinder information is the same as that of the FE with the addition of an arrow for a flash ready light. This ready light operates identically to that on the FG for TTL exposure indication. The FE2 has a meter compensation of plus to minus 2 stops in 1/3 stop increments. This is located with the ASA dial (ASA 12 to 4000) around the film rewind. If the exposure compensation is turned to a number other than zero, a lighted plus/minus sign appears in the viewfinder as a reminder that it has been activated. The meter is activated by pressing down on the shutter release button and will turn itself off after 16 seconds. The film advance lever is a single stroke action, standing out at 30 degrees. When fully pushed into the body, it locks the shutter release button.

The FE2 has a fixed prism with 93% viewing and has 3 interchangeable screens of the new bright screen type. The standard screen is still the K2 matte with center split rangefinder. Additionally the B2 plain matte with 12mm center circle and the E2, the same as B2 but with 2 horizontal lines and 3 vertical lines, are available. The FE2 also has a memory lock button like that in the EL series. Push the self timer lever in towards the lens mount to activate and hold it until the exposure is completed. It also retains the same depth-of-field lever as that of the FM/FE. The FE2 uses the same **MD-12** motor drive, but does have a new data back, the **MF-16**, which does not need to be connected to the PC socket.

1983 also saw the introduction of the **FA**. Though cosmetically different from the FE2, the FA shared many of the same features: 1/250 flash sync, TTL flash, 3 bright screens, M250 manual shutter, ASA scale and compensation range, memory lock and depth-of-field lever, self timer, 93% viewing and shutter release-meter activation with automatic 16 second shut down. But the FA brings to Nikon bodies a whole new metering system, Automatic Multi-pattern (AMP).

In simple terms, AMP metering takes five readings of the screen (3 SPD are in use) and com-

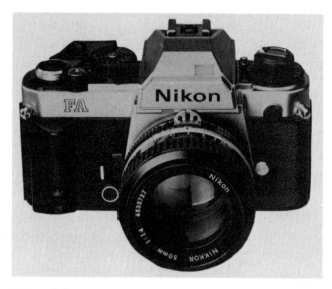

Nikon FA.

putes these values to arrive at a correct exposure. First, five sensors corresponding to five segments, individually sense the light coming through the lens. These analog values are compressed logarithmically. Then a high-speed sequential comparison A/D (analog to digital) converts to digital values. The computer in the camera then takes into account the lens focal length, aperture/shutter speed and other basic exposure needs. Finally, the computer relays all this information to other programmed scene values already stored (said to be over 100,000) to compare and provide a final number. This is an oversimplified explanation. The astonishing part is the speed at which this whole procedure is done. This meter has an exposure range of EV1 to 20.

There is a button located on the base of the front lens mount ring. Turned and pushed in switches the metering to 60% center-weighted. The AMP mode requires the use of AIS lenses on the FA to take advantage of all modes. The FA brought with it Programmed Mode, Shutter Priority, Aperture Priority and Manual Mode, all working with the AMP system. The programmed mode has P-HI bias built-in, switching automatically to faster shutter speed if a lens longer than 135mm is attached. The FA has the plastic body aperture ring, so non-AI lenses cannot be mounted onto the body. Using an AI or AI'd lens limits the camera to aperture priority (it will automatically switch to this mode if set to "P" or "S") or manual mode only. Information provided in the viewfinder depends on the mode in use.

In "P" mode, the LCD (Liquid Crystal Display) above the viewfinder displays the fixed speed closest to the automatically selected speed (stepless shutter speeds). A "HI" or "LO" LCD warns that over or underexposure may occur with the current light situation in relation to the film speed and/or lens. The aperture will be set at the lens' minimum aperture but the camera will not display the aperture it has picked. It does display shutter speed. A "FEE" LCD indicates that the aperture, which must be set at its minimum f/stop, has not been set there.

In "S" mode, the LCD displays the integral aperture number closest to the f/stop selected (a stepless aperture). The photographer chooses the desired shutter speed (shutter speed is displayed); the camera must match it with the correct aperture for the correct exposure. If the chosen shutter speed cannot be matched with an aperture setting for correct exposure, the camera will pick the closest shutter speed that will work with the aperture which has been picked (reverting to aperture priority mode) and the LCD will give a warning of "HI" or "LO".

In "A" mode the LCD displays the best shutter speed for correct exposure in accordance to the f/stop chosen. A warning of "HI" or "LO" will be displayed by the LCD if the correct exposure cannot be made with the aperture selected. The aperture is displayed by the ADR.

In "M" mode, the LCD displays the manually selected shutter speed preceded by "M" (for manual) with a plus or minus sign (aperture displayed by ADR). Correct exposure occurs if both the plus and minus signs are lit at the same time. Either one or the other by itself shows over or underexposure. The f/stop chosen is always displayed top center of the finder by ADR when in manual or aperture priority.

The FA has a unique motor drive, the **MD-15**. It can use the MD-12, but its special features are available only with the MD-15. The MD-15 is slightly slanted outwards towards the lens, providing better balance and handling. The drive uses eight AA batteries. When connected to the FA, they power both the camera and the motor drive (not so with the MD-12). When attaching the MD-15 to the FA, both the small cap to the right of the battery cap (which does not need a battery when attached to an MD-15) and the handgrip on the front of the camera must be removed.

On the rear of the camera at the top-right is a button that must be pressed to get the camera shutter speed to go into the M250 (in case of power failure providing a manual 1/250 speed) or "B" setting. To the left of this button is a lever that operates the eyepiece curtain. This must be closed when taking photographs and the photographer's eye is not covering the eyepiece window. The meter cells are here and the extra light coming in can change the meter by as much as three stops.

The FM2n, FE2 and FA shared the same basic shutter curtain design with special, honeycombed titanium blades. These curtain blades are attached to the shutter mechanism by a pin that goes through a hole with a nylon sleeve. The first shutter with this design had a problem that showed up over time, especially in the FA. The nylon sleeve will wear slowly, especially if 1/500 to 1/4000 shutter speeds are used frequently. This wear can actually cause the shutter to gain one full stop, going from a setting of 1/500 to an actual speed of 1/1000 for example. When working at 1/4000, the actual speed could be 1/8000. Ultimately this extreme speed could cause the shutter blades to crash into each other. Upon visual inspection it would appear as though someone had pushed a finger through the shutter. This problem occured only in the early models (no serial numbers available for these models) and did not persist for long. The FM2n, FE2 and FA are cameras still in demand and used by thousands of photographers without problems.

The FM2 was updated in 1983 with the introduction of the **FM2n**. With most of the features and the exact same body as the FM2, the FM2n's big change is in the shutter. The FM2n has a flash sync of 1/250 in the normal range of speeds, maintaining metering capabilities. The FM2n can also use the bright-view screens that the FE2 and FA use. All other features remain the same including the all manual shutter (which means the FM2n cannot operate TTL with flash). In 1989, the honeycombed shutter blades of the FM2n seem to have been replaced by the same, completely smooth blades found in the N8008. The improved design and the strength of the new blades in the N8008 warranted this design change. This also shows that Nikon plans to have the FM2n around for sometime to come.

In 1984, Nikon continued the EM and FG line with the introduction of the **FG-20**. This is a scaled down FG, both in physical size and features. The FG-20 retained all the features of the FG except the program mode and TTL flash metering. It did keep the warning beep for low shutter speeds and 2 stop compensation button for backlit shots. This simplified camera did not go over well with the public and was shortly discontinued.

The N Series

Nikon moved more aggressively into the consumer market in 1985 with its N Series cameras, the first being the **N2000**. This mechanically outstanding little camera was packed with new features that made it quite exciting. One of the most remarkable is its built-in motor drive, Nikon's first. The motor drive advances film only (rewinding is still a manual operation). It can do 2.5FPS (2.0 FPS when using auto exposure lock). The motor drive has three settings. "C" for continuous, firing as long as the shutter release button is depressed; "S" for single, allows one shot per press of the shutter release; "L" locks the camera. Lifting up and turning the ring around the shutter release button selects the mode. Pressing the shutter release button half way down engages all metering operations. This shuts off after 16 seconds. Right below the shutter release button is a lever with a wave symbol and a dot. This is an optional warning beep that works as on the FG.

Film loading is made easier by the N2000. Load the film into the back of the camera (which is opened by pulling up on film rewind knob) and pull the film leader over to the red square. Now close the back. Press the shutter release and the camera will wind the film to frame one. On the left side of the camera back there is a window showing the film cassette displaying its ASA/ISO and number of exposures. There is also a film advance confirmation indicator that will spin every time the film is advanced, providing it has been loaded correctly.

The shutter speed range is 1 second to 1/2000 with a "B" and 1/125 flash sync with full TTL flash automation. The N2000 also has four other settings on the shutter speed dial: "A", "P DUAL", "P", "P HI". "A" is aperture priority similar to that on all Nikons. "P DUAL" is a new feature. It selects the highest possible shutter speed when a 135mm or longer lens is in use (same as P HI). It will switch

to "P" mode when a lens shorter then 135 is used (lenses must be set at minimum f/stop for any of the "P" modes). This feature prevents the photographer from having to remember to change modes for shooting fast when neither a high shutter speed nor lots of depth-of-field is desirable.

The "P HI" mode will always pick a shutter speed of 1/200 or 1/300 to eliminate shake when using telephoto lenses, selecting the correct aperture to match that shutter speed. "P" will compromise, giving a good depth-of-field as well as a high shutter speed. In addition to these modes, the N2000 also provides the option of complete manual operation. As with the FA, AIS lenses are required to take full advantage of all these features. It can only accept AI, AI'd or AIS lenses since the AI prong on the aperture ring cannot lock up.

The new metering in the N2000 uses the Light Intensity Feedback Exposure Measurement System. This system works the moment the lens is stopped down (the start of the picture taking process). The exposure is measured again and in response to the computed value, the shutter speed is precisely adjusted to eliminate exposure error. This system is used when the camera is in program or aperture modes. In the manual mode, exposure is determined by a pre-measured exposure value. It is pointless to measure it again since the photographer chooses the shutter speed and aperture.

The viewfinder with 93% viewing provides exposure information in a new way. No ADR exists, so it is necessary to examine the lens to determine the aperture in use. The shutter speeds are displayed on the far right, arranged in a line, 1/2000 going down to 1 with an arrow at either end. These LED's light differently depending on the information being relayed. In "P", "P HI" and "A" modes, the shutter speed will light up for the mode in use. If two light up, it means that an intermediate shutter speed is in use (this is a stepless shutter speed). In manual mode, the correct shutter speed will blink. When only the blinking shutter speed is lit up, exposure is correct. If either triangle lights up, an incorrect exposure is indicated, the top triangle for overexposure, the bottom for underexposure. The flash TTL lightning bolt is located under the bottom triangle and works like the FG/FE2 TTL light.

Another new feature on the N2000 is DX coding. Film cassettes have a black and silver bar code. DX coding in the N2000 can read this bar code and automatically sets the ASA. To set a preferred ASA, turn the ASA dial to the desired ASA or to the DX notch for that mode. The N2000 also has a plus or minus 2 stop compensation located on the ASA dial. Film ASA settings go from 12 to 3200 when set manually, and 25 to 5000 in the DX mode. When the camera is loaded with a non-DX coded film cassette and set at DX, the camera will lock up after the film has advanced to frame 1. There is a red indicator lamp next to the ASA dial on the back that alerts the photographer to a problem. A warning beep will also go off at the same time as a visible signal.

The N2000 does not have a standard cable release socket. It does have a terminal on the front of the camera above the lens lock button that accepts the **MC-12a** remote cord. This same socket allows the use of Nikon's other remote triggering devices. The N2000 comes with the **MB-4**, a AAA battery holder built into the base of the camera that holds the batteries that power the camera. This can be removed and the **MB-3** can be attached which allows use of AA batteries. The tripod socket hole on the N2000 is off-center. If it were in the center of the camera, the socket would go right though the batteries. Nikon makes the **AH-3** accessory which is a 1/2" thick plate that will recenter the hole. This also provides extra protection for the camera base.

The N2000 sold very well when it first came out, but a newer version of the camera was introduced just one year later. In 1986 the **N2020**, a dual autofocus camera came on the market. The N2020 is identical to the N2000 with the addition of new features, principally the autofocus module in the body.

Nikon must have felt that having the autofocus motor in the camera body was a superior design to the motorized lenses of the ill fated F3AF. The N2020 has its own new line of autofocus lenses which do not have internal motors. It can also use any previously made Nikon lens. It meter couples with AI lenses and works the different modes with AIS lenses. The N2020 carries out Nikon's main design directive of planned non-obsolescence, retaining the bayonet F lens mount even with autofocus technology.

The autofocus motor is housed in the camera body, connected to the lens via a small shaft on the lower left of the lens mount ring. The actual motor is under the shutter release button whose power is transferred to the lens mount via a gear train. The

autofocus sensor is located in the bottom of the mirror box. By placing the detector there, it can read the focal plane, know the amount of deviation and whether the incoming light portions have changed places on the detector or not.

Nikon's original algorithmic principles can detect the defocus amount (the distance between the actual focal point and the focal plane). This can be processed electronically and, because the direction (the focal point before the focal plane or in back of it) is easily detected, commands the camera to direct the lens to align the actual focal point with the detector. The detector incorporates 24 pairs of CCDs (Charge Coupled Devices) in two arrays (a total of 96 CDDs) mounted to a ceramic plate.

The total analog output of each CCD is converted into a digital form via an Autofocus Interface IC for relay to a host CPU (Central Processing Unit). The host CPU processes the data by using Nikon-developed AP's (automatic processors), then outputs to focus. Below the Infrared Cut Filter is a detector that is actually two types. The larger CCD is called the f/2.8 detector, the smaller is the f/4.5 detector. Depending on the lens in use, the camera will automatically select the correct detector. This explanation is an overview of the autofocus system in the N2020. When compared to the F3AF, we can see that Nikon completely changed its thinking on autofocus operation.

The dual autofocus comes from the choice of Single Servo, "S", or Continuous Servo, "C", modes. Single Servo "S" works (flip the switchover lever on camera body to "S") by lightly pressing the shutter release button activating the metering and autofocus. Once the camera focuses on the subject, the focus will not change until the shutter release button is released and then pressed again. Continuous Servo "C" works when the shutter release button is pressed and the camera is pointed at the subject. On continuous, the camera will constantly change the focus while the button is depressed.

In the viewfinder a green dot appears when the camera is in focus. A red X will light up when focus is not possible. There are also two arrows that provide focus assist when focusing manually. Turning the lens in the direction indicated by the arrow illuminates the green light when correct focus occurs.

The N2020 has three interchangeable screens. None of these have the split rangefinder, made unnecessary by the autofocus assist. The E and J screens have the same design as all others but are of the bright view system. N2020 screens work only in the N2020; the N2000 does not have interchangeable screens.

One problem that can occur with the N2020/N2000 has to do with the use of long focal length lenses for a prolonged period. When these longer focal length lenses are left connected to the body, the weight of the lens hanging on the lens mount ring seems to contribute to front focusing problems. The lens mount seems to get pulled out just a small distance by the weight of the lens. With the N2020/N2000, a little more care in this area is recommended to curtail any such problem arising.

The age of the pocket camera capable of everything prevailed in the mid 1980's and Nikon made a number of pocket cameras to meet the demand. In 1987 Nikon introduced the N4004. Though not really a pro camera, amateurs were much impressed. The N4004, a true Nikon, advanced available autofocus technology with the exclusive AM200 module. Unlike the N2020 with 96 CCDs, the N4004 with its AM200 has 200 CCDs. This optical module, unique among autofocus cameras of the time, features one-piece construction for reliability and efficiency.

The **N4004** uses the autofocus lenses that were available for the N2020 (and any later AF lenses introduced). Manual lens can be mounted but all metering and program modes are lost. The N4004 operates differently than previous Nikons in that the f/stop is changed on the body and not the lens. When a lens is mounted to the N4004, set the lens to its minimum f/stop and leave it there. On the top-right side is found most of the camera's operational system.

The camera has a built-in motor winder and molded handgrip. The shutter release is at the top of the handgrip. Like all other Nikons of the day, this release turns the camera's functions on (shutting off after 16 seconds when not touched). Next to the prism are two dials: the shutter speed dial with shutter speeds of "B", 1 second to 1/2000 and the letters "A" and "L", and the aperture dial with apertures of f/1.2 to f/32 and the letter "S". When the "L" is in the window on the dial, the camera is in the locked position and will not fire.

When the "A" is in the window, aperture priority mode is in effect. Select the aperture desired by turning the aperture dial until is appears in the window (do not turn the aperture ring on

the lens). Putting the "S" in the window of the aperture dial sets the camera in shutter priority. Select the shutter speed on the other dial. If there is an "S" in the window on the aperture dial and an "A" on the shutter speed dial, the camera is in program mode. Manual mode is selected with the f/stop on aperture dial and the shutter speed on the other dial. Coupled to the metering system is an exposure lock button that is located inside the handgrip on the front of the camera. Next to these dials is a button which, when pushed, will rewind the film. Notice that the N4004 is made entirely from non-metal materials; the film back is plastic.

If the camera cannot focus on the subject chosen, the exposure is not correct, or with a combination of these two (including pilot error), the camera will not fire. Nikon calls this the automatic fail-safe operation which is part of the Decision Master System. The N4004 has manual focus as well as autofocus, permitting complete control if desired. The N4004 is powered by AA batteries, a nice feature, which are housed in the handgrip of the camera.

Nikon N4004.

The N4004 has DX coding but no ASA selection dial or exposure compensation. It does have a self timer and a very new feature, built-in flash. When viewing though the viewfinder (93% viewing), the exposure indicators are at the bottom as in the FM. There are plus, zero and minus signs to indicate correct exposure. When the exposure is too low, the flash will pop up on the camera and full TTL flash comes into operation, with the flash lightning bolt indicating correct flash exposure. This bolt will appear when the camera recommends the use of flash, especially for backlit subjects. The N4004 is the first Nikon to offer balanced fill flash for just such problem exposures, incorporating its triple-sensor metering system. On the left of the display is the focus indicator which will light when the camera is in focus.

Up to this time, autofocus systems for Nikon (as well as those of most manufacturers) were not taken very seriously by many photographers. In the spring of 1988 this all changed with the introduction of the N8008. The **N8008** was so well designed and feature packed that many said it would make an average photographer good and a good photographer great. Never before had a camera received such high acclaim so fast, but the N8008 earned its reputation.

The main new feature of the N8008 is its metering. The N8008 has Matrix Metering (a much improved version of AMP metering of the FA) which evaluates light in its entirety as the camera lens sees it. The improvements on the AMP metering are one-component SPD sensor module with five segments, use of a more powerful computer for faster and more comprehensive calculations and advanced Nikon software to enable operation under more varied conditions.

The matrix metering works by dividing the picture-taking scene into five segments. Each segment's output is compared and two basic parameters, brightness value and degree of contrast are established. The scene is segmented into sets of brightness and contrast classifications that together comprise a 5x5 matrix. Upon reading additional data (i.e., which segment is brighter and by how much), Matrix Metering appropriates the suitable algorithm pattern from four computation methods: Low-Brightness Weighted, High-Brightness Weighted, Average, and Center-Segment. The output values from the five segments are included in the computation along with the automatically determined computation method. Optimum brightness value is then determined. Another part of the matrix system is Exposure Screening. When comparing the exposure information from each of the five segments, the system is programmed to factor out extremes of brightness and darkness. Using special algo-

rithms, the matrix metering can recognize scenes which include such extremes as snow, sand or the sun in the picture.

Switching the matrix off and using the 75% center-weighted metering is another alternative. On the top-left of the camera next to the prism is a button with the symbol for matrix metering. Press this down and turn the thumb wheel (the proper name is Command Input Control dial) until the center-weighted symbol shows in the display. As soon as a manual focus lens, extension tube (even connected to an AF lens), teleconverter (even connected to an AF lens) or any other accessory without a CPU is attached to the N8008, even with the camera set at matrix metering, center-weighted metering is the only available option. The N8008 has matrix metering whether the camera is in the horizontal or vertical position and will work as described above no matter which way the camera is held.

Coupled to this amazingly accurate metering is Cybernetic Flash TTL Sync. A cyber is an electronic device that performs automatically. In the N8008, the computer is the cyber, automatically adjusting the shutter speed in accordance with the f/stop and TTL flash for correct flash and ambient light exposure. The N8008 provides four different flash metering options: Matrix Balanced Fill-Flash, Center-Weighted Fill-Flash, Matrix TTL Flash Control, and Center-Weighted TTL Flash Control.

TTL is flash metering done at the film plane. The amount of time the flash tube is left on is governed by the f/stop set on the lens. The camera's computers operate it all for proper exposure. Proper flash exposure is accomplished by either flash to subject distance and/or f/stop. The shutter speed affects only ambient light and not the flash effect, but the combination of the two manually balances the flash. Without TTL, creative choice is limited to f/stop and flash to subject distance. With TTL, use whatever f/stop works to produce the desired photographs. All these computations are time consuming and too much to handle for most photographers, but not for the N8008.

In Matrix Balanced Fill-Flash, the camera's computer balances the exposure for the ambient light (the background) with the exposure by the flash (the foreground). The camera will automatically pick a shutter speed from 1/60 to 1/250 (stepless shutter speeds) to give the correct exposure in conjunction with the f/stop selected. The camera's computer will also shut off the flash to give the correct exposure for the f/stop selected. The computer can shut down the flash giving a 1:1 exposure ratio (equal light from the flash as from the ambient light), or compensation up to minus 1 stop less flash than ambient light, depending on how the computer sees the scene (for control of this ratio, see SB-24). This is being done at the speed of light.

Center-Weighted Fill-Flash allows intentional metering of the scene background while the cybernetic system fixes the TTL flash output to minus 2/3 stop below standard output level. This occurs when the value measured by the Center Segment is within controlled shutter speed/aperture range. The result is a flash fill 2/3 stop less than the ambient light whenever shooting in this mode.

Part of this whole process is the new shutter designed and installed in the N8008. With a top shutter speed of 1/8000 and a slowest of 30 seconds, the N8008 is capable of a wider range than ever available before. The vertically traveling, aluminum-alloy shutter curtains (no longer titanium) are used because of their rugged, reliable operation throughout the shutter speed range. The same shutter, because of its reliable performance, was installed in the FM2n in 1989. This Nikon technological advance also gives the N8008 its sure-fire 1/250 flash sync.

The N8008 has the same three program modes as the N2020/N2000: Program Dual "PD", Program High "PH" and Program "P". It also has Shutter Priority "S", Aperture Priority "A" and Manual "M". For any of the program modes or the shutter priority, an AF lens (with a CPU) must be mounted. Change to a manual focus lens and the camera automatically switches to aperture priority. To switch modes, first push down on the "Mode" button on the top-left of the camera, then turn the thumb wheel until the correct mode comes up in the LCD display on the top of the camera or, if viewing through the camera, in the internal LCD display. There are three other buttons located with the "Mode" button on the top-left of the camera. All are activated by pressing down on the button while turning the thumb wheel to get the desired setting.

The "ISO" button is used to set the ISO/ASA. Manually set the desired ISO/ASA or set the camera to DX coding. In DX mode it has an ISO range of 25-5000, a ISO range of 6 to 6400 when manually

set. When in DX mode and a film cassette is loaded the camera cannot read, it will flash the ISO in the LCD panel, beep if the camera is set to beep mode, and the shutter will lock up, disabling the camera from firing. The "Drive" button controls the built-in motor drive. When set to "CH" the camera can fire up to 3.3FPS. In "CL" mode it will fire 2.0FPS and in "S" once each time the shutter release button is pressed.

The last button, the "ME", has two functions. When pressed in and the thumb wheel is turned, the camera Multiple Exposure is activated allowing nine exposures on one frame of film at one time. The film counter disappears and is replaced by the number of frames set for multiple exposure. This stays in the display until all the shots have been fired. Note that the exposure computations for these multiple exposures must be done by the photographer. Pressing the "ME" button and pressing the button above the LCD display at the top-left corner will rewind the film. Both buttons have the same symbol for film on them for easy recognition. This same symbol will show in the LCD display on top indicating the film is loaded correctly. In the lower right-corner of the LCD the current frame number is displayed.

On the top-left, below the four-section mode button, is the self-timer. Activate it by pressing in and then turning the thumb wheel. It can be set for up to 30 seconds or to take two exposures at one push of the shutter release button at ten second intervals. Above the LCD panel on the top-right is a button with a plus/minus symbol on it; this is the meter exposure compensation. Press down on the button and then turn the thumb wheel, to go from plus 2 to minus 2 stops compensation. A bar graph by which the compensation is set appears in the LCD display.

The same graph is used when in manual exposure mode. The ON-OFF-BEEP lever is right here and the shutter release button right above it on the handgrip. Switched to ON, it will not sound the warning beep system. For this mode, the switch must be all the way to the right to access the warning signal. When activated, the camera's LCD display on top and inside the viewfinder reports all current camera settings. After 16 seconds the camera will shut down, leaving the basic info displayed: frame number, metering mode, etc..

The viewfinder on the N8008 is a High-Eye-point finder with the same eyepiece diameter as that of the F3HP with all the same advantages. The finder provides 92% viewing. Information display is very clean and simple, a great help with so many camera options. When in one of the program modes, aperture priority or shutter priority, the display bar will show an "A","S" or "P". In any of these modes, the corresponding shutter speed and aperture in use will also be displayed. There is no ADR window, so with a manual focus lens, there is the loss of the f/stop display. In manual mode, the analog graph will appear, permitting adjustments of the shutter speed/aperture (which are displayed) for the desired exposure.

The focus indicator is on the far left of the display. It is the same as that on the N2020, relaying the same information. The N8008 has interchangeable screens, as in the N2020. But these are brighter screens than ever before available. For autofocusing, the screen has a small bracket dead center of the screen. This bracket must be over the subject for the picture to be in focus. There is an autofocus lock that can be used to recompose a photo if so desired. The TTL lightning bolt is also in the display on the far right, working as in previous models. The display inside the viewfinder will automatically light up in lower light levels. To control this manually, there is a button on the back-right with a little burst symbol on it that, when pushed, will light up the inside display only. The LCD panel on top of the camera cannot light up.

The N8008 has the Advanced AM200 autofocus module that is basically the same as that of the N4004 with minor electronic additions. There is a built-in 8-bit microcomputer unit using special autofocus software that quickly processes focus information obtained by the 200 CCD's. There are three computers in the N8008 and one in the AF lens; all work together using the Nikon software. The motor in the body powering the focusing in the lenses is coreless. This is more efficient than the older cored motor. The coreless motor takes less power and space enabling the N8008 to work with four AA batteries and maintain its small physical size. There are three such motors in the N8008, one for autofocusing the lens, one for motor drive functions and one for such basic mechanical operations as aperture opening/closing, mirror up/down and shutter cocking.

The N8008 has a depth-of-field button that is located on the front of the camera right of the lens

mount ring. Below this is the "AF-L" button which locks the autofocus. The auto exposure lock, "AE-L", button is on the back of the camera next to the button that lights up the viewfinder display. Press that in and hold it until the exposure is completed in order for it to work. On the other side of the lens mount is the lens lock button which must be depressed to remove the lens from the body. Here, too, is the autofocus selector switch which works the same as that on N2020.

The N8008, like the N2020, has auto film loading but here it also rewinds the film. If the camera is on beep warning, it will beep and flash the film indicator on the top of the camera to signal the end of the roll of film. The interesting thing about all this incredible photographic technology is that it is all housed in a polycarbonated housing. The front of the camera, including the handgrip, has a nice rubberized coating for a good, solid grip. The back of the camera (which is interchangeable) is a buffed plastic. The body aperture ring is also plastic and will accept only AI or AIS lenses.

The F4s

The fall of 1988 was even more exciting than the spring with the introduction of Nikon's newest pro model camera, the **F4s**. The F4s is the culmination of all the bodies previously described plus a whole lot more. It's no surprise it received the *European Camera-of-the-Year* and *Camera Grand Prix* awards in 1989. The F4s is fully loaded with technological features that can easily scare new buyers away. In practice, it is the most user friendly camera that Nikon has manufactured. The engineers at Nikon crammed 1,750 parts, four coreless motors and batteries into this small package making the F4s possible.

First is understanding its name. F4, of course, comes from being the fourth in the line of Nikon Pro F bodies. But **F4** also stands for the basic F4 body with a MB-20 battery pack. The **MB-20** holds only four AA battery and provides a firing rate of 4.0FPS. In the US, the F4 is only available as the **F4s**. It is the F4 body but with the **MB-21** battery pack which holds 6 AA batteries providing a firing rate of 5.7 frames per second. The MB-21 adds 7oz of weight to the F4. A gain is made of a vertical firing button plus the outstanding molded handgrip. In 1991, Nikon, Japan, released the **F4e** for the international market not including the US. This is the F4 body with the standard **MB-23** battery pack with AA battery insert. Either way, an F4 is an F4 no matter which battery pack is attached.

The F4 has autofocus capability, but that is not its main attribute. It features the same advanced AM200 module as in the N8008. It has Continuous, Single and Manual focus modes just as the N8008. The F4's autofocus capability is faster, because of new designs in the body with more space to incorporate them.

One new feature is the switchable filters. These two filters are incorporated into the base of the mirror box. These automatically switch according to the shooting situation. One filter cuts infrared light to prevent erroneous focus detection from the chromatic aberrations of the lens in use. The other transmits infrared light for use with a flash

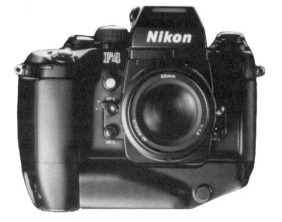

Nikon F4s with high speed battery MB-21 containing six AA-type batteries.

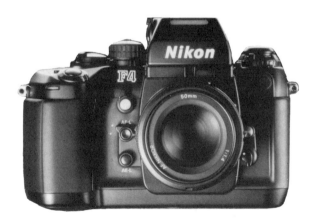

F4 with MB-20 containing four AA-type batteries.

which has an infrared AF illuminator. These have a dust remover that operates keeping dust off their surface. The F4 even has little windshield style wipers that clean the autofocus contacts inside the body. These clean the lens contacts each time the camera is turned on. Another reason for the greater autofocusing speed is a new coreless motor that produces 15% more torque and rotation speed than that in the N8008.

When the firing rate button is set to the "CL" mode and the autofocus mode selector is set to "C", the camera's computer can focus track. Focusing on a moving subject, the camera's computer will calculate the speed and movement of that subject. While the mirror is up and the exposure is about to occur, the computer will calculate the distance traveled by the subject during exposure and refocus the lens accordingly.

Like all other pro models, the F4 has interchangeable prisms, but unlike any previous model. The F4's prisms are mounted to the camera via a rail system. By pressing in the small lever at the top-left of the camera next to the prism, the prism will slide towards the back of the camera. This very important new design allows the **DP-20** (the standard prism on the F4) to have an ISO, TTL hot shoe (incorporating a semiconductor switch to prevent damage by flash from frequent use) on its top. This is the first pro model to standardize its hot shoe with all other current Nikon camera bodies enabling complete compatibility of flash and flash accessories.

All F4 prisms have 100% viewing but some loose metering capabilities. The **DP-20** (standard) is the only prism that provides Matrix, Center-weighted and Spot metering. The **DA-20 AE Action Finder** provides only Spot and Center-Weighted metering. It has a TTL hot shoe on top for use with flash. It comes with a large eyecup that contains a rubberized shutter to prevent light from entering when using the camera remotely.

The **DW-20 Waistlevel** and **DW-21 6x Magnifier** only have Spot Metering available, because they rely on what is built into the body. Both of these finders have a port to connect the SC-24 cord permitting TTL flash. With these finders, there is no "on camera" location to attach the flash so a bracket or hand holding is required.

When these prisms are attached to the F4, the information display in the viewfinder changes.

The readout display at the base of the screen is lost as well as the frame counter and exposure compensation displays at the top-left corner. These are replaced with a two sided readout: on the right is the shutter speed in use, error messages etc., on the left is the mode at which the camera is set. If in manual mode, the number of stops the exposure may be off is displayed. When the correct exposure is obtained in manual mode, the readout will say 0.0 with a plus/minus sign and two triangles indicating that the exposure is correct. The autofocus indicator and flash indicator are still present in their normal location.

Metering with the F4 with the DP-20 provides all three options of metering. The Matrix metering on the F4 works the same as that in the N8008. One big difference is the F4 does not require lenses with CPU's to work in the matrix mode. This allows full use of AI and AIS lenses along with AF lenses. The Center-Weighted metering is the traditional 60% because the F4 has spot metering. Spot metering reads 2.5% of the finder area in the center of the screen for its exposure reading.

Contrary to popular belief, there is no matrix flash metering. The sensor for the flash is at the base of the mirror box and operates center-weighted. The statement "Matrix Flash Fill" refers to the ambient light receiving the matrix reading and exposure calculated accordingly.

On the right side of the DP-20 prism is the metering switch with three symbols, matrix, center-weighted, and spot. Turn the dial to pick the desired metering pattern. This information is displayed in the prism finder display by the same symbols as on the switch. The cosmetics of the metering pattern switch were changed within a year of introduction to one that could not be easily switched by accident.

Right in front of the metering pattern selector is a window with a zero showing. This indicates exposure compensation dialed into the prism compensating for a bright screen that was installed. Take the prism off the camera to access this control and use the special tool supplied with the F4 to make a change. For the majority of the screens, this value will not require changing. The DP-20 also has built-in diopter (-3 to +1) correction for those who need prescription lenses and want to use the F4 without having to wear glasses.

The placement of controls on the F4 is slightly different from those of the other pro models, al-

though the same basics designs of the F/F2/F3 hold true. On top of the handgrip is the shutter release button. Surrounding the shutter release button is the film advance mode ring. "L", standing for lock, shuts the camera off and is the only way to shut the power off completely. The camera, left in any of the other modes, will stay on and slowly drain the batteries.

"CH", continuous high, delivers 5.7FPS with the MB-21 or 4.0FPS with the MB-20. "CL", continuous low, delivers 3.4FPS with the MB-21 and 3.3FPS with the MB-20. In "CL" mode, activation of the focus tracking slows down the firing rate. "CS", continuous silent, delivers 1FPS with the MB-21 and 0.8 with the MB-20. The "silent" does not imply that the camera cannot be heard when fired. Rather, it's the mode used in situations when the camera's noise needs to be less obvious. The clock symbol is the self timer which provides a ten second delay. All speeds in the above examples apply when a 35-70f3.3-4.5 autofocus lens is attached and in Continuous Servo mode. Firing rates can be faster in manual focus mode or slower, if a slow shutter speed is in use.

Behind the shutter release button on the back edge is the double exposure lever. Just pull out the lever before firing the camera. The film will not advance until the lever is released. The film registration in the F4's film transport has the close tolerance of a pin registered camera. This is great for multiple or sequence shooting. Next to this is the metering compensation dial with plus and minus 2 stop compensation in 1/3 stop increments. If compensation has been set, a

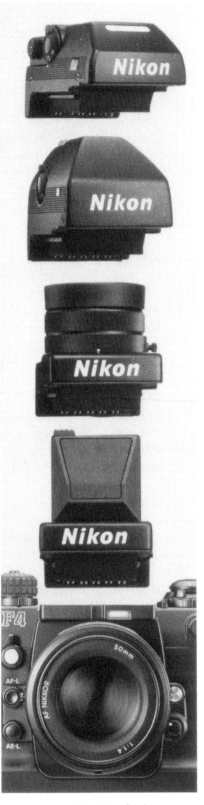

Interchangeable Viewfinders.

plus/minus sign lights up in the top right corner of the viewfinder as a reminder.

Under the compensation ring is the lever for changing program modes. There is "M" for manual, "A" for aperture priority, "S" for shutter priority, "P" for program mode and "PH" for program high. The viewfinder display inside the camera will indicate the current mode. Operational procedures for the F4 in these modes is the same as those for the FA, N2000/N2020, and N8008.

The shutter coupled to all these firing rates and mode buttons is revolutionary. Because of its shutter's design, the F4 has a 1/250 flash sync and 1/8000 top speed. This is the first (and only camera to date) that can deliver 6FPS while all the other features are working. Four of the shutter blades are made from special epoxy plates with carbon fibers to maximize strength while reducing weight. The others are made of a tough aluminum alloy.

The shutter is a dual, multi-bladed curtain shutter. This assures that light does not leak past the thin curtain blades and fog the film. In the FE2, FM2 and FA, the problem of light leaking past the shutter curtains of the ultra thin blades on their fast shutters prevented them from having a mirror up function. The dual, multi-bladed shutter of the F4 allows it to have the fast sync and mirror lock up. To make all this work smoothly every time, and to eliminate all vibrations, the F4 shutter has a tungsten-alloy shutter balancer. The balancer rises slightly when the shutter curtains operates. The anti-directional movement of the balancer absorbs vibration caused by

shutter curtain travel. The balancer does not need much power; it is designed for high density and minimum drive. The balancer along with the efficient shutter braking system protects against shutter bounce. It is not needed when using high shutter speeds, 1/500 or faster, but can make a big difference with shutter speeds from 1/15 to 1/250. This balancer makes vibration free photography a reality.

The all electric F4 (there are no manual overrides if the batteries go dead) has four coreless motors installed to power all the functions. The Shutter Charging Motor is placed beside the sprocket and takes care of mirror down operation. This takes 20% of the motor rotation which includes mirror control, aperture, shutter and release magnet resetting. The rest of the rotation takes care of charging the shutter curtain. The Spool Motor is located inside the film take-up spool and advances the film. The sprocket functions as a film perforation counter and not a film advancer as in conventional cameras. An exception to this applies in the MF-24 back where the sprockets do help drive the film.

The Rewind Motor located at the lower side of the film cartridge chamber rewinds the film. It also changes the filter of the Advanced AM200 autofocus module. The Autofocus Motor takes care of moving the mechanisms necessary to focus the lens. There is also a two-motor partnership between the shutter charging and the spool motors. They work simultaneously to achieve high-speed film advance (parallel control). When such high speed is not required, the shutter charging and film advance motors are driven sequentially (series control). When the firing rate is set to the "CS" mode, the power repeats ON-OFF operation, making the motor repeat the sequence of fast to slow movement.

The F4 is packed with other features we have yet to discuss, but the microelectronics inside the camera make them all possible. The F4 has the largest computer system ever built into a 35mm SLR camera. There are nine ICs including two 8-bit microcomputers and one 4-bit microcomputer. The DP-20 has four ICs including one 8-bit microcomputer. As with any computer, it must be grounded or static electricity can create problems. As the camera's computer cannot be grounded, this static electricity can cause havoc leading to occasional failure in powering up. On the last page

of the F4 instruction book, there is a small box with a solution for this static electricity block. Simply take the batteries out of the camera and then reinsert them.

Other modern electronics include the advanced AM200 module with 200 CCDs and a special spot meter sensor incorporated adjacent to the AM200 module. A TTL sensor monitors the flash light exposure on the film and the flash/matrix-balanced-fill flash. Multi-meter SPD sensors located beside the viewfinder eyepiece lens detect scene brightness and combines the information with the matrix metering system. Hybrid, multi-layer printed circuit boards under the mirror box consist of several layers of epoxy glass. These printed circuits are sandwiched in these layers. They are commonly used in computers, but those in the F4 mark first time this technology has been incorporated into a 35mm camera.

There are two film rewind modes on the F4. To activate manual film rewind, first press the button in the middle of the lever R1. This is located between the shutter speed and compensation dials. Once pressed, pull the lever away from the body and turn the film rewind knob on the top-left of the camera. The R1 lever will stay out without being held during the time the film is rewound. This can be used in conjunction with the "CS" firing mode is when silent operation is required.

The second film rewind is motorized and starts by pressing down the button on the R1 lever and then pulling it out as with manual film rewind operation. Next, press the button next to the R2 imprint and push the lever to the left. Let go of the R1 lever as soon as the R2 button is pressed and pushed out. The red light above the R2 imprint will light as the film is being automatically rewound, and will stop blinking when rewinding is complete. This same red light will also blink rapidly if the film is not being correctly reloaded with the shutter locked up to prevent firing.

The R2 button can accidentally brush up against something and get knocked into position for rewinding the film. When this happens during normal firing, the camera will sound like it is in silent mode "CS". The camera will fire normally, but not faster than single frame. To remedy the situation, just push the R2 lever back to its normal location.

The film rewind knob also opens the camera back. Below the knob is the ISO dial where the ISO

Nikon
F4 Focusing Screens

Nikon offers you a choice of 13 interchangeable focusing screens for the Nikon F4 camera to match exactly any focal length lens or picture-taking situation. The advanced B-type BriteView screen comes with the F4 as standard equipment. For attaching and detaching the focusing screen, see the camera instruction manual.

Caution: Each focusing screen consists of a glass condenser lens on top and an acrylic resin focusing plate on the bottom. Because the image is focused on the acrylic resin plate, you should avoid scratching or getting dirt or fingerprints on this side of the screen.

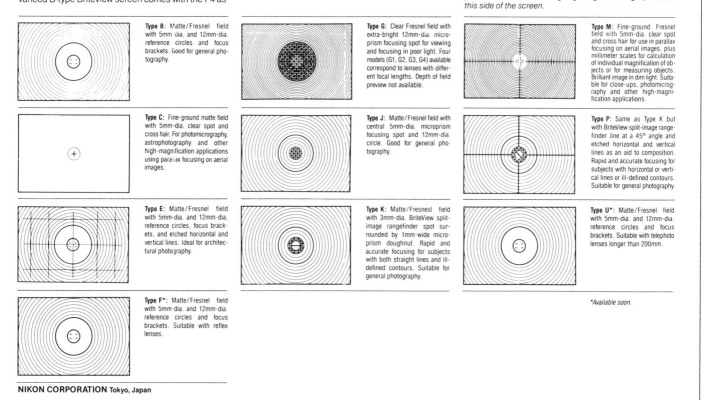

Type B: Matte/Fresnel field with 5mm dia. and 12mm-dia. reference circles and focus brackets. Good for general photography.

Type C: Fine-ground matte field with 5mm-dia. clear spot and cross hair. For photomicrography, astrophotography and other high-magnification applications using parallax focusing on aerial images.

Type E: Matte/Fresnel field with 5mm-dia. and 12mm-dia. reference circles, focus brackets, and etched horizontal and vertical lines. Ideal for architectural photography.

Type F*: Matte/Fresnel field with 5mm-dia. and 12mm-dia. reference circles and focus brackets. Suitable with reflex lenses.

Type G: Clear Fresnel field with extra-bright 12mm-dia. micro-prism focusing spot for viewing and focusing in poor light. Four models (G1, G2, G3, G4) available correspond to lenses with different focal lengths. Depth of field preview not available.

Type J: Matte/Fresnel field with central 5mm-dia. microprism focusing spot and 12mm-dia. circle. Good for general photography.

Type K: Matte/Fresnel field with 3mm-dia. BriteView split-image rangefinder spot surrounded by 1mm-wide microprism doughnut. Rapid and accurate focusing for subjects with both straight lines and ill-defined contours. Suitable for general photography.

Type M: Fine-ground Fresnel field with 5mm-dia. clear spot and cross hair for use in parallax focusing on aerial images, plus millimeter scales for calculation of individual magnification of objects or for measuring objects. Brilliant image in dim light. Suitable for close-ups, photomicrography and other high-magnification applications.

Type P: Same as Type K but with BriteView split-image rangefinder line at a 45° angle and etched horizontal and vertical lines as an aid to composition. Rapid and accurate focusing for subjects with horizontal or vertical lines or ill-defined contours. Suitable for general photography.

Type U*: Matte/Fresnel field with 5mm-dia. and 12mm-dia. reference circles and focus brackets. Suitable with telephoto lenses longer than 200mm.

**Available soon.*

NIKON CORPORATION Tokyo, Japan

can be manually set from 6 to 6400 or to DX coding. To override the DX coding, the ISO must be manually set. Below this dial on the front of the camera is a standard PC socket for connection with flash units requiring PC connections. This is not a TTL socket. Beneath the PC socket next to the lens mount ring is the lens lock button. Below this is the autofocus selector switch for the "C", "S" and "M" modes. These operate the same as those on all autofocus Nikons. The F4 is the first Nikon body since the FE to have a fold back AI coupling pin on the aperture ring allowing non-AI lenses to be mounted to the camera. Operation of the fold back AI prong is the same as on the FE.

On the other side of the lens mount ring are the Autofocus Lock (AF-L), the Autofocus Exposure (AE-L) and the depth-of-field and mirror lock up buttons. Depress the lower button marked AE-L to activate it. This will display an "EL" in the center of the prism display. It works only as long as the button remains depressed, including throughout the exposure if the value is to be held.

Using the AE-L button when in "A" mode permits complete control of the exposure even though the camera picks the shutter speed. The camera displays the shutter speed selected according to the aperture in use. This shutter speed can be accepted by the photographer or the camera switched to manual mode to override camera's choice. A faster method of gaining manual control while in "A" is utilizing the exposure lock button. Move the camera around so it sees different lighting until the desired shutter speed appears in the window. At that time press in on the AE-L button to lock in the shutter speed. This provides immediate control over the shutter speed without taking

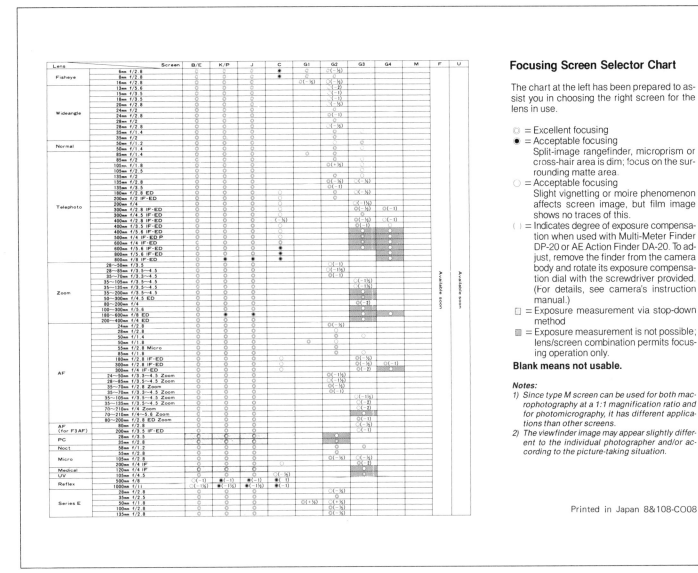

Focusing Screen Selector Chart

The chart at the left has been prepared to assist you in choosing the right screen for the lens in use.

◎ = Excellent focusing

● = Acceptable focusing
Split-image rangefinder, microprism or cross-hair area is dim; focus on the surrounding matte area.

○ = Acceptable focusing
Slight vignetting or moire phenomenon affects screen image, but film image shows no traces of this.

() = Indicates degree of exposure compensation when used with Multi-Meter Finder DP-20 or AE Action Finder DA-20. To adjust, remove the finder from the camera body and rotate its exposure compensation dial with the screwdriver provided. (For details, see camera's instruction manual.)

▯ = Exposure measurement via stop-down method

▨ = Exposure measurement is not possible; lens/screen combination permits focusing operation only.

Blank means not usable.

Notes:
1) *Since type M screen can be used for both macrophotography at a 1:1 magnification ratio and for photomicrography, it has different applications than other screens.*
2) *The viewfinder image may appear slightly different to the individual photographer and/or according to the picture-taking situation.*

Printed in Japan 8&108-CO08

time to switch modes, manually set the shutter speed and then switch back to "A" mode.

The AE-L button is convex which distinguishes it by touch from the next button up, the concave AF-L button. The AF-L button is a great feature when using the "C" autofocus mode. The AF-L button has a small lever on it making it perform two functions at once, AF-L and AE-L. Set the lever to the single white dot for AF-L and to the white and red dot for AF-L and AE-L operation in one. Above this is the mirror lock-up and depth-of-field button which works just like those on the F2 and F3.

Nikon released all new screens for the F4, the **Bright-View**s. The same nomenclature used for the F, F2, and F3 screens holds true for the F4 screens. The F4 standard screen is the "B" and not the "A" that all other Nikons had as original equip-

ment. This is because the F4 has an built-in electronic rangefinder. The F4 screens have a small rectangular bracket in their center. The autofocus reading and the electronic rangefinder are based here.

The autofocus indicators lights are inside the viewfinder, top-right. The green dot indicates in focus. Two red triangles indicate which way to turn the lens if manually focusing for proper focus. The electronic rangefinder and the red X notify the photographer that the camera cannot focus on the subject. The compensation warning sign is directly to the right of these indicators. In the top left corner of the viewfinder is one of the best features of the F4, a frame counter. It is no longer necessary to look on top of the camera to see what frame is in use. To the left of this is a window that displays the amount of compensa-

tion selected with the compensation dial next to the shutter speed dial.

The display at the bottom of the finder indicates other options in use. On the far left is the metering pattern signal, next to the shutter speed. Next to that is the f/stop if in "S" or in one of the "P" modes. Here the camera displays "FEE", "HI" or "LO" if the camera is not set correctly. "FEE" means that the lens is not set to the minimum aperture. "HI" or "LO" refers to the exposure which is corrected by opening or closing the aperture or changing shutter speed as needed.

On the far right the F4 display indicates which mode is in use. An "A", "S", "P" appears when in those modes are in use or in manual, the bar graph appears with a range of plus and minus 2 stops in 1/3 increments. Placing the single dot dead center on the bar graph means correct exposure is achieved.

In dark or dim situations, turn the lever under the shutter speed dial in the front of the camera until the red dot appears. This activates a light that stays on as long as the meter is on lighting up the display information. This also lights a small light above the aperture enabling the use of the ADR readout which is top dead center in the viewfinder. It is visible in all modes.

Most owners of the F4 do more vertical shooting with the F4 because of the molded handgrip and the very convenient vertical firing button on the end of the MB-21. These make for easy access and more successful shooting. Nikon anticipated this by including matrix metering with a switchover for vertical shooting. The matrix vertical sensor in the F4 is different from that in the N8008 in the way it knows it's turned vertical. The F4 matrix vertical sensor is incorporated on both sides of the eyepiece lens of the DP-20. When the camera is turned vertical, a mercury switch enclosed in each of the two sensors is automatically activated detecting the vertical position. When this sensor detects the vertical position, the metering output assignment changes the five segments. Whether the F4 is vertical or horizontal, the eyepiece shutter may be used to keep out extraneous light which will change the meter reading.

The F4 like the N8008, has Cybernetic Flash Sync, Matrix Balanced Fill-Flash, Center-Weighted Fill-Flash and TTL flash. These all work the same as in the N8008 providing the same features. The F4 also incorporates these features when the camera is in the vertical position. There are many other features available to the F4 user when using the SB-24 flash which are discussed in depth in the Flash Chapter.

When working with black and white film and using dark red or deep orange filters, you run the possibility that the electronic rangefinder and autofocus will not function properly. Nikon recommends manual focusing when using these filters. With a film such as Polapan, which has the very dark film backing, TTL flash will not work properly without some type of compensation. The meter sees the dark film and keeps the flash on longer than correct exposure requires because it is so dark.

When using teleconverters, if it's an AI version, matrix metering will be lost. A teleconverter that is AIS must be used to maintain matrix metering. These are the TC-14A, TC-14B, TC-201 and TC-301. Many photographers still use the older TC-14's and wonder why the exposure is not coming out correctly. When an AI teleconverter in attached to the F4 and the F4 is in matrix mode, the camera automatically changes to center-weighted though the selector switch still says matrix. The viewfinder does relay the information that the camera is in center-weighted to inform the photographer of this change.

There have been minor changes made to the F4 since its introduction, most of which are cosmetic and can be retrofitted to older F4's. The cosmetic changes include clearer lettering on the shutter speed dial as well as a higher unlocking button and greater tension on the shutter speed dial. There is a bigger compensation dial. The metering mode switch tang is smaller and the resistance tension is greater, the spring on the release lever for opening the back is stronger and the battery warning responds at a lower voltage. These changes were phased in on new bodies with serial numbers between 2100000 and 2180000.

The N4004s

In 1989 the N4004 got a slight revision in the N4004s. The upgrade is the advanced AM200 module of the N8008 and a lock on the two dials to prevent accidentally knocking the camera out of program mode. Otherwise it is exactly the same camera as the N4004.

The N6006

In the summer of 1990, Nikon introduced two new cameras to replace the N2020 and N2000—the N6006 and N6000. Although they offer similar features, the N6006 has additional major features not incorporated in the N6000. The popularity of the **N6006** is like none seen before with the public at large. They are not the only ones to see its value for photojournalists have also latched onto this unique package of technical wizardry.

One drawback to the N6006 is its battery. Its power source, a 6V lithium battery, can expose a maximum of 75 rolls of film and at 14 degress, only 3! Use of the built-in flash knocks these numbers down even further. This does not seem to be slowing down sales of the camera but is increasing sales of 6V batteries.

The N6006 has superior autofocus capability featuring Focus Tracking. Focus Tracking is operational in any film advance or autofocus mode combination. If the subject is moving, Focus Tracking analyzes the speed of the subject and will drive the autofocus to anticipate the subject position at the exact moment of exposure. Focus detection is in as low a light level as EV-1 (with ASA 100) while providing "CF", "S" and "M" (switch located under lens lock button) focus modes. It utilizes the AM200 module as in the N8008 and F4. The autofocus in the N6006 as a result is faster than that in the N8008 but not so fast as the N8008s.

Its metering allows for Matrix, Center-Weighted and Spot with an "AE-Lock" increasing its flexibility. Press the "SLW" button left of the prism on top, and turn the command dial until the symbol for the desired metering pattern appears in the LCD panel.

The "AE-L" lever will either operate just the "AE-L" function or the combination "AE-L/AE-F"

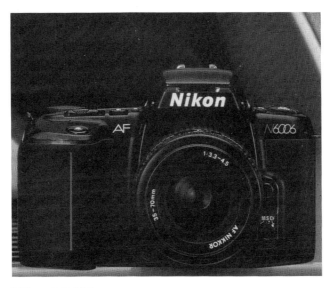

Nikon N6006.

function. Changing this function requires pressing the "Shift Button" first and then the "Drive/AF-L" button. Pressing the "Drive/AF-L" while holding down the Shift Button changes the message in the LCD panel to say "AF-L" or "——", the later indicating just "AE-L" in use. If "AF-L" appears, the combined "AE-L/AE-F" is in effect when the lever is pressed in.

Coupled with these are "S", "A", "M", and "P" modes as in the N8008 as well as a new "Pm" Auto Multi-Program mode. The "Pm", Auto-Multi-Program Exposure Control is designed to take control in low lighting, when coupled with a lens with a CPU (AF or P lens). It will not use a shutter speed slower than the focal length without warning the photographer. Changing the exposure mode requires pressing down the "Mode" button while turing the command dial until the desired symbol is displayed in the LCD panel.

A new feature of the "P" or "Pm" is called "Flexible Program". When in these modes, lightly press the shutter release button and the exposure information will appear. If a different aperture or shutter speed is desired, turn the command dial until the desired combination is displayed. When done correctly, the exposure mode indicator will blink in the LCD and viewfinder display. This is canceled when the camera is turned off or the camera automatically shuts down after 8 seconds.

The N6006 has a built-in Auto Exposure Bracketing mode providing three or five frame of bracketing. This only operates with "P", Pm", "S", or "A" modes. In "P" or "Pm" modes, shutter speed and aperture will be automatically changed. In "S" mode, the aperture will be changed and in "A" mode the shutter speed will be changed during bracketing.

To set the camera to Auto Exposure Bracketing first make sure the camera is set to an appro-

Command dial/shift button functions
Combined with buttons listed below, the command dial and shift button provide various functions.

Button	With Command Dial	With Shift Button
Metering system (⚫)/Slow sync button	To select metering system, rotate dial while pressing this button. (See page 41)	With shift button pressed, this button is used to set/cancel slow sync for flash photography.
Exposure mode (MODE)*/Automatic Balanced Fill-Flash (📷) button	To select exposure mode, rotate dial while pressing this button. (See page 47)	With shift button pressed, this button is used to set/cancel automatic balanced Fill-Flash for flash photography.
Film speed (ISO) button/Film speed setting mode (DX/M) button	To manually set film speed, rotate dial while pressing this button. (See pages 25 to 26)	With switch film speed setting mode (auto for DX-coded film or manual), push it while pressing shift button. (See page 24)
Film advance mode (DRIVE)/ AF-L function button*	To set film advance mode, rotate dial while pressing this button. (See page 27)	With shift button pressed, this button is used to set/cancel autofocus lock function. (See pages 32 to 34)
Exposure compensation (🔲) button	To make exposure compensation, rotate dial while pressing this button. (See pages 66 to 67)	—
Auto exposure bracketing (BKT) button	See pages 68 to 72.	
Self-timer (⏱)/Rear-curtain sync button	Rotate it to set self-timer operation. (See pages 73 to 74)	With shift button pressed, this button is used to set/cancel rear-curtain sync for flash photography.
—	With shift button pressed, rotate command dial for flash output level compensation. For details, see pages 35 to 37 in "FLASH PHOTOGRAPHY", a separate instruction book.	

*Pushing any two of MODE, ISO, DRIVE and BKT buttons simultaneously for more than one second sets N6006 for basic shooting.

In the following cases, command dial can be used by itself.

In Programmed auto exposure mode	Turn command dial for flexible program
In Shutter-Priority auto or Manual exposure mode	Turn command dial to set shutter speed

priate exposure mode. Next, press and hold in "Shift Button" then push "BKT/SET/R". The "+/-" and blinking "BLK" symbol on the LCD panel and "+/-" blinking in the viewfinder remind you the auto bracketing is operational. After the auto shut off by the camera, the "BKT" on the LCD panel will no longer blink.

Setting the degree of bracketing and number of frames requires pressing the "BKT" button and turning the command dial until the desired combination appears in the LCD panel. Bracketing is in 0.3, 0.7 and 1.0 stops increments. With the "3F" selected, the camera will expose one frame under, one without and one overexposed. With "5F", the camera will expose two frames under, one without and two overexposed. In "S" advance mode the camera will take one shot each time the shutter released is pressed, counting down the number of exposures. In "C" advance mode, the camera will fire off all frames by pressing the the shutter release button just once.

The N6006 has a built-in, pop-up flash that's just a hint of the camera's flash technology. The built-in flash provides a guide number of 43 with ISO 100, and draws power from the 6V battery. The flash is not heavy duty. Its recommended use prohibits flashing more than 20 times within a 5 sec-

ond or shorter interval. If this occurs, let the flash rest for at least ten minutes before firing again.

The built-in flash can be operated to provide Matrix or Center-weighted balanced fill flash. There are a number of lenses, primarily long telephotos and zooms, that have partial or no compatibility with the built-in flash. Refer to page 78-79 in the N6006 manual for a complete list. It is also recommended there be no lens hood attached when using this flash to avoid vignetting. If the flash is popped up, an auxillary speedlight if attached cannot be fired.

The N6006 has built into its system Matrix Balanced Fill-Flash, Center-Weighted Fill-Flash, Spot Fill-Flash, Standard Fill-Flash. These provide Automatic Balanced Fill-Flash, Manual Flash Output Level Adjustment (a complicated way of expressing flash exposure compensation), Slow Sync-Front Curtain Slow Sync and Rear-Curtain Sync-Rear-Curtain Slow Sync. Note: usable film speed for TTL flash photography is ISO 25 to 1000.

These features were formerly only available to F4 and N8008 owners using an SB-24. In fact, it's important to note that the functions on the SB-24 are overridden by those of the N6006. With the SB-24 in use, the zoom, lens aperture, ISO and angle of coverage setting must be set manually on

the SB-24, just as if a non-CPU lens were in use. Setting "M" or "SEL" buttons on the SB-24 has no effect, and no message will appear on its LCD panel. The setting of these modes on the N6006 confused users just as they do on the SB-24 which are very similar.

Automatic Balanced Fill-Flash automatically compensates the flash output to balance foreground subject and background. This is achieved by first pressing and holding down the Shift But-

ton then pressing the "Mode/man & sun" button. This has been done correctly when the "man & sun" symbol appears in the LCD panel. Select the desired metering pattern as normal to utilize Matrix (requires use of a lens with a CPU), Center-Weighted, or Spot Fill-Flash. Note, the TTL flash exposure is still only center-weighted, the Matrix, Center-Weighted and Spot strictly refer to ambient light metering and not the flash.

The N6006 operation with flash when in the

Programmed mode is unique to the Nikon system. With the exposure mode set to "P" or "Pm", turn on the flash unit making sure it is switched to TTL. If the flash is not set to TTL, the mode indicator and "man & sun" blink for a few seconds to warn of mis-setting. With a lens 60mm or shorter, the shutter speed can range from 1/(focal length) to 1/125. (1/(focal length) for a 20mm lens would be 1/20.) Using a lens 60mm or longer, 1/60 or 1/125 are the only possible speeds. Switching the camera to Slow Sync provides shutter speeds of 30 seconds to 1/125.

There are a number of warnings the camera's LCD can flash when controls are improperly set. "FEE" blinks when aperture is not set to minimum f/stop. The analog display appears when ambient light exposure is either over or under exposing. The lightning bolt in the viewfinder indicates proper or improper flash exposure as with previous Nikons.

Operation in "S" and "A" modes are basically the same as in "P or Pm" modes. The same warnings appear if the flash is not set to TTL. In "S", the camera will default to 1/250 if the camera is set to a higher shutter speed. In "A", control of depth-of-field is back with the photographer with the camera providing the correct flash exposure automatically.

The section "Exposure Compensation in TTL" is where most get lost in the instruction book. The N6006 provides three methods to make exposure compensation: manual adjustment of output, camera EV compensation, and Auto Bracketing. These can be used separately or in combination.

Manual Flash Output Level Compensation is the most commonly desired but misunderstood function. Press and hold in the Shift Button while pressing the "Mode/man & sun" button to call up the "man & sun" symbol in the LCD panel. Next, press the Shift Button calling up the "lightning bolt, +/–" Flash Output level symbol. While holding down the Shift Button, turn the command dial to set desired compensation. Compensation from +1EV to –3EV is available. Remove finger from Shift Button and the analog display will disappear leaving the "lightning bolt, +/–" symbol to indicate flash compensation is dialed in.

Slow Sync Flash - Front-Curtain Slow Sync works with a slow shutter speed sync. This permits correct low-light, ambient light exposure working with shutter speeds 30 seconds to 1/125. When the camera is in Slow Sync, it will automatically correctly expose the ambient light even in low light levels and provide correct TTL flash exposure. Where in Normal Sync, it works at 1/60 or 1(focal length).

The camera must be used in exposure mode "P", "Pm" or "A" when using Slow Sync. With this, press and hold in the Shift Button then press the "matrix/SLW" button left of the prism. The "slow-lightning bolt" symbol appears in the LCD panel when Slow Sync is activated. In this mode, the flash is taken at the beginning of the exposure. This function is most effective when used in concert with exposure compensation previously described.

Rear-Curtain Sync Flash - Rear Curtain Slow Sync, the flash fires at the end of the exposure. Activate by pressing and holding the Shift Button while pressing in the "self-timer-RE" button. When Rear Curtain Sync is activated, "rear-lightning" symbol appears in the LCD panel. In "S" or "M" mode, only Rear Curtain sync is available. In "Pm" or "A" modes, both Rear Curtain and Slow Sync can be used in concert.

The N6006 works with a thumb wheel control dial as that on the N8008. Because it has a built-in flash, the camera has no port to light up the internal display, so a light comes on all the time to illuminate the display. The camera also has a High Eyepoint finder, but has a square eyepiece. It provides only 92% viewing of the actual photo. It also has a built-in motor drive providing up to 2FPS, powered by the 6V lithium battery. It accepts a standard cable release but has no port for an electrical cable release.

The **N6000** does not have autofocus capability nor built-in flash. It is a manual focus camera only, but has all TTL flash capability and features of the N6006. Neither camera has interchangeable screens. The N6006 offers an electronic rangefinder and the N6000 a split-rangefinder screen. All other features, design, and basic camera body are the same. Neither camera accepts a multi-function back nor the MC-12a cord, only an AR-3. The backs on these cameras are solid plastic, the bodies are polycarbonate as that of the N8008.

The N6000 has all of the sophisticated flash capability of the N6006 but its LCD panel displays some of the error messages differently. Refer to the N6006 section for explanation of flash use and the

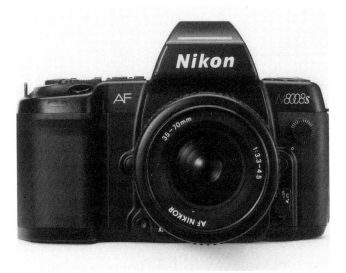

Nikon N8008s.

N6006/N6000 Flash Photography Instruction Manual for specifics on error messages.

The spring of 1991 Nikon introduced an updated N8008, the **N8008s**. The "s" can stand for "spot" or "speed", because those are the only new features in this updated version.

The N8008s has a spot meter incorporated with matrix and center-weighted metering. Like the other metering systems, AF lenses or lenses with CPUs are required to take advantage of the spot metering. The area metered by the spot meter is approximately 3.5mm in the center of the viewing screen. It is activated as with all metering pattern changes in the N8008.

The autofocus coreless motor in the N8008s is the same charging motor as in the F4. This update increases the speed of the autofocus in N8008s by 15%. This a noticeable and vast improvement. The momentary whirl of the motor when the shutter release is first pressed in the N8008 is no longer heard in the N8008s.

All other features, functions, and operation of the N8008s are the same as in the N8008. Those doing home electronic modifications, be forewarned that the electronics for firing the N8008s are different from the N8008. To customize an electronic release for this camera that will activate autofocusing, metering, and shutter release, a different resistor will need to be installed from that used to activate the same function in the N8008.

Nikon Body Production Dates

Model	Introduction	Discontinued
Pro Models		
F body	1959	1972
F Photomic	1962	1966
F Photomic T	1965	1966
F Photomic Tn	1967	1968
F Photomic FTn	1968	1972
F2 body	1971	1980
F2 Photomic	1971	1977
F2S	1973	1976
F2SB	1976	1977
F2A	1977	1980
F2AS	1977	1980
F2T	1976	1980
F2H	1976	1980
F3	1980	1983
F3HP	1982	still in production
F3T	1982	still in production
F3AF	1983	1988
F3P	1983	1988
F4s	1988	still in production
Nikkormat Series		
Nikkormat FT	1965	1967
Nikkormat FS	1965	1971
Nikkomrat FTn	1967	1975
Mikkormat EL	1972	1977
Nikkomrat FT2	1975	1977
Nikkormat ELw	1976	1977
Nikkormat FT3	1977	1978
Nikon EL2	1977	1978
FM/FE Series		
Nikon FM	1977	1982
Nikon FE	1978	1982
Nikon EM	1979	1984
Nikon FM2	1982	1984
Nikon FG	1982	1986
Nikon FE2	1982	1987
Nikon FA	1983	1987
Nikon FG-20	1984	1986
Nikon FM2n	1983	still in production
N Series		
Nikon N2000	1985	still in production
Nikon N2020	1986	1989
Nikon N4004	1987	1989
Nikon N4004s	1989	still in production
Nikon N8008	1988	still in production
Nikon N6006	1990	still in production
Nikon N6000	1990	still in production
Nikon N8008s	1991	still in production

NIKON LENSES:
THE EVOLUTION

In 1959 when Nikon introduced the Nikon F, they introduced their first SLR lenses. This was the start of a long legacy that would come to be known as Nikkor optics. There are two main reasons Nikon set the industry standard for quality in lens production since their beginning. Their superior optical design with constant new innovations, and a complete line of lenses to solve any photographic problem, have kept them the industry leader.

Every owner of a Nikon lens is sure to rave about a favorite lens and why it's the sharpest lens Nikon ever made. Actually, almost every claim is true. Nikon optics are the best around. Only a few Nikon lens designs are "good" by their standards (that's still better than what other manufacturers produce). The evolution in Nikkor lenses is not as radical or dramatic as in the bodies, but their designs run parallel with them and their change in technology.

Nikkor lenses are manufactured by Nikon (Nippon Kogaku), who started manufacturing optics in 1925. The optical engineers at Nikon start with the most basic element of photography in their lens design, light. They manufacture their own optical glass and completely assemble the entire lens in its mount. Rare earth elements are used to the fullest in glass manufacture. Even the glass crucibles with their platinum liners are made by Nikon. Once the glass is ground, polished, coated, and finished for mounting, the mechanical procedure for manufacturing the lens barrel and helicoid that houses the glass is just as precise.

Lens barrels are made of special aluminum alloys, with phosphor bronze at points of wear to maintain continued precise alignment. The seating of the elements in the lens barrel and the lens mount must be milled so that the lens will precisely fit into the camera mount to assure accurate alignment of the aerial image with the film plane. The result of this combination of optical and mechanical precision delivers maximum distortion-free performance. Lenses provide maximum corner-to-corner sharpness without vignetting at full aperture. This is Nikon's description of their 1960's lens manufacturing process. This has changed as new technology in lens design, especially computers, started to become an important factor in lens manufacture.

In the 1960's the process of manufacturing Nikkor optical glass was descibed thusly: first, raw materials are heated to 1500 degrees C and melted in a crucible. The mixture is then either cooled in the crucible until it hardens or cast according to its desired use. The mixture cooled in the crucible, once cooled, is gotten out and broken into lumps. These lumps are carefully inspected for bubbles, stria, and nontransparent elements. After inspection, the glass is reheated until it's soft enough to allow molding into rough blocks. It is then cut or pressed and annealed by cooling slowly for up two weeks. This yields rough discs of the right size for a particular lens element. The glass is then inspected again before the grinding-polishing stage. The lens surface is ground by fine meshed sand (i.e., carborundum or corundum) to rough cut the element to the requisite curvature.

The surface is then polished with cerium oxide to obtain the final lens curvature, texture, and clarity. The extraneous marginal edges are ground off to make sure the polished lens will have its optical axis in the center. Next, a thin low-reflective layer of coating is applied to the glass surface by a vacuum depositing method to minimize surface reflections. This produces optical glass that is

Optical glass raw materials.

V-blender for mixing raw materials.

Pressing the glass.

virtually bubble-free (completely bubble free is an impossibility). The elements are now precisely seated in element groups which are fitted into lens mounts that are then seated in the lens barrel to extremely close tolerances.

The glass is coated during this manufacturing process. The surface of elements that are in contact with air will reflect as much as 4 to 5 percent of the light striking them. When light enters a lens with a number of element surfaces (the more surfaces, the greater the possible problem), a significant amount of the light will be lost by reflection before it reaches the film plane. Reflection can also cause flare, reducing the contrast of the picture. Lens coating is designed to reduce this loss from reflection to as little as less than one percent. Lens surfaces are coated with a thin layer or multiple layers with varied refractive indexes. The thickness of one coating layer is equal to one-fourth of the wave length of light and varies according to the type or usage of the lens.

A Nikkor lens with single coating may be recognized by a blue, magenta, or amber tinted reflection of light in the front element. The stable chemical properties of these coatings not only prevents surface reflections but helps protect the surface of the lens. The main coating in a single layer is magnesium fluoride. This procedure changed in 1969 as newer multicoated lens designs were introduced.

When the F first came on the market, there were some rangefinder lenses that could work on the F with two special adapters. The 135f4 Short Mount lens requires the **BR-1** while the others require the **N-F** adapter. These rangefinder lenses were:

180f2.5 Short Mount
250f4 Short Mount
350f4.5 Short Mount
500f5 Short Mount
1000f6.3 Short Mount

These lenses were designed primarily for the Nikon S series rangefinder models to be used in conjunction with a reflex housing. The **N-F** adapter fits between the F camera body and the lens allowing the correct amount of extension that the focusing housing provided on the Nikon S rangefinder. The adapter permits the camera to work either horizontally or vertically, but there are no linkages for automatic diaphragm or meter coupling (which didn't exist when these were manufactured).

The lenses are called "Short Mount" because they can be used without the N-F adapter, hence short mount. They are also known as "Preset". The lenses don't link up with the automatic lens diaphragm in the F body. The camera cannot keep the lens aperture open at its maximum aperture for

bright viewing and focusing. Nor can it then close down the aperture to the selected f/stop at the time of exposure. With the short mounts, turn one ring to the desired f/stop for proper exposure. Turn a second ring to open the lens to its maximum f/stop for focusing. Then manually close it down to the "preset" f/stop. This was not a fast system and made action photography difficult.

These lenses were also very heavy and bulky.

Lens	Apertures	Weight	Attachment Size
180f2.5	2.5-32	60oz	82mm
250f4	4-32	32oz	68mm
350f4.5	4.5-22	59oz	82mm
500f5	5-45	324oz	108mm
1000f6.3	6.3	21.9 lbs	52mm in Filter Ring

The 1000f6.3 is the first mirror lens Nikon produced being the odd man in the lineup. It's not much smaller than the current 2000mm mirror lens and in its day considered a monster. It's amazing its lens design consists of only three elements in two groups, that's all! Its minimum focusing distance is 100 feet so final image size is small. It has a filter ring that uses 52mm filters, but will not accept any other.

These lenses were not enough to make a viable working camera system, so Nikon introduced all new lenses designed for the SLR F. It would be 25 years before Nikon would introduce a new line of lenses for a new body. All of the lenses manufactured by Nikon until 1977 had the non-automatic indexing coupling on the top of the aperture ring that engages the metering prong on the bodies' meter (see body chapter for more information of body meter coupling). The first lenses introduced with the Nikon F in **1962** were:

21f4
28f3.5
35f2.8
50f2
58f1.4
105f2.5
105f4 Preset
135f3.5
85-250f4-4.5

These original lenses were unique for a couple of reasons. First, they are designated in centi-

meters instead of millimeters, for example 5cm instead of 50mm. Secondly, the original lenses are designated with a letter to indicate the number of elements in the design. These letters are the first letter of the Latin word for that number:

U *one element* **(Uns)**
B *two elements* **(Bini)**
T *three elements* **(Tres)**
Q *four elements* **(Quatuor)**
P *five elements* **(Pente)**
H *six elements* **(Hex)**
S *seven elements* **(Septem)**
O *eight elements* **(Octo)**
N *nine elements* **(Novem)**
D *ten elements* **(Decem)**

These letters occur after the word "Nikkor" on the serial number ring at the front of the lens. This system was completely dropped from Nikkor lenses by 1974 since many never understood what it meant or really cared how many elements were in the lens design.

All of the new lenses for the F were SLR in design except the 21f4. SLR stands for Single Lens Reflex—viewing through the lens that takes the picture. It must be remembered that this was radical in 1962. 35mm photography for the masses was in its infancy.

The **21f4** is a throwback to rangefinder days. The rear element on the 21 extends out past the lens mount. The mirror of a camera must be raised to mount the lens not permitting SLR viewing. The 21mm comes with a finder that slips on the accessory shoe of the F. This permits framing of the photograph. It has a length of 1", an aperture range from f/4 to f/16, no meter coupling, a filter size of 52mm, an angle of view of 81 degrees, a weight of 4.75oz. The 21mm is very compact. Serial numbers 225001 or higher will fit all Nikkormats, below that number will not; all 21's will fit the F, F2, etc.

The **28f3.5** first came out as a 2.8cm on the barrel, but it was later changed to 28f3.5. The 28f3.5 is a very compact lens. It has a length of 2", an aperture range from f/3.5 to f/16, meter coupling, a filter size of 52mm, an angle of view of 64 degrees, a weight of 7.75oz. Although the 28f3.5 was never thought of as an outstanding lens, it sold rather well even though it was never highly regarded. Its optical formula did not change much over the years, although its cosmetics did.

The **35f2.8** was similar to the 28f3.5 with the original lens having centimeter markings of 3.5cm. It has a length of 2", an aperture range from f/2.8 to f/16, meter coupling, a filter size of 52mm, an angle of view of 53 degrees, a weight of 7oz. It never enjoyed a reputation of being a great lens but sold well because of the focal length. Like the 28f3.5, it did not change much over the years optically but did change cosmetically.

The **50f2** was the first "normal" SLR lens manufactured by Nikon. It is relatively slow at f/2. It has a length of 1.5", an aperture range from f/2 to f/16, meter coupling, a filter size of 52mm, an angle of view of 39 degrees, a weight of 7.2oz. This little lens, though not suited for low light photography, works great for general and close-up photography. This is especially true on a bellows. At f/2, it delivers excellent resolution and outstanding color rendition. Closing down to f/5.6, it's fantastic! When working with the lens reversed, the corners suffer slightly and it's best to close down to f/8. This lens sold by the thousands, going through few changes over the years. Multicoating, an all black barrel, and rubber focusing ring (non-AI) are the extent of the changes.

The **58f1.4** is a unique lens that never had a chance to catch on with photographers. This lens has a little more than "normal" coverage. It has a length of 2.5", an aperture range from f/1.4 to f/16, meter coupling, a filter size of 52mm, an angle of view of 34 degrees, a weight of 12.8oz. The lens was designated 5.8cm on the barrel, never acquiring millimeter markings. It's excellent at f/1.4, and closing down is not required for better results. It is still sought out by old time photographers who use the F/F2, but it's not capable of being converted by Nikon to AI coupling.

The **105f2.5** quickly caught on with photojournalists stationed in Japan after the Korean conflict in 1959. It was considered by many as the best lens on the market at the time. The 105f2.5 is a lens that has become a standard for portrait work. A very simple design, the lens is compact. It has a length of 3", an aperture range from f/2.5 to 22, meter coupling, a filter size of 52mm, an angle of view of 19 degrees, a weight of 13oz. It's gone through many cosmetic changes since its release. The first version had a chrome lens barrel and front. That was changed to a chrome lens barrel with a black front. Then it became all black with a larger focusing ring and a minimum f/stop of f/32. It then went to a rubber focusing ring and back to f/22. It maintained that design until 1977.

It was said its optimum performance was best at f/5.6, but when used at f/2.5 it produces equally outstanding results. In advertisements of the day, the hexagonal form of the aperture blades was stressed because of the clean, out-of-focus highlights they produced in the background. When the lens was bought, it came with a shade which could be reversed over the lens when stored and turned around when in use. This lens was the basis for Nikon's growing reputation for lens design!

The **105f4 Preset** is a rangefinder lens that Nikon retro-fitted to work with the bayonet F mount. On an F, this rather odd looking lens (marked 10.5cm rather than 105mm) is extremely light. It has a length of 3.75", an aperture range of f/4 to f/22, stop down metering, a filter size of 34.5, an angle of view of 19 degrees, a weight of 9oz. There is no automatic diaphragm operation, but there is TTL viewing. It's a preset, operating the same as the short mount lenses. Its days were numbered even before the F was introduced, and it was discontinued not too long after, becoming a rare, unforgotten, and not much sought after lens.

The **135f3.5** was Nikon's second "portrait" lens introduced this year. It's short for its focal length. It has a length of 3.5", an aperture range of f/3.5 to f/22, meter coupling, a filter size of 52mm, an angle of view of 15 degrees, a weight of 13oz. It was popular for only a short while. Like the 105f2.5, it changed cosmetically over the years, but not as much nor as often. It ended up with a minimum aperture of f/32 which helped its popularity briefly, but it was never known as an outstanding lens.

The **85-250f4** was Nikon's first zoom design. It incorporates an internal zoom mechanism operated by pushing and pulling a ridge around the lens barrel. This is a big lens with lots of glass. It has a length of 20", an aperture range from f/4 to f/16, meter coupling, a filter size of 95mm, an angle of view of 24 to 8 degrees, a weight of 70oz. When in use, it's necessary to keep track of the focal length because it requires compensation as it zooms. At the 180mm focal mark it loses light until the 250mm mark where it is at f/4.5.

The offering of lenses did not change much over the next two years other than the discontinuation of the 58f1.4 in 1960 and the 105f4 Preset in 1961. Discontinuation of a lens does not necessarily

mean immediate unavailability of new stock for purchase, rather, that it's no longer manufactured. Many photographers, when looking back at the variety of lenses available to the first users of the Nikon, wonder how Nikon ever made it this far. It should be remembered that photography was enjoyed by a limited number of "weekend" photographers back then in comparison to the hundreds of thousands of "weekend" photographers in the field today.

The next group of lenses to help fill out the Nikon lens line was introduced in **1963**. The lenses were:

8f8 Fisheye
35f3.5 PC
50f1.4
55f3.5 Micro, Compensating
200f4
43-86f3.5
200-600f9.5
200f5.6 Medical
500f5 Mirror

The **8f8 Fisheye** was a very exciting lens when it was introduced. Up until this time, there had been no other lens like it. Hundred of thousands of photographs soon appeared in print taken with this lens as the age of the "Fisheye" began. The 8mm was only the first of many fisheyes to come, brought on by an increasing popularity. The 8mm has an angle of view of 180 degrees, and is a fixed-focus fisheye (everything in focus, so no focusing ring). This lens will only mount on cameras with a mirror lock-up since the rear element sticks into the body, resting only millimeters away from the film plane.

With the mirror locked, there is no viewing through the lens. An auxiliary viewfinder is used to frame the picture. This finder has only 160 degrees of coverage, 20 less than the lens. A photographer could get his feet in the picture if he were not careful. The finder has its own small lens cap for protection when not in use. The finder attaches to the accessory shoe of the camera for viewing when in use. The 8mm takes a circular image, not filling the frame but leaving black in the corners of the picture.

The 8mm has a variable f/stop, going down to f/22. However, the depth-of-field is so immense, closing down is only an advantage when focusing on a very close subject. Because the angle of view

covers from the filters threads out, front filtration is impossible. Nikon provides built-in filters in a turret, L1a, Y48, Y52, O57, R60, XO which are mostly for B&W work. The L1a can be used for color. A unique feature of the 8mm is its rear lens cap which fits over the long rear element. It also provides an accessory shoe to which the finder can be attached when not in use.

The **35f3.5 PC** (perspective Control) was a first in its day. The front element assembly can shift from its optical axis, moving the image from the film image. This allows the camera to be parallel with the subject, normally a building and shift the front element to bring the subject back into the frame.

The **50f1.4** is physically bigger than the 50f2 to accommodate the bigger glass. The "normal" lens was improved with the faster maximum aperture. It has a length of 2", an aperture range from f/1.4 to f/16, meter coupling, a filter size of 52mm, an angle of view of 39 degrees, a weight of 11.5oz. As normals go, the Nikon 50f1.4 is very good, rendering good sharpness even when shot wide open. In the write ups at the introduction of the 50f1.4, it was claimed that the flare potential had been eliminated because of the use of integrated multi-layer coating on all air surfaces of individual elements.

The description does suggest more than one layer. But this is not the same as multicoating and the light reflections of the front element look like all other lenses with single coating. The 50f1.4 went through many cosmetic changes over the years. It become multicoated in the model with the all black barrel and rubber focusing ring (non-AI coupled). The 50f1.4 has good sharpness when used normally. When reversed, the corners suffer and it's not recommended. Nor is it recommended for copy work.

The **55f3.5 Compensating Micro** is another unique lens whose legend lives long after its production has ceased. Nikon has always called their close-focusing lenses "Micro". The usage is incorrect. Micro means greater than 1:1 magnification, whereas "Macro" means less than 1:1 magnification and is the term that better fits the 55f3.5. The lens by itself can focus to 1:2 life size (1/2 life size) and with the M-ring (included with the lens when purchased) it can go to 1:1. The 55f3.5 could also focus to infinity (when no M-ring was attached), which was a spectacular achievement in 1963. The 55f3.5 is quite a compact design. It has a length of 2.5", an aperture range of f/3.5 to f/22, meter cou-

pling, a filter size of 52mm, an angle of view of 36 degrees, a weight of 8.8oz.

The 55f3.5 couples with the meter for full automatic diaphragm linkage. It also has "automatic aperture compensation" (hence the name), which provides an image of constant brightness regardless of the focused distance or magnification. "Compensating" is a nickname this lens earned because of this feature. This means no recalculation of exposure is necessary or exposure factor added in when doing close-up photography. When focusing closer, the aperture will automatically open up. At 1:2 the lens will have opened up 1 full stop. If using the **M-ring**, open up one stop manually to compensate for the light loss from the increased magnification. One interesting note: the 55f3.5 aperture closes down to f/32, but meters only couple to f/22. Disengage the coupling to close down to f/32.

The **200f4** design is not particularly special or radical. It has a length of 8", an aperture range from f/4 to 22, meter coupling, a filter size of 52mm, an angle of view of 10 degrees, a weight of 19.25oz. It has a built-in lens hood that pulls out for use. The original design stayed the same until 1977, with only minor cosmetic changes. The ring on the barrel between the hood and the focusing collar changed from chrome finish to black and the last version is multicoated. It was a very popular lens in its day. It is still in use and readily available. A sharp lens, it's a good, inexpensive way to get into telephoto work.

The **43-86f3.5** is a design that lasted until 1981, going through many changes cosmetically and one optically. It has a length of 5", an aperture range from f/3.5 to f/22, meter coupling, a filter size of 52mm, an angle of view of 45-22 degrees, a weight of 14oz. It's a small zoom and was a popular range in its day. By Nikon standards, the early version was not sharp, but this changed when it became multicoated. The serial number on Nikon lenses are normally six digits long, but the later versions of the 43-86 have seven digits (testimony to how popular and how many were manufactured). These models are the sharpest and are the recommended version.

The **200-600f9.5** was something of an enigma, a big lens in size and a rather strong seller in the stores. It has a length of 27", an aperture range from f/9.5 to f/22, stop down metering, a filter size of Series 9, an angle of view of 10-3 degrees, a weight of 85.5oz. It has a tripod collar permitting rotation of the lens for vertical and horizontal shooting, click stops at every 90 degrees. It cannot be hand held. The lens comes with a hood and a close-up lens. An orange distance scale engraved on the barrel is for "close-up" work and is symbolically related to an orange ring on the filter.

The 200-600 was actually a variable f/stop zoom, going to f/10.5 when zoomed out to 600mm. Like the 43-86, the early version (denoted by a chrome ring on the end of the lens) is not fantastically sharp but a later, shorter (by 2 inches), sharper version is quite a nice lens. In 1977, it came out in an ED version, a rare and *very* sharp lens. One measure of the lenses' popularity is that they rarely appear on the used market. Those who purchased it new got a good thing and they know it. Production numbers of the ED model is believed to be few since its f/stop was so slow and recent trends have been towards faster lenses.

An extremely curious lens, the **200f5.6 Medical Nikkor** came out for the medical field. Nikon designed many lenses for the scientific community in the early days, probably because of the overwhelming demand to document scientific innovations photographically. It has a length of 7.75", an aperture range from f/5.6 to f/45, stop down metering, a filter size of 38mm, an angle of view of 10 degrees, a weight of 23.6oz. It was designed for close-up photography where a good working distance as well as superb illumination of the subject is required.

The Medical Nikkor can focus at 11 feet at its maximum with an image ratio of 1:15. With a close-up lens attached to the lens, 3:1 magnification can be attained. Focusing of the subject is accomplished by moving the camera/lens closer or farther away from the subject until in focus. Changing the combinations of any of the six close-up filters changes the magnification. The Medical Nikkor is powered by either the **LA-1** (AC) or **LD-1** (DC) units and has four focusing bulbs to illuminate the subject during focusing as well as a built in ringflash for exposure. It is self compensating for exposure (no aperture ring) by matching up the film ASA to the image ratio on the barrel of the lens. The magnification ratio from 1/15x to 3x or a numerical number from 1 to 39 can be imprinted on the lower corner of the final picture (optional). The 200f5.6 Medical Nikkor was in production until the early eighties.

The **500f5** was the first catadioptric (mirror)

for Nikon and at the time was popular. Catadioptric is the technical name for the optical design of the mirror lens. Catoptric means reflecting light and dioptric means transmitting light. The "mirror" lens uses both of these systems to get the image to the film. The first element focuses the image on the back mirror which then reflects that image onto a second mirror attached to the center of the front element. This sends the image back through a different lens element near the back of the lens that focuses the image on the film plane.

It has a length of 13", a fixed aperture, no meter coupling, a filter size of 122mm, an angle of view of 4 degrees, a weight of 59oz. The 500f5 is not easily hand held because of this size. It has a built-in tripod mount allowing 90 degree turns of the camera for vertical shooting. 39mm filters must be attached on the back of the lens at all times to have accurate focus. The filters that came with the lens were L39, Y53, O56, R60, ND. The exposure is changed by shutter speed or by the addition of ND filters. With a minimum focusing distance of 50', the lens did not sell well. It was, however, a nice lens as far as sharpness goes.

The 500f5 is where "doughnut" highlights caused by mirror lens design first appeared. The highlights are caused by the mirror attached to the front element. As light enters the lens, it's bent around that mirror causing the black hole or "doughnut" shaped highlight. There is nothing that can be done to eliminate the highlight other than be aware of the background, using it to hide or eliminate the highlights.

Nikon did not rest on its laurels for long, coming out with more lenses in **1964** to help round out the lens line. The new additions were:

55f3.5 Micro
85f1.8
300f4.5
600f5.6
800f8
1200f11

The **55f3.5 Micro** is only slightly different from the earlier compensating model. The original model was discontinued with the introduction of the this macro lens. This 55mm does not compensate (must be done manually) and the optical formula was changed from the 55f3.5 compensating. The new 55mm has slight a modification in the air

gap between element groups. All measurements and dimensions are the same. There is one cosmetic change in that the new model has a rubber focusing ring. The lens attains 1:2 by itself. An **M2 ring** is required to achieve 1:1 magnification. At the time of introduction, it was proclaimed the sharpest lens for general photography available, not losing any sharpness when focused down to 1:1. It was said to have better resolving power across the whole plane of focus than the finest grain film could hold. The lens does have magnification and exposure compensations etched on the barrel for ease of operation. This model 55 would soon receive multicoating; the cosmetics remained the same.

The **85f1.8** from the first was a widely accepted lens. It was bought for its focal length and lens speed and is still widely sought after today. An extremely sharp lens with excellent edge to edge quality in a small package, this is one of Nikon's truly great lenses that would not be surpassed until the 85f1.8 AF was introduced 23 years later. It has a length of 4", an aperture range from f/1.8 to f/22, meter coupling, a filter size of 52mm, an angle of view of 23 degrees, a weight of 15oz. It is easily hand held even at slow shutter speeds because of its compact size. It went through only one major cosmetic change when the chrome barrel was made all black and the metal focus ring became rubber. Sadly it was discontinued in 1977 and never was sold as an original AI although thousands have been converted to AI, a testament to its popularity.

The first **300f4.5** started the long dynasty of Nikon's 300's. It has a length of 8", an aperture range from f/4.5 to f/22, metered coupling, a filter size of 72mm, an angle of view of 6 degrees, a weight of 35oz. It's easily hand held, even at slower shutter speeds because it's so well balanced. It doesn't have a moveable tripod collar, but has two tripod sockets permanently attached to the barrel for vertical or horizontal shooting. It has a built-in shade, sliding out to provide adequate flare protection. The design did not change except for minor cosmetic changes until 1977 when the AI version was released.

The **600f5.6, 800f8** and **1200f11** were the beginnings of today's dynasty of telephotos. These "Super Telephotos" were quite innovative in design and application and they were very popular. The three focal-element units are attached to a focusing unit, the original being the **CU-1**. The three separate front-element units screw in and out

of the CU-1, enabling the body to be attached to the CU-1 while changing the focal length in use.

The CU-1 has an automatic diaphragm with an aperture range of f/4.5-f22. It can be manually closed down to f/64 with the 800 & 1200 but in either case, stop down metering must be employed. These lenses are as physically long as their focal length, so they can by no means be hand held. A special attachment, the **Cradle**, later came with the CU-1 to facilitate use on a tripod. The lenses are very sharp with excellent color and contrast, but their physical size makes them very hard to manipulate. Another disadvantage is their lack of meter coupling. The CU-1 was later discontinued and the **AU-1** introduced. It does the same job but has a more modern design and a 52mm built-in filter drawer.

Lens	Filter Size	Angle of View	Weight (element only)	Length (w/CU-1)
400f4.5	122mm	6 degrees	66.8oz	18.3'
600f5.6	122mm	3 degrees	84oz	20.6"
800f8	122mm	2.3 degrees	80.8oz	28.4"
1200f11	122mm	1.4 degrees	123oz	36.5"

In 1966, a **400f4.5** was added to complete the line. All these lenses can easily be used at their maximum aperture retaining excellent quality, although closing them one to two stops will give maximum sharpness. In 1975 the 600, 800 and 1200 where converted to an ED edition. The ED versions were quickly snatched up and are now hard to find. The ED editions are absolutely outstanding. With the advent of EDIF lenses in 1978, this line of lenses was discontinued, and today they are very hard to find.

In **1965** Nikon introduced five new lenses to round out their original lens line. Three saw action instantly as photojournalists assigned to the Vietnam conflict found them extremely well suited for their work. The lenses were:

35f2
55f1.2
135f2.8
50-300f4.5
1000f11 Mirror

The **35f2** was the fastest wide angle lens offered by Nikon at the time and was quickly adopted by photojournalists. Its compact design greatly helped its popularity. It has a length of 2.5", an aperture range from f/2 to f/16, meter coupling, a filter size of 52mm, an angle of view of 53 degrees, a weight of 10oz. Its sharp picture quality and solid contrast made it a hit. Its angle of view of 53 degrees took it far enough away from a normal lens that many photojournalists called the 35f2 their normal lens.

The **55f1.2** was the fastest Nikkor available, with a maximum aperture of f/1.2. It permits shooting wide open without any loss in quality. It was well accepted by photographers, particularly because of the fast f/stop, but especially its quality kept it popular. It has a length of 2.5", an aperture range from f/1.2 to f/16, meter coupling, a filter size of 52mm, an angle of view of 36 degrees, a weight of 14.8oz. This lens is known to have a sharper center than edges so is not recommended for use reversed on a bellows or in copy work. It went through several cosmetic changes, the last models having a rubber focus ring. It is the last model that is the most popular and sought after today.

The **135f2.8** made quite an impact. It was a fast telephoto in 1965, making it very popular. It has a length of 4.25", an aperture range from f/2.8 to f/22, meter coupling, a filter size of 52mm, an angle of view of 15 degrees, a weight of 21.9oz. Closing down just one f/stop to f/4 provides its best performance, but it isn't a lens noted for picture quality. It has a built in lens shade that locks into place by screwing into place, true whether in use or back for storage. An interesting thing about this lens is that it did not change cosmetically until immediately before a whole new model came out in 1977. In a very limited run, the 135f2.8 came out all black with rubber focusing ring and multi-coated. This is a very rare version. This lens is not recommend for any type of close-up work because the corners suffer with close focusing.

The **50-300f4.5** is a big lens that had its moment of fame because it was the only 6x zoom (6x focal length in one zoom) on the market. In its original model, it was said that at the 300mm end of the zoom, chromatic aberrations (a problem many worried about then) were virtually elimi-

nated giving excellent resolution and contrast. Making a lens containing normal to telephoto focal lengths created a large package. It has a length of 12.5", an aperture range from f/4.5 to f/22, meter couping, a filter size of 95mm, an angle of view of 25 to 4 degrees, a weight of 5.1lbs.

It is a two ring zoom, one ring focuses, one ring zooms. It is a true zoom, and can be focused on a subject and zoomed back and forth without loss of focus. It can also focus to 8.5 feet which was good in its time. It has a built-in tripod collar that allows for 360 degree rotation. It also has two strap lugs permitting carrying to avoid stress on the body lens mount. It went through a few cosmetic changes over the years, being refined each time. There are many photographers still using this old lens and getting outstanding results!

The **1000f11** is Nikon's second mirror lens, optically constructed just as the 500f5 but with a longer focal length. It has a length of 9.75", a filter size of 108mm (no threads for filter), a fixed aperture of f/11 (stop down metering required), an angle of view of 1.2 degrees, a weight of 4.2lbs. Some say they can hand hold this lens, but it's best to put it on a tripod.

Its optical performance is improved compared to the 500f5, as it focuses down to 26 feet and delivers a sharper image. It has a filter turret in the rear like that of the 8mm fisheye containing four filters, the L39, Y48, O56 and R60. It has a tripod collar allowing for either vertical or horizontal photography and a reversible front lens shade. The lens is well corrected for high resolution and good contrast with minimized "doughnut" highlights because of the small aperture. Depth-of-field is good because of its small f/stop. Popular even today, this lens has only been changed once, and that was the replacement of the filter turret with the 39mm screw-in filter system at the rear.

Two years passed until **1967** before any new lenses were seen from Nikon, and then it was only two. They were:

7.5f5.6 Fisheye
24f2.8

The **7.5f5.6 Fisheye** is similar to the 8f8 Fisheye. Like the 8mm, it requires a camera with mirror up function and utilizes an auxiliary finder to frame the photograph. It has the same built in filters in a turret as the 8mm and the same angle of view, 180

degrees. The 8mm had been discontinued in 1966 and this lens served as its replacement.

Nikon's **24f2.8** was to become a staple for photographers for decades to come. It's a very compact wide angle, adding to its popularity. It has a length of 2.75", an aperture range f/2.8 to f/16, meter coupling, a filter size of 52mm, an angle of view of 74 degrees, a weight of 10.2oz. This was the first lens to incorporate **Close Range Correction** (CRC). This floating-element design is coupled to the focusing ring and provides automatic realignment of elements as the lens is focused closer. It results in outstanding corner-to-corner image quality.

The 24f2.8 is excellent wide open with optical quality barely changing when closed down. This is a popular lens to use on a bellows or reversed and is best at f/8. The 24f2.8 went through many cosmetic changes through the years, from the original chrome barrel to the newer rubber focusing ring design. The 24f2.8 is probably one of the best selling lenses Nikon has ever designed and one that every Nikon owner has had at least once.

It was not until **1969** that Nikon released new lens designs, but what a new group they were! This group of lenses could be categorized as "specialized " because of their applications. The lenses were:

6f2.8 Fisheye
10f5.6 OP Fisheye
20f3.5
45f2.8 GN
105f4 Bellows
500f8 Mirror
2000f11 Mirror

There was never a lens like the **6f2.8** fisheye before 1969. Still in production, it is truly a remarkable achievement in optical design. It has a length of 6.75", an aperture range from f/2.8 to f/22, meter coupling, a weight of 11.5lbs, and a front element 235 millimeters across! Not only is the size of this lens big, but so is its coverage, 220 degrees! The lens was originally developed for special applications in meteorological and astronomical research (as were most fisheyes). It also served environmental and architectural design applications. A further use is in quality control for such things as pipes, boilers, and other constricted areas where any other lens could not be employed.

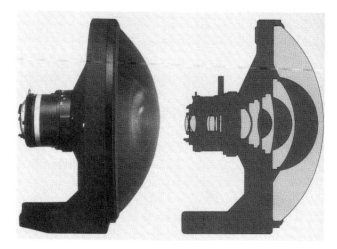

Fisheye-Nikkor 6mm f/2.8.

Because of the 220 degree coverage, it can literally see behind the photographer, thus creating the danger of accidently getting one's feet in the picture. It comes with a special lens cap made of leather that fits around the element and then snaps into place with two snaps on the back of the element barrel. It has filters (L1A, Y48, Y52, O56, R60, XO) built into a turret, with no means for front element filtration. It also comes with a special wood lens case. This is the only fisheye at this time that will meter couple and that is SLR. The first photograph I ever saw taken with this lens was at a Nikon School of Photography class, where they had a grasshopper resting on the front element with it and everything else in the picture totally sharp—it's an amazing lens! This lens went through no changes and is still available from Nikon, but it's not cheap!

The **10f5.6 OP** Fisheye was another fisheye lens designed with the scientific community in mind. It's not an SLR lens, but has the same design as the 7.5mm and 8mm with the rear element sticking into the camera body. It has the same accessory finder with 160 degrees coverage and built-in filters in a turret as the 7.5 and 8mm. It's just a little larger than the other two fisheyes. It has a length of 4.25", an aperture range from f/5.6 to f/22, stop down metering, no front filter, a weight of 14.1oz.

What makes the 10f5.6 OP special is the Orthographic Projection (OP) element formula. Orthographic Projection (aspherical) means that the lens gives even exposure throughout the image including any point light source. In comparing photographs taken with the 10mmOP and the 7.5mm or the 8mm, the 10 OP will have an even blue sky where as those taken with the 7.5mm or 8mm will have a light band of blue above the rest of the blue sky. All three of these fisheyes have the a coverage of 180 degrees, but the 10 OP is the nicest of the three, being sharper and cleaner in the final image. There would be only one other Nikkor lens to receive an aspherical lens design, the 58f1.2 Noct.

The **20f3.5**, the widest, non-fisheye lens, got the photographic world very excited. It provided a whole new perspective in picture taking while providing through-the-lens viewing. The 20f3.5 is a large lens, bigger than any other wide angle at the time. It has a length of 2.75", an aperture range from f/3.5-22, meter coupling, a filter size of 72mm, an angle of view of 83 degrees, a weight of 13.8oz.

What is amazing is that the 20f3.5 has 2 degrees wider coverage than the 21f4. This is because the 20f3.5's rear element is flush at the lens mounting flange where that of the 21f4 is only 5mm away from the film plane. The 20f3.5 was called a retrofocus design because it did not need the mirror locked-up to mount the lens. This term is no longer used because no lens has since been manufactured that needed the mirror locked-up.

The **45f2.8 GN** (**G**uide **N**umber) was an ingenious lens, incredibly sharp and amazingly small. It has a length of 20mm (3/4"), an aperture range from f/2.8 to f/32, meter coupling, a filter size of 52mm, an angle of view of 42 degrees, a weight of only 5oz. The 45GN was designed to make flash photography easy and quick, solving the problems of correct exposure automatically. It was designed before flashes had the ability to take care of exposure via their own sensors or those in the camera.

The way the lens worked is so simple, it's surprising that there were not more models manufactured. Activating the 45GN requires matching up the Guide Number of the flash (printed on the aperture ring 180 degrees opposite of the aperture numbers) with the coupler attached to the focusing ring, and pushing the coupler into place. This coupler locks the focus ring to the aperture ring. When the lens is focused, the aperture will turn in concert, changing the f/stop of the lens for the correct flash exposure. It's so simple and so accurate! This was particularly popular with wedding photographers because exposures were accurate on every frame.

The 45GN is great to use on a bellows. Its four element design, though not called flat field, provides the quality of a flat field lens. It's an excellent lens for close-up photography when attached to a bellows, with a decent working distance. It also has a minimum f/stop of f/32 for excellent depth-of-field (not recommended past f/22 though). The 45GN is still used by photographers today for slide copying, even though it's been discontinued since 1977. It never came out in an AI version, but many have been converted to AI. The shade for the 45GN (no number was ever given to it) is one of the oddest shades Nikon ever made. The shade is 52mm across, but cuts straight-flat in over the top of the lens, with a small hole in the center for viewing. A unique style of shade!

The **105f4 Bellows** lens is still widely used, having applications that many photographers find appealing long after its discontinuation. This lens was designed specifically for use on the PB-4 and PB-5 Bellows but works on any bellows. It focuses from infinity to 1.3x. The lens has no focusing helicoid of its own, relying on the extension or contraction of the bellows to focus. It has a length of 2", an aperture range from f/4 to f/32, stop down metering, a filter size of 52mm, an angle of view of 19 degrees, a weight of 8.1oz. It is a preset lens, having no automatic diaphragm linkage. The aperture does have aperture click stops every 1/3 stop (the only Nikkor which does) for presetting exposure.

The 105 Bellows lens is extremely sharp, and though not a flat field design, it does render outstanding sharpness from corner to corner. On the bellows, it has an excellent minimum focusing distance of 6" at maximum magnification. Another very popular use for the 105 bellows (often called the short mount 105) is attaching it reversed to a 200f4 via an off brand 52-52 thread adapter. This combination produces a 7x magnification with a working distance of 4". For optimum results, set the aperture on the 105 bellows wide open and do not close down the 200f4 past f/16.

The **500f8 Mirror** is a completely new design from the 500f5. It has been slimmed down in size from the 500f5. It has a length of 5.6", fixed f/8, stop down metering, a front attachment size of 88mm (no filtration possible), an angle of view of 4 degrees, a weight of 2.2lbs. Besides the much smaller lens, the minimum focusing distance is considerably less at 13' compared to 50' of the 500f5. The 500f8 maintains the same filter system, rear mounted 39mm screw-in filters, one having to be in place to complete the optical formula. This lens can be hand held, but it does have a tripod collar with a click stop for vertical or horizontal shooting. Like the 500f5, the 500f8 still has the drawback of "doughnut" highlights. When purchased new, it comes with a case. In the lid of the case are the four filters for the rear mount.

The **2000f11** was the largest lens ever manufactured by Nikon. Its power is equivalent to that of a 40x telescope, or 40 times the power of a 50mm lens. It has a length of 24", an aperture fixed at f/11, stop down metering, a front element approximately 250mm, an angle of view of 1 degree, a weight of 16.5lbs. Filtration is achieved by four filters in a turret that requires the turning of a knob to change. L39, Y48, O56 and R60 filters are supplied with the lens. It comes in a cradle/turret that looks like a machine gun mount which adds another 7lbs to the lens and mounts onto a tripod (this cannot be hand held). The lens also has a built-in, stationary hand grip on top of the lens barrel. The lens mount rotates with click stops for vertical and horizontal shooting and is well suited for astronomical photography. This is a rare lens.

Four lenses were introduced in **1970**, three of which were to become legendary and would become mainstays in the world of photography for the next 20 years. The lenses were:

8f2.8 Fisheye
35f1.4
180f2.8
80-200f4.5

Nikon introduced the **8f2.8 Fisheye**, a SLR lens riding in the wake of a seven year popularity for the "Fisheye" look. Of all Nikkor fisheye lenses, the 8f2.8 Fisheye is the only one that is really usable and practical in the field. It is easily hand held. It has a length of 5", an aperture range from f/2.8 to f/22, meter coupling, a front attachment 122mm (no filtration possible), an angle of view of 180 degrees, a weight of 2.2lbs. Not only is it three/four stops faster than the 7.5mm, 8mm or 10 OP, but it is also SLR, permitting viewing through the lens when shooting.

This is very important with a lens this wide. Non-SLR fisheye photographs usually contained unwanted elements in the picture which this ver-

sion eliminated. The 8f2.8 has a built-in filter turret with L1A, Y48, Y52, O56 and R60 filtration and comes with a metal lens cap. The lens focuses to 1', and when focused at this range, makes for extremely easy emphasis of the foreground. It also has an equidistant projection formula for even exposure and excellent sharpness. It still produces a circular image, but straight line rendition can be achieved in the center of the picture if care is taken in placement of the horizon.

The **35f1.4** made photojournalists ecstatic with its introduction. It was the first Nikkor lens to be introduced originally with multicoating. It has a length of 2.75", an aperture range from f/1.4 to f/22, meter coupling, a filter size of 52mm, an angle of view of 53 degrees, a weight of 14.6 oz. It ended up replacing the 50f1.4 for many of the photojournalists as their standard lens because of its compact size, speed, and sharpness. Another great feature of the 35f1.4 is the floating element design (CRC) for extreme sharpness from corner to corner, even when focused down to 1' (closest focusing distance). The first design had an all metal focusing ring, but later had a rubber focusing ring.

There have been very few lenses as popular as the **180f2.8** in the Nikon line. This incredibly sharp lens earned its reputation for greatness from the start. Because of the optics required to make a fast telephoto, the 180f2.8 is not a small, compact lens. It has a length of 5.6", an aperture range from f/2.8 to f/32, meter coupling, a filter size of 72mm, an angle of view of 11 degrees, a weight 29.3oz. It also has a built-in shade that pulls out for use. The original five element design continued throughout the entire production life of the lens, as well as in the later ED version. It is believed that the early version of the 180 had a front element of ED glass not announced by Nikon. This is possible since it has the same incredibly sharp quality as the ED version.

The **80-200f4.5** is the zoom to which all other zooms would be compared for the next 11 years as a standard of quality. It is very easily hand held. It has a length of 6.4", an aperture range from f/4.5 to f/32, meter coupling, a filter size of 52mm, an angle of view of 25 to 10 degrees, a weight of 29.3oz. It is a push-pull zoom, 200mm at the rear, pushing out to 80mm. A true zoom, it holds its focus while zooming (as long the focusing ring isn't moved) and maintains a constant f/stop at all focal lengths. The sharpness of the 80-200f4.5, even

wide open, is excellent, no matter which version. It is not recommended with a teleconverter, as the edges especially lose sharpness. The original non-multicoated version was later replaced with a multicoated one. Both versions are extremely sharp, but the multicoated version renders better color.

In **1971** Nikon continued their line of "fast" wide angles with the introduction of only one lens. The lens was:

28f2

The **28f2** never reached the fame of the other fast wide angles. As with the 35f1.4 and 24f2.8, the 28f2 has the floating rear element (CRC) for superior sharpness even when close focused. The 28f2 was the second lens originally introduced with multicoating, which gave the lens its great contrast and color rendition. It has a length of 2.7", an aperture of f/2 to f/22, meter coupling, a filter size of 52mm, an angle of view of 64 degrees, a weight of 12.2oz. Although popular at first, the 28f2 never attained the reputation it deserves. An excellent lens, its ability to focus close (down to 1') with its shallow depth-of-field and wide angle of coverage made it a natural for most photojournalists but it never caught on with the general public. Originally, it came with a metal focusing ring, which was replaced with a rubber one prior to AI.

In **1972** Nikon introduced only one lens and it was to be the last new circular image fisheye. The lens was:

6f5.6

The **6f5.6** is the pudgiest model of all the fisheyes. It has the same design as the 7.5mm, 8mm and 10mm OP with its rear element extending into the camera body. It differs from the others in that it has a coverage of 220 degrees (but still uses the 160 degree finder) as opposed to the 180 degrees of the others. It has a length of 1.7", an aperture of f/5.6 to f/22, stop down metering, an attachment size of 89mm (built-in filters), an angle of view of 220 degrees, a weight of 15.2oz. It also employs the equidistant projection formula for even exposure over the entire 220 degree coverage. This is one of the rarer lens, not often found on the used market. It is a very compact lens and delivers excellent quality. Its biggest drawback is its wide coverage

with no way of viewing the final picture. The auxiliary finder is 60 degrees short of the lens, which makes accurate composition impossible.

In the early 70's Nikon began to release all of their new lenses with multicoatings and updated existing lenses with multicoating. The application of multicoating and the compounds used in these coatings are a trade secret. Nikon gave this process a new name, **Nikon Integrated Coating** (**NIC**), which means the coatings are part of the optical design. The coating(s) are an integrated part of the optical formula so that the lens is constructed as a whole unit, glass, grinding and coatings combined. When a particular lens is designed, all air-surfaces are examined and analyzed. A coating is chosen for each element. This can be the same for all elements or different, depending on the lens design.

This system is very important for color photography. The major benefit in using Nikon lenses is that no matter which lens is used, all deliver the same color rendition of the scene. Being able to change lenses and maintain such standards is a mark of quality. Lenses manufactured after this time have the NIC coatings, making possible many of the later "radical" designs otherwise not possible.

The three exciting lenses were added to the inventory in **1973** by Nikon were:

15f5.6 Ultra Wide
16f3.5 Full Frame Fisheye
400f5.6

The **15f5.6** is Nikon's first Ultra Wide with the widest angle of view (other than fisheyes) to be manufactured up to this date. It is a special lens with new technology that makes it a legend in lens design. It has a length of 2.7", an aperture range from f/5.6 to f/22, meter coupling, an angle of view of 110 degrees, no filter attachment (filter turret), a weight of 19.8oz. This is a particularly sharp lens with linear dimension the same as that of a 50mm lens. That means it has straight line rendition, and horizontal and vertical lines stay straight in relation to each other, neither curved nor distorted.

The lens has been a favorite of many magazine photographers since its introduction. It can photograph a subject in the foreground, maintain the background in focus while preserving all linear relationships. The lens uses a filter turret with L1A, Y48, O56, R60 installed. These are in a ring that encompasses the entire lens. A lock must be depressed to turn the turret. One bothersome feature of the 15f5.6 is the focusing ring which is around the large portion of the lens barrel. Its narrow width makes use difficult. It can be slow and awkward to use, especially when working fast or wearing gloves. Because of the lens' angle of view, no shade can be attached, but there is a built-in scalloped lens shade that provides some shading. The photographer's hand can be used for extra shading if using a camera body with 100% viewing. This is also the best method to eliminate flare, which is a problem with ultra wides.

The **16f3.5** is a wonderful lens, a full frame fisheye with 170 degrees coverage. It has a length of 2.5", an aperture range from f/3.5 to f/22, meter coupling, an angle of view of 170 degrees, no filter attachment, a weight of 11.6 oz. The 16f3.5 accepts no front shade or filter, so a built-in a scalloped shade and a filter turret are provided. The filter turret is a new design, similar to the 15f5.6 design. The filters in the turret are L1A, Y48, O56, R60 but it is common to find this lens with filters other than those indicated. Many of these filters were modified by photographers for their particular needs. The most common modification is the installation of color correction filters for interior work.

The 16f3.5, although full frame, will distort the image. It is a fisheye, curving horizontal and vertical lines, especially those close to the lens. This can almost be neutralized if the horizon line is running through the center of the picture, keeping the horizon straight. Point the lens slightly up or down and the horizon will curve up or down. Figures can be rendered almost normal looking by keeping the horizon straight thus making the 16f3.5 excellent for photographs relating foreground with background.

The **400f5.6** telephoto has outstanding optics. Although some can hand hold it, it's best when used attached to a pistol grip or gunstock. It is not a small lens but is well balanced. It has a length of 10.5", an aperture range from f/5.6 to f/32, meter coupling, a filter size of 72mm, an angle of view of 5 degrees, a weight of 3.1lbs. It has a built-in lens shade and a tripod collar with 360 degree rotation for vertical and horizontal shooting. The focus throw (the amount the lens barrel has to be turned to focus from infinity to the minimum

focusing distance) of the 400f5.6 is quite long. This can cause problems photographing any sort fast action subject.

A later version of the 400f5.6 would be an "ED" model. It has a front element of "ED" glass and the distinctive gold band around the lens barrel. The original version was more than likely "ED" but lacked the gold band to acknowledge such. The correction of chromatic and other optical aberrations in the 400f5.6 resulted in outstandingly high resolution. It maintained excellent image contrast and sharpness even wide open, all of which are attributes of an "ED" lens.

In **1974** Nikon introduced nine new lens designs. It was one of the widest spectrum of lenses to be introduced at one time. The lenses were:

18f4
20f4
28f2.8
28f4 PC
35f2.8 PC
50f1.8
105f4 Micro
28-45f4.5
180-600f8 ED
360-1200f11 ED

The **18f4** added to Nikon's growing collection of Ultra Wides. It was good timing, as fisheyes were starting to lose their popularity, which left a gap that the ultra wides were filling. It has a length of 2.3", an aperture range from f/4 to f/22, meter coupling, a filter size of Series 9 (held in place by the shade HN-15), an angle of view of 100 degrees, a weight of 11.1oz. An excellent lens, its principal drawback is its corners are not as sharp as its center. It lacks CRC for close-up work. It only focuses down to 11.8" which is a disappointment. It's a great lens for getting into the world of ultra wides if found on the used market, where they sell for a fraction of their original cost.

The **20f4** (which replaces the 20f3.5) is an entirely new design. It is much smaller than the previous f/3.5 version. It has a length of 1.9", an aperture range from f/4 to f/22, meter coupling, a filter size of 52mm, an angle of view 94 of degrees, a weight of 7.4oz. This compact wide angle was very popular when first introduced because of its small size and relatively low price. Its sharpness is about the same as that of the 20f3.5, although some

thought the lens had lost more than just the 1/3 stop in the update. The 20f4 is excellent reversed, either on a bellows or attached to a 105mm lens.

The **28f2.8** was an intermediate design. It falls between the fast and more expensive f2 and the slower and less expensive f/3.5. This happy middle ground proved to be a popular design and was well received by most photographers. It has a length of 2.1", an aperture range from f/2.8 to f/22, meter coupling, a filter size of 52mm, an angle of view of 74 degrees, a weight of 8.5oz. It can focus down to 11.8", but it does not employ CRC, so the edges and corners are not as crisp as the center. Although not extremely sharp, the 28f2.8 produces photos good enough for reproduction. Cosmetic changes were few over its entire production.

The **28f4 PC** (**P**erspective **C**ontrol) is a noteable new lens design. The 28f4 PC lens barrel actually shifts, as the front element moves up to 11 degrees away from the film axis. This enables the photographer to maintain the camera back parallel to the subject while keeping the subject in the picture. It has a length of 2.7", an aperture range from f/4 to f/22, meter coupling preset, a filter size of 72mm, an angle of view of 74 degrees, a weight of 14.1oz. It can close focus to 11.8" which is wonderful for photographing miniatures and for those applications requiring perspective control.

Operating the 28PC is quite simple. Set the camera up on a tripod, then frame and focus on the subject. Next, tilt the camera body until the back of the camera (same as the film plane) is parallel to the subject. Using a level on the camera back assures proper alignment. This step causes subject cut off at the top of the frame. This is where the shift knob comes into play. Proceed to turn the shift knob on the lens. As it's turned, the subject will start to come back into alignment in the frame. Stop shifting when the top of the subject is entirely inside the frame. The subject is now perspectively correct in relation to the film plane and any distortion has been eliminated.

Note: Before shifting, it's necessary to meter via stop-down metering if the camera's meter is to be utilized. Set the preset at the desired f/stop once metered, and open the manual diaphragm all the way once metering is accomplished so focusing is possible during shift correction. When it's time to take the picture, close down the manual diaphragm to the preset setting.

Owing to limitations of the 35mm film for-

mat, there is only 11 degrees of correction possible when the camera is vertical and 8 degrees when horizontal. Shifting the lens ten degrees actually adds ten degrees to the angle of view, so the 28f4 PC will have 84 degrees of coverage making it equal to a 24mm lens. In addition to these features, the lens is very sharp and a real asset to any photographer desiring corrections of a large format camera in a small package.

The **35f2.8PC** works on the exact same principle as the 28PC. It has a length of 2.5", an aperture range from f/2.8 to f/32, preset, a filter size of 52mm, an angle of view of 62 degrees, a weight of 9.8oz. When the lens is shifted, its angle of view increases to 74 degrees. As its operation is the same as the 28PC, refer to notes above for operation.

The **50f1.8** has had more design and cosmetic changes than any other Nikon lens. The original design had the look and feel of lenses of that time. It has a length of 1.8", an aperture range from f/1.8 to f/22, meter coupling, a filter size of 52mm, an angle of view of 46 degrees, a weight 7.7oz. The original design had an all black barrel with a rubber focusing ring. When the AI version was introduced, the lens was slimmed down slightly.

The **105f4 Micro** is an excellent, all-purpose macro. It's the culmination of design work begun with the 55f3.5 and the 105f4 Bellows lens. The 105f4 Micro can focus from 1:2 to infinity without a bellows or any other accessory. Hand holdable, the 105f4 is a medium sized lens. It has a length of 4.1", an aperture range from f/4 to f/32, meter coupling, a filter size of 52mm, an angle of view of 23 degrees, a weight of 17.6oz. The 105f4 has a built-in shade and when focused at 1:2 the lens is 6.7" long.

The 105f4 has a greater subject-to-lens working distance than the 55f3.5 when at 1:2, 9 inches compared to 3 inches. It's just as sharp though from corner to corner. Like the 55mm, it has color coded depth-of-field and magnification scales on the barrel for normal application or use with an extention tube. The matched extension tube (PN-1) is required to go to 1:1 magnification. With wear, the focus can loosen and cause slippage when working at a specific magnification ratio. To avoid the expense of a relube, tape or a rubber band may sometimes solve this problem. The lens changed only once during its production, but never became extremely popular.

The very nice **28-45f4.5** was the first wide angle zoom for Nikon. Even though its range is short (not even a 2x change in focal length), its size and quality made it very popular. It has a length of 3.6", an aperture range from f/4.5 to f/22, meter coupling, a filter size of 72mm, an angle of view of 74-50 degrees, a weight of 15.5oz. This is a two ring zoom, one ring for focusing, the other for zooming. The lens is quite sharp throughout its entire zoom range. It is sometimes hard to find in today's used market, probably because it tends to be a "keeper."

A beautiful lens, the **180-600f8 ED** has never been very common and remains hard to find, new or used. Hampered by its high cost and large size, it has regrettably not been used by many photographers. It is incredibly sharp. It has a length of 15.9", an aperture range from f/8 to f/32, meter coupling, a filter size of 95mm, an angle of view of 13 to 4 degrees, a weight of 7.6lbs. The second and fourteenth element are ED glass. In 1974 the f/8 speed was not a factor in its slow sales. But today, with speed so important, it has kept this magnificent lens from common use.

This lens marked the inauguration of a special, new optical glass invented and manufactured by Nikon. Extra-low Dispersion (**ED**) glass revolutionized optical technology by combining glass and coating. Telephoto lenses (300mm and longer) were said not to have the same crisp snap to their images as did the shorter focal lengths.

White light that our eyes perceive is made up of a multi-spectrum of colors. White light is split by the lens elements on its journey through the barrel to be put back to its constituent colors as it hits the film plane. This is called dispersion. In optical design, one element compensates for the dispersion caused by another element as light passes through it. This is usually done for just blue and red (the high and low end of the spectrum). With shorter focal length lenses dispersion is not a readily noticeable problem and there is no need for correction.

With 300mm or greater focal length telephoto lenses, element relationships cannot be arranged to correct for dispersion, so the blue band of light focuses past the film plane where all the other wavelengths are focused, with a resulting lack of critical sharpness. Some manufacturers have artificially grown crystals of calcium fluorite which solves this problem but they have the drawback

that they are sensitive to heat and humidity that can change the focus and/or sharpness of the lens.

The actual formula for ED glass is a guarded secret, but it is a specially manufactured glass with coatings that make long lenses with fast maximum apertures possible. The ED glass is physically very hard so it can be used as a front element. It is not sensitive to heat and humidity like the fluorite and can be used in severe environments with few problems. Lenses with ED glass have a gold band around the barrel to signify ED glass, usually on or near the focus ring. Lenses with ED glass are expensive, but their quality is unparalleled.

The **360-1200f11 ED** is a behemoth, the longest push-pull zoom in 35mm photography! It has a length of 27.7", an aperture range from f/11 to f/32, meter coupling, a filter size of 122mm, an angle of view of 6.5-2 degrees, a weight of 15.7lbs. It's a very large lens, exceeded only by the 2000mm at 38lbs. It has ED glass (second and fifteenth elements) which contributes both to the incredible image quality and to its high price tag (suggested list in 1984 was $7800). It also has a special tripod collar design (cantilevered) for superior balance for both vertical and horizontal framing. The lens is supplied with four handles for quick focus and zooming. An important feature of this lens is that it can focus down to 20 feet. That's outstanding for such a long lens. The number of owners of this lens world wide would probably fill a small room, but those few privileged individuals have an outstanding lens.

Nikon introduced six new lenses in **1975**, only one of which was a really new design with the other five being revisions. The lenses were:

300f2.8 ED
300f4.5 ED
400f5.6 ED
600f5.6 ED
800f8 ED
1200f11 ED

From its introduction, the **300f2.8 ED** became a very sought after lens by the photographic community. This fast lens came at a time when photographers were demanding faster lenses for greater available light photography as well as the isolation of a limited depth-of-field. It has a length of 9.9", an aperture range from f/2.8 to f/32, man-

ual meter coupling, a filter size of 122mm, an angle of view of 8.1 degrees, a weight of 5.7lbs. This lens is heavy for one with only six elements. It has a built in lens shade that pulls out and a tripod collar for vertical and horizontal shooting. The aperture is a preset design which makes for very slow operation. It requires stop-down metering or the use of a hand held meter. With the ED glass, the 300f2.8 is sharp at f/2.8 which makes it a stand out with press photographers. This is one of the Nikon's rarer lenses, and is rarely seen on the used market.

The **300f4.5 ED** is an ED version of the 300f4.5 AI. The front element is ED glass which adds 2oz to the original version. In all other aspects, the 300f4.5 ED has the same specs as those of the 300f4.5 but with a higher price tag. This lens was produced for just one year. Some can be found on the used market, but for the money the non-ED version is a better buy.

The **400f5.6 ED** is the same as the 400f5.6 released a year before except it now has an ED glass front element with a few minor cosmetic changes. If photographs from the two 400f5.6's were to be compared, little difference would be found which led many to believe that it was an ED lens from the start. Nikon has never confirmed this conclusion, but either version is outstanding, whether marked with the gold band or not.

The **600f5.6 ED**, **800f8 ED** and **1200f11 ED** are revisions of the earlier front elements. They still need focusing units to work and still lack meter coupling. But they now have ED glass. Excellent before ED glass, they are now outstanding! The elements changed little from the original versions The 600f5.6 lost 0.2 lbs, the 800f8 gained 1.3 lbs and the 1200f11 gained 1.4 lbs. All of these lenses have just 5 elements except the 1200f11 ED where two elements were combined into one group in the new versions. These are extremely rare lenses and make an excellent introduction to telephoto photography.

In **1976** only two models were introduced. The lenses were:

13f5.6
135f2

The **13f5.6** Ultra Wide, the widest of wide angle lenses, covers 118 degrees! This is not a small lens. It has a length of 4", an aperture range

from f/5.6 to f/22, an attachment size 115mm (no threads), meter coupling, an angle of view of 118 degrees, a weight of 43.7oz. Like the 15f5.6, the 13mm has a built-in scalloped lens shade (the photographer's hand still works great for additional shading), a floating rear element design (CRC), a rectilinear element design for straight line rendition, and can focus down to under one foot. A new feature of the 13mm is that it accepts 39mm bayonet filters. Unlike those in the turret system, these are bayoneted to the rear of the lens. It still cannot be polarized nor be used without a filter in the rear, but now there is a choice of filtration for differing needs. The ability to focus to 11.8" and its tremendous angle of view and depth-of-field deliver an entire world in focus. This is a lens that must be seen and used to be believed!

The **135f2** is a magnificent lens which became instantly popular with photojournalists because of its focal length and speed. It has a length of 4.1", an aperture range from f/2 to f/22, meter coupling, a filter size of 72mm, an angle of view of 18 degrees, a weight of 30.3oz. It's a clean and simple design that delivers outstanding performance. Over the years of production it has not even changed cosmetically. Nikon did it right the very first time.

In **1977** Nikon introduced a whole new metering system for all their lenses and bodies. **AI** (Automatic Indexing) would be on every lens and body to be released from this time forward. This makes for rapid lens changing while shooting (refer to body chapter for specifics). All the lenses in production in 1977 were changed to the AI system and received cosmetic changes at the same time.

Some lens' cosmetic changes were so slight that it is difficult to notice the change. Others, such as the 135f3.5, 135f2.8, and 200f4 changed radically, becoming much smaller and slimmer, losing their metal focusing ring. This smaller size made them attractive to users. All the lenses now had all-black barrels, rubber focusing rings, and multicoating. Nikon was able to effect all this change without modifying the bayonet F mount. Also retained was the non-AI metering prong on the new AI lenses, affording owners of older bodies the use of the new optics while maintaining meter coupling. Lenses that had a fixed aperture or were preset in design remained the same since they are not capable of metering coupling.

The lenses still in production that became AI were:

6f2.8 Fisheye	35f1.4	135f3.5
8f2.8 Fisheye	35f2	180f2.8
13f5.6 Ultra Wide	35f2.8	200f4
15f5.6 Ultra Wide	50f1.4	300f4.5
18f4	50f1.8	400f5.6 ED
20f4	55f1.2	43-86f3.5
24f2.8	55f3.5	80-200f4.5
28f2	105f2.5	50-300f4.5
28f2.8	105f4 Micro	180-600f8 ED
28f3.5	135f2	55f1.2
360-1200f11 ED	135f2.8	

These lenses, as well as the PC, Mirror, Medical, and five new lenses made up the entire lens line for Nikon in **1977**. The new lenses were:

85f2
400f3.5 EDIF
600f5.6 EDIF
1000f11
200-600f9.5 ED

The **85f2** never seemed to catch on with Nikon users. It was intended to fill the shoes of the discontinued 85f1.8 which it really couldn't do. It has a length of 2.4", an aperture range from f/2 to f/22, meter coupling, a filter size of 52mm, an angle of view of 28 degrees, a weight of 15.2oz. It came with a reversible shade, the HS-10, which mounted backwards for easy storing. The lens never changed in design or cosmetics during its production run. It's one of the Nikon lenses that is not highly regarded.

The **400f3.5 EDIF** was, at the time of its release, the fastest 400mm on the market. It was the first Nikon to be released with **IF** (Internal Focusing) which revolutionized telephoto lens design. It has a length of 10.4", an aperture range from f/3.5 to f/22, meter coupling, a filter size of 122mm, an angle of view of 6.10 degrees, a weight of 5.7lbs. The first and second elements are ED glass.

The 400f3.5 EDIF has a built-in tripod collar for full 360 degree rotation as well as a built-in lens shade. The tripod collar has two strap lugs to accept a neck strap, preventing the camera's lens flange from bearing the weight of the lens when being carried. The lens also has a filter drawer, accepting 39mm screw-in filters. There is no 39mm

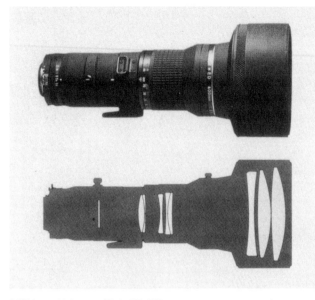

Nikkor 400mm f/3.5 IF-ED.

polarizing filter made for this filter drawer. A polarizing gel can be used in the Gel Holder supplied with the lens but it's not a quick or easy alternative. 39mm screw-in filters have a special filter mount, the glass actually being 37mm in diameter. A standard off-brand 39mm filter will not fit in this filter drawer because its mount does not taper to the correct proportions.

The Internal Focusing (IF) technology is an internal, mechanical focusing operation. Normal lens construction consists of a helicoid, a large, heavy threaded assembly in which the elements are moved back and forth by the turning action of the focusing ring (like turning a bolt into a nut). The lens expands and contracts with focusing because of the helicoid. With an IF lens, the barrel does not expand or contract, as there is no helicoid. The elements move internally in relation to each other and the film plane. This means a smaller, quicker focusing lens, that can actually focus closer than a non-IF lens. The 400f3.5 EDIF is not small, but it's smaller than the 400f4.5 lens. The IF design also permits it to focus two feet closer than the older lens.

The EDIF lenses all have in common a unique feature, a focus preset. On a small ring just above the focusing ring is silver locking knob. This is the focus preset which works very simply. For example: if photographing a baseball game and sitting behind home plate, focus can be preset on second base. This is performed by focusing on second base then turning the preset focus ring locking it into

place. While photographing the game, the focus ring will probably go past the preset point a couple of times and the lens will click past the spot. This is normal and will not effect the operation of the lens. When the steal happens at second base, turn the focusing ring until it clicks into place at the preset. This enables the capturing of the play fast and tack sharp.

The **400f5.6 EDIF** is a magnificent lens that's more than just an IF version of the earlier 400f5.6. It is an amazingly sharp lens when used wide open. It has a length of 10.2", an aperture range from f/5.6 to f/32, meter coupling, a filter size of 72mm, an angle of view of 6.1 degrees, a weight of 42.3oz. The second element is the only ED glass element. This can be a hand held lens, especially when used with a pistol grip or gunstock. Because of its light weight and remarkable balance, using it on a gunstock enables a photographer to work with shutter speeds as low as 1/30 second. This lens never received due credit from photographers because of its speed. The photographers who do own and use this lens know it's one of Nikon's best.

The **600f5.6 EDIF** is designed with all the attributes described above. This is another "sleeper" lens ignored by most photographers because of the slow aperture. It has a length of 31.8", and aperture range from f/5.6 to f/22, meter coupling, a filter size of 122mm, an angle of view of 4.1 degrees, a weight of 5.3lbs. The first and second elements are ED glass. The 600f5.6 EDIF is an extremely sharp lens even wide open and it focuses to 18 feet. This is the best choice for the photographer who wants to own an excellent telephoto for little money. There are many on the used market which can be purchased at a reasonable price compared to the price of a new lens.

The **1000f11** was redesigned to modernize the cosmetics and sharpen the optics. It has a length of 9.5", an aperture of f/11, fixed meter coupling, a filter size of 39mm screw-in, an angle of view of 2.3 degrees, a weight of 67.1oz. The filter turret is no longer present, using rear mount 39mm screw-in filters instead, which makes the lens much sleeker. The shade is built-in, pulling out into place for use which is much more convenient than the original model. The lens also has a rapid focus handle which can be attached for quick focus. The tripod collar has a full 360 degree rotation for vertical and horizontal shooting. The sharpness is improved,

Nikon

LENS MANUFACTURING PROCESS

TEXT & PHOTOS COURTESY OF NIKON

At Nikon the lens manufacturing process begins with the creation of the most basic of all lens components–the optical glass used to make individual lens elements.

Properties of optical glass

Optical glass differs from regular glass in the following ways:

1) It must be absolutely transparent and colorless.

2) It must be homogeneous, i.e., free of bubbles and striae (filaments of imperfections), and free of internal stress.

3) It should be strong enough to resist scratches or the corrosive effects of chemicals and stable even if exposed for long periods to strong light.

4) Its refractive index and dispersion must meet specifications exactly.

Raw materials

The basic ingredient of glass is silica or sand, the most abundant substance on earth: silica consists primarily of silicic acid. To this, potassium carbonate, barium and lead oxide are added. After iron oxide has been removed, the silica is pulverized and then mixed with additional chemicals to give it its distinctive optical properties.

Continuous melting method

The most up-to-date, energy efficient and pollution-free method of producing optical glass is the electrical continuous melting method. The big advantage of

Lens axis inspection.

this process is that large quantities of exceptionally high quality glass–virtually free of bubbles and striae–can be produced fast and economically.

The continuous melting method takes advantage of the special electrical properties of the glass raw materials, that is, at ordinary temperatures the materials are electrically non-conductive, but in the molten state they become highly conductive. First, the mixture of raw materials is fed into a large platinum-lined melting pond containing an electrode. Current, applied to an electrode then flows directly to the raw materials. Because of the electrical resistance encountered, tremendous heat builds up, which, in turn, causes the materials to melt. Then once melted and combined, the glass is easy to maintain in the molten state by applying a constant voltage. This method has numerous merits; among them are: 1) Very few striae occur because of less vaporization from the surface of the molten glass; 2) It's easy to create a temperature high enough to prevent bubbles and striae from occurring in the first place.

Finally, the molten glass is either poured out in a continuous stream to form a long bar or precisely controlled amounts are poured into molds for making individual lens blanks.

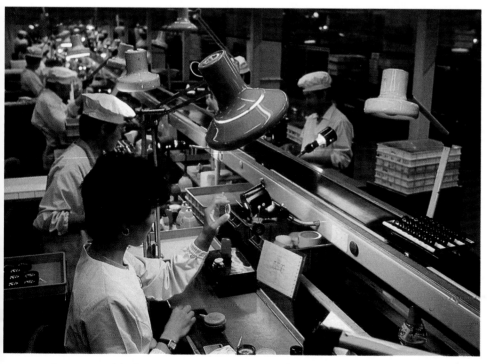

Lens assembly line.

Glass inspection.

Inspection

To insure uniformity, all Nikon optical glass is carefully checked to see that its optical properties, such as refractive index and dispersion, are up to specifications. Then it is examined minutely for bubbles, flaws (splits) and striae. Just because Nikon produces its own glass doesn't automatically insure its use in Nikkor and Nikon lenses. Only if it is free of all defects does the glass go on to the next step of lens manufacturing.

Because the flow of molten glass is so complex in nature, the electrical continuous melting method had formerly been considered too difficult to put to commercial use. However, at Nikon's glassworks, the flow is automatically controlled by computers as the result of extensive research using computer-simulation techniques and various field tests.

Pressing the glass

In the continuous melting method, in which molten glass is poured directly into molds, this step is unnecessary. However, in all other cases, the glass is first cut into large lumps, which are then sawed up into element-sized pieces using a diamond tipped saw. Then they are placed into iron molds and the molds are heated to "red heat," pressing the glass into the shape of the mold. Finally the glass pressings are removed from the molds (at which stage they become "lens blanks") and are annealed or cooled slowly.

Annealing

After checking the pressed glass, annealing takes place in computer controlled electric furnaces where the temperature is gradually reduced over a long period of time. Annealing is certainly one of the most critical steps in the lens manufacturing process because it 1) eliminates distortion, 2) adjusts delicate optical properties, and 3) eliminates differences in optical properties. Most Nikon optical glass requires one or two weeks for annealing, but certain types take as long as six months to cool down!

Shaping the lens elements

The lens blank is first milled, using a diamond cutter (curve generator), to shape the surfaces to approximately the desired curvature. This is done to both sides of the blank. This process has a great effect on the final quality of the polished lens. The blank then passes to the smoothing shop. Here, successively finer grades of carborundum (aluminum oxide) are used in combination with an iron tool to smooth out the minute ridges left from the milling stage. When finished, the

Lenses being removed from annealing oven.

blank's surface is very finely ground to the required curvature. Now, it's thoroughly cleaned to remove all traces of abrasive and is passed on to the polishing shop.

Polishing the lens elements

In the polishing stage, the final curvature and characteristic high "polish" of a fine lens are achieved. The polishing process is similar to smoothing except that a polishing agent, usually cerium oxide, is substituted for abrasive.

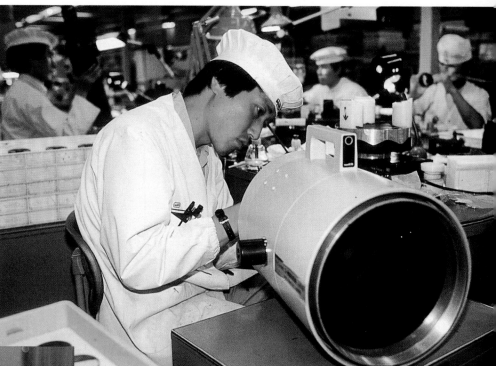

Reflex-Nikkor 2000mm f/11 being assembled.

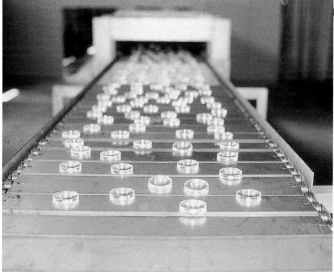

Lens blanks on assembly line.

plate shaped to a curve opposite that of the lens and is quite fast and very accurate to 1/10,000mm. The critical final test; conducted with a sophisticated laser beam system, is accurate to 3/100,000mm.

Ultrasonic cleaning

Now the lens elements are loaded into metal trays and cleaned automatically in special ultrasonic cleaning apparatuses of Nikon's own design. This step is very important because the quality of the final coated surface is greatly determined by the condition of the lens surface before the coating is applied.

Testing

When the element has received its final polish, its surface is tested to insure that it has both the correct radius of curvature and "figure." Figure, in this case, means that the element is perfectly spherical and free from distortion. The accuracy requirements of the finished element are so high that optical methods, using the wavelength of light itself as the measuring device, have been employed. This is done to both sides of the blank. This optical method uses a test-

Centering

After testing, the element then passes on to the centering shop where the physical center of the lens element is exactly aligned with its optical center. In most cases, this step is done rapidly and automatically using original Nikon-designed equipment.

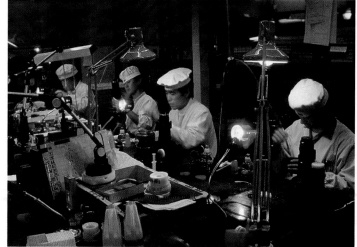

ED lens assembly line.

Multicoating the lens elements

The next step in the process is really a separate process in itself–applying Nikon Integrated Coating. For optimum performance, a large computer analyzes the individual specifications to determine the most suitable type of anti-reflective coating for each type of lens and lens element. Here between three and ten layers of anti-reflective coating are applied to the lens elements depending on the function of the individual lens element within the overall design.

Individual lens elements of the same type are loaded into a jig which is then placed inside a large vacuum chamber. At the bottom of the chamber are various coating materials contained in crucibles. The chamber is then pumped down to a very close approximation of an absolute vacuum, and electric current is applied to the coating materials in series, causing them to vaporize and be deposited on the elements. The process is continuously monitored and, when the correct layer is reached, the current is cut off. This process is repeated several times (depending on the number of layers to be deposited) until the element is fully coated. Total time for applying Nikon Integrated Coating is between thirty and forty minutes, depending on the number of individual layers required. After coating, the elements are removed from the chamber, and the edges are carefully painted black to eliminate reflections off the side.

Spread: Sagamihara Plant, established 1971. Production of Nikon's own optical glass using platinum crucible by the continuous melting method: production of special 35mm SLR lenses such as fisheye and ED Supertelephoto lenses.

This page: Visual inspection.

Facing page, left: Vacuum coating machine.

Facing page, right: Vacuum lens coating.

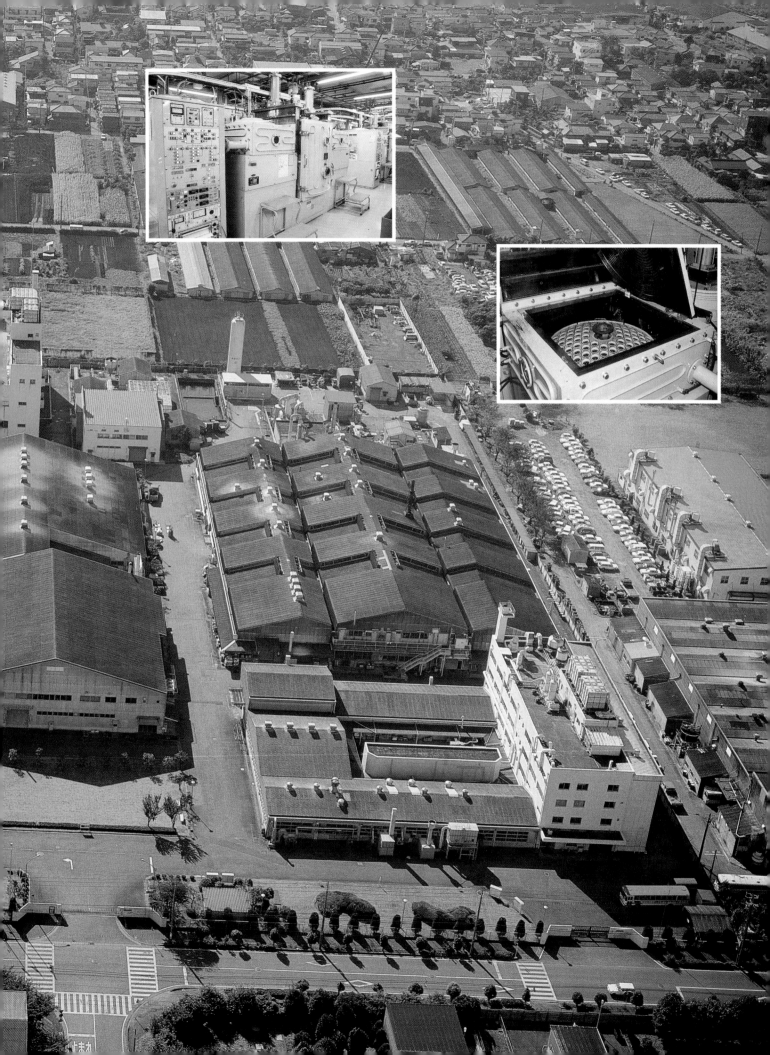

Assembly line at Nikon Mito Plant.

Metalworking

Mechanically, the components of the lens involve simple metalworking techniques including turning, milling, stamping, heat treatment, plating, cutting, threading and painting. Unfortunately, all these components then have to fit together inside a very small container, and they have to fit together with a degree of accuracy that is seldom even contemplated outside the research laboratory. But, in

F4 assembly line.

Nikon's case, we are talking about an actual production line process!

One of the prime requirements for the lens barrel components is concentricity, for the lens elements must align perfectly; any eccentricity on their part will result in a decentered lens—thus destroying all the efforts which have so far been put into the production of the lens. However, there are many other aspects which are just as important in insuring that you get the best out of every lens. The matte black paint used inside the lens must not only be good at preventing reflections, but it must also be carefully applied so that it does not fall off in use and fill the inside of the lens with tiny little flecks of paint. These are just a few

examples of the care and attention to detail that go into the making of every Nikkor and Nikon lens.

Assembly

Next comes assembly, where the two separate worlds of optics and mechanics are blended together to produce a fine photographic product—the Nikkor or Nikon lens. Highly trained technicians assemble the components. Each lens element is carefully fitted in place, seated against its locating stop; its ring is then screwed down with just the right degree of torque so that the element is held firmly but not too tightly—otherwise strain and distortion will occur. Thermal expansion of both the glass and metal components of the lens has to be taken into consideration when deciding on how much torque to apply. The placement of the element is then checked and the lens passes on to the next assembly stage where another element is added, and so on down the assembly line until the lens is finished.

specific distance (which is automatically controlled depending on the len's focal length) are ten targets containing 256 Charge-Coupled Devices (CCDs) each. Their purpose is to sense the delicate contrast of each wavelength of light electronically. The data is then fed to a computer which evaluates it and provides a display on a CRT screen

F4 performance test at -20° C (-4° F).

Testing

Now comes the most exciting part of all—testing. to insure absolute quality control, Nikon uses three separate types of lens tests: Modulation Transfer Function (MTF), projection, and photographic testing.

In Nikon's original computerized measurement of Modulation Transfer Function, the Nikon Automatic MTF Measurement System (NAMS) is used. Utilizing the latest in electronics and computer technologies, Nikon automatically measures the contrast per lines per millimeter of each lens. This is how it works: First, the lens to be tested is mounted on a special test apparatus and tiny beams of light are projected through the lens from back to front. Directly in front of the lens at a

F4 light leak test.

in the for m of contrast per lines per millimeter. A printout also accompanies each lens.

MTF testing is a very reliable way of judging the quality of a lens for two important reasons: 1) Because everything is done electronically, it eliminates any errors in human judgement or vision, making the results repeatable, and 2) a precise comprehensive rating is made possible by incorporating a lot of data into a single reading. As an additional benefit, MTF testing is incredibly fast (individual testing takes only 6 seconds!), so every single Nikkor or Nikon lens coming off the production line can be tested.

F4 strict performance check.

Mito Plant (where F4 is manufactured).

Manufacturing camera "FPC" (Flexible Printed Circuit).

For numerically measuring the actual resolving power of a lens, Nikon also employs projection and photographic testing. In projection testing, a miniature resolution chart plate is placed behind the lens at the plane of focus where the film would ordinarily be located inside the camera. Strong light from a standardized light source is then projected through the plate, causing a large image to be formed on a matte glass-beaded screen several meters away. An experienced technician, standing on the other side of the screen, then examines the projected image. The lens is checked at various apertures and any defects in optical quality are magnified enormously and are therefore easy to spot. Projection testing is an important part of the regular assembly line process, because it provides a rapid visual check of the image quality of the lens, making any eccentricity apparent.

As a final check, Nikon periodically selects random samples from the production line and tests them photographically in the studio using a resolution test chart. The resulting fine-grain black and white negatives are then examined critically for sharpness.

In this way, Nikon makes sure that every Nikkor and Nikon lens will be worthy of its fine reputation.

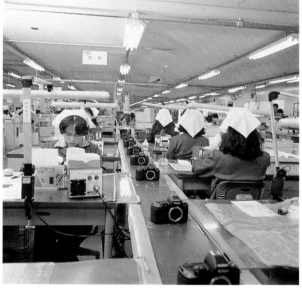

8008 assembly line.

and the lens delivers quality not before available in a mirror lens.

The **200-600f9.5 ED** is an updated version of the earlier 200-600f9.5 which was discontinued the previous year. The specs for the lens did not change nor did its popularity grow. This lens is extremely rare, as probably few were manufactured.

In **1978** 10 new lenses came on the market. They were:

24f2
58f1.2 Noct
300f2.8 EDIF
400f5.6 EDIF
35-70f3.5
50-300f4.5 ED
TC-1
TC-2
TC-200
TC-300

Nikkor 300mm f/2.8 IF-ED.

The **24f2** is a perfect example of the increasing wave of fast lenses that were coming from manufacturers. Nikon was at the forefront in fast lens designs. It has a length of 2.4", an aperture range from f/2 to f/22, meter coupling, a filter size of 52mm, an angle of view of 84 degrees, a weight of 10.8oz. Its small size really lends itself to being hand-held wide open in low light levels. It has the floating rear element design (CRC) for outstanding quality corner to corner even when at

Zoom-Nikkor 50-300mm f/4.5 ED.

the minimum focusing distance of 11.8". Not many know or have experienced its excellence, probably because of the high price which keeps most non-professionals from owning it. The images of the 24f2 have that legendary Nikon snap.

The **58f1.2 Noct** has a reputation for outstanding optics. It has a length of 2.5", an aperture range from f/1.2 to f/16, meter coupling, a filter size of 52mm, an angle of view of 40.5 degrees, a weight of 17.1oz. The 58mm Noct has the infamous aspherical lens surfaces and front element for outstanding results at f/1.2, even when shooting in darkness with point light sources in the photograph. Viewing through this very bright lens is an awesome experience.

The **300f2.8 EDIF** is an incredibly bright, sharp, and outstanding lens widely used in all areas of photography. It has a length of 9.8", an aperture range from f/2.8 to f/22, meter coupling, a filter size of 122mm (39mm filter drawer), an angle of view of 8.1 degrees, a weight of 5.8lbs. Only the front two elements are ED glass. Used wide open, the 300f2.8 is sharp corner to corner.

The 300f2.8 has the advantage of ED glass as well as IF for quick focusing. Its minimum focusing distance of 13 feet. It has a 360 degree tripod collar and a built-in lens shade. The f/2.8 is very conducive to working in low light without flash with ASA 400 film. Seen at every press conference, football game, and other major events, it owes its popularity to its ability to isolate the subject so effectively. At f/2.8, the depth-of-field of the 300f2.8 is so shallow that a football player on the field pops right out from the crowd in the stands. Fashion photographers utilize the depth-of-field and angle of view because it enables them to use selectively only those background elements they want. This is truly a lens for all seasons.

The **35-70f3.5** is a zoom intended for photojournalists, and proved itself as a vital tool in their work. It has a length of 4", an aperture range from f/3.5 to f/22, meter coupling, a filter size of 72mm, an angle of view of 62 to 34 degrees, a weight of 19.4oz. The 35-70f3.5 is a two ring zoom, one for focusing and one for zooming. It's a true zoom so once focused, zooming will not change the focus.

It has good corner to corner image quality but never really attained popularity.

The **50-300f4.5 ED** is more than an ED version (the second element being ED glass) of the 50-300f4.5. It's a redesigned, smaller, sharper lens than its predecessor. It only lost 2 oz in weight but lost 1.8 inches in length. It is still not suitable for hand holding. All other specs are the same. The ED version received greater respect and acceptance from photographers than did the non-ED version.

The **TC-1** and **TC-200** were the first teleconverters (2x) produced by Nikon in 19 years of SLR lens production. They both double the focal length of the lens while losing 2 f/stops. The TC-1 and TC-200 are the exact same teleconverter, the only difference being the meter coupling. The TC-1 couples with the non-AI system and the TC-200 couples with the AI system. Neither converter can be used on the opposite metering system, as it is not possible to mount on the lens because of the ridge needed to achieve metering coupling specific to each system. Both are small, 1.8" long.

Note: When mounting the TC-1 to a metered body and a coupled lens, make sure the lens, converter, and body are all coupled together, as it's not an automatic system. The coupling on the converter at the junction with the lens is spring loaded and can be easily knocked away from being coupled.

These converters are designed to be used in conjunction with lenses whose rear element is flush at the rear, where the lens mounts to a body. The front element of the TC-1/TC-200 is inset 15mm to accept the back of those lenses whose elements actually protrude a few millimeters. The optical formula of the converters is matched to that of the lens so even illumination and sharpness is continued when the proper converter and lens are combined. These converters do take two stops of light. A lens with an f/stop of f/2 will have an effective f/stop of f/4 when the converter is attached. The depth-of-field will be only half that of the lens in use but the minimum focusing will remain the same, and image size will double at that same point.

The **TC-2** and **TC-300** complement the TC-1/TC-200, being the 2x converters for longer lenses. As with the TC-1/TC-200, the TC-2 meter couples with the non-AI system and the TC-300 couples with the AI system. They are only 3.3" long. The TC-2/TC-300 front element extends out 23mm from the lens mounting flange where the converter and lens couple. These converters work on lenses whose rear element is inset in the back (not flush in the back) allowing the front element of the converter to extend into the lens when they are coupled together. The reason for a different converter for these lenses is to maintain even exposure and sharpness. A TC-200 connected to a 400mm lens, for example, will vignette all four corners of the photograph because they are incorrectly matched and cannot transmit light from the lens to the film plane.

Nikon came out with seven new lenses in **1979**. They were:

16f2.8 Fisheye
20f3.5
50f1.2
300f4.5 EDIF
600f4 EDIF
800f8 EDIF
TC-14
35f2.5 E
50f1.8 E
100f2.8 E

The **16f2.8 Fisheye** is a completely new lens, not just a revision of the 16f3.5. There are a number of changes between the two lenses, which make the 16f2.8 the better choice. It has a length of 2.6", an aperture range from f/2.8 to f/22, meter coupling, a filter size of 39mm bayonet, an angle of view of 180 degrees, a weight of 11.6oz. The specs tell the story on the changes. The 16f2.8 is 1/2 stop faster, has 180 degree coverage compared to the 170 degrees of the 16f3.5 and accepts 39mm bayonet filters. The lens is supplied with four filters in the CA-2 case when purchased new. These mount on the rear of the lens (one must be in place). It is still a full frame fisheye with all the same characteristics of the 16f3.5.

The **20f3.5** is a completely new lens, not just a redesign of the 20f4. There are 11 elements in the 20f3.5, but only 10 in the 20f4. Even with this extra glass, the lens is 1/3 stop faster. It has a length of 2", an aperture range from f/3.5 to f/22, meter coupling, a filter size of 52mm, an angle of view of 94 degrees, a weight of 8.3oz. This 20f3.5 is considerably smaller than the original 20f3.5 and is the sharpest 20mm yet. Unlike many of the other wide

Nikkor 600mm f/4 IF-ED.

angles, it lacks the advantage of CRC. Even though it focuses to one foot, the corners are not quite as sharp as the center.

The **50f1.2** is a new lens design. It has always had loyal supporters, but was never a big seller. It has a length of 2.3", an aperture range from f/1.2 to f/16, meter coupling, a filter size of 52mm, an angle of view of 46 degrees, a weight of 13.4oz. It's a sharp lens but lacks the resolution of the 58f1.2 Noct. The Noct design is also superior because of its asperical element which eliminates flare. In everyday shooting, however, the majority of photographers would not see a great deal of difference. The price difference between the lenses (it's at least $1000) usually persuades most to purchase the 50f1.2.

The **300f4.5 EDIF** was an entirely new design utilizing ED glass and IF focusing. It has one more element then the conventional 300f4.5, but weighs less. It has a length of 7.9", an aperture range from f/4.5 to f/32, meter coupling, a filter size of 72mm, an angle of view of 8.1 degrees, a weight of 2.3lbs. The 7oz weight loss and the much slimmer lens barrel are a direct result of the internal focusing design. With the removal of the helicoid unit for focusing, Nikon achieved a smaller lens. This is also a sharper lens that focuses three feet closer. The second element is the only ED glass in the lens. One can easily hand hold this outstanding photographic tool.

The **600f4 EDIF** is magnificent and is in constant demand. Still the fastest 600mm lens produced by any manufacturer, its massive size has

not decreased its popularity. It has a length of 18.1", an aperture range from f/4 to f/22, meter coupling, a filter size of 160mm (39mm screw filter drawer), an angle of view of 4.1 degrees, a weight of 12.4 lbs. The first and second elements are ED glass.

This remarkable lens provides extremely bright viewing. Considering its size, it's well balanced for tripod use (it cannot be hand held) and focuses to 26 feet. It has a built-in lens shade that screws to lock into place whether in use or backward for storage. It comes with a large tripod collar, with three separate sockets for screwing the collar to a tripod. The size of the front element is so large that no metal or plastic front cap is available. It comes with a leather slip-on cap. It originally came with the TC-14, another new lens released that year. The TC-14 converts the 600f4 into a 840f5.6 lens that still focuses to 26 feet. When attached, the quality of the converter is so outstanding that there is no loss of image quality.

The **800f8 EDIF** is an outstanding lens. It never caught on with photographers though, probably because of its slow speed of f/8. Considering its power, it's a small package. It has a length of 18", an aperture range from f/8 to f/32, meter coupling, a filter size of 122mm (39mm filter drawer), an angle of view of 3 degrees, a weight of 9.4lbs. The first and second elements are ED glass. The 800mm is a long, skinny lens with only the front few inches 122mm in diameter, so it's very well balanced. It's dark for viewing, but still manageable in low light levels. It can be bought on the used market for relatively little money, making it an incredible buy.

The **TC-14** is a 1.4x teleconverter of outstanding quality. As mentioned above, it was originally released with the 600f4. The TC-14 has a length of 1.9", meter coupling maintained, a magnification of 1.4x, a 1 stop light loss, a weight of 4oz. The TC-14 can be used on lenses other than the 600f4, and because of popular demand, Nikon released it as a separate unit. The TC-14 works on the same lenses as the TC-300. Its front element protrudes out, so it can only be mounted to lenses whose rear element is inset. When attached to a lens, it causes no reduction in quality which is why it's in such great demand.

Series E lenses were an experiment by Nikon in testing the waters of the consumer market. The main differences between and Nikon E lens and the standard Nikon F lens was in the way they

were manufactured. Rather than being hand assembled like the standard Nikon F lenses, the E Series are assembled by machine. This means that some assembly points are glued instead of screwed and more plastics were used in the barrel design to facilitate the process. Internal parts such as the helicoid were also made with lesser materials than the prime Nikon F lens.

They are AI meter coupled but do not come with the non-AI coupling prong. They will not meter couple with older bodies. The non-AI coupling can be retrofitted to the lens by some repairs facilities at a nominal price. The optics are still prime Nikon glass with most lens designs receiving NIC coatings. The E Series came on the market about the same time as the EM body. It was an attempt to entice more amateur photographers to the Nikon system with low price optics and body.

The **35f2.5 Series E** is typical of Series E design, being very small in size. It has a length of 1.5", an aperture range from f/2.5 to f/22, meter coupling, a filter size of 52mm, an angle of view of 62 degrees, a weight of 4.4oz. Optically this is a good lens, but it did not sell well.

The **50f1.8 Series E** was not popular. It has a length of 1.3", an aperture range from f/1.8 to f/22, meter coupling, a filter size of 52mm, angle of view of 46 degrees, a weight of 4.4oz. This is probably one lens design that is best forgotten.

The **100f2.8 Series E** was one of the best of the E Series line. It is very sharp and comes in a nice, compact package. It has a length of 2.1", an aperture range from f/2.5 to f/22, meter coupling, a filter size of 52mm, an angle of view of 24.2 degrees, a weight of 6 oz. Although the entire barrel and focusing ring are plastic and have a very different feel to them than a normal Nikon F lens, they sold extremely well and are still quite popular.

In **1980** Nikon introduced five new lens designs. Three were Nikon F lenses that became legends and two were Series E lenses that were to become the favorite of the E Series. They were:

15f3.5 Ultra Wide
200f2 EDIF
25-50f4
28f2.8 E
75-150f3.5 E

The **15f3.5** Ultra Wide is more than just revision of the 15f5.6. It is the most sought after ultra

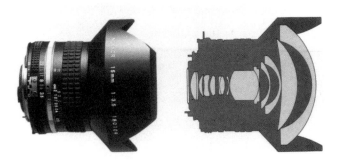

Nikkor 15mm f/3.5.

wide because of its amazing angle of coverage, straight line rendition, and outstanding sharpness. It's easy to hold because of its relatively compact size. It has a length of 3.5", an aperture range from f/3.5 to f/22, meter coupling, no front filter size (39mm bayonet in rear), an angle of view of 110 degrees, a weight of 22.2oz. It does have the same scalloped lens shade design as in the 15f5.6.

The biggest improvement of the 15f3.5 is in the focusing ring which is at the rear of the lens. That makes it smaller in diameter and wider for holding, which makes the lens much easier to focus. The 15f3.5 uses 39mm bayonet filters at the rear of the lens (one must be in place), but does not accept front filters which means it cannot be polarized. The 15f3.5 is standard equipment for thousands of photographers, and keeps Nikon very busy trying to meet demand. Since its introduction many have said that the f/3.5 flares more than the f/5.6, but both lenses flare to the same degree because of their wide angle of coverage. Using these lenses on cameras with 100% viewing is a must, insuring unwanted elements are not in the picture and enabling the use of the photographer's hand to block out the flare.

The **200f2 EDIF** is a beautiful lens, but its size prevents many from using it. It has a length of 8.7", an aperture range from f/2 to f/22, meter coupling, a filter size of 122mm, an angle of view of 12.2 degrees, a weight of 3.8 lbs. The first and second elements are ED glass. It has a built-in shade of the same style as that of other long lenses but has no 39mm filter drawer. It has a tripod collar with full 360 degree rotation for vertical and horizontal shooting. Even with its incredible sharpness, the size kept the 200f2 from wide use. The 180f2.8, which is extremely close in focal length and f/stop, is much smaller, and contributed to the cold reception given the 200f2.

The **25-50f4** is an extremely sharp lens that attained popularity only after being discontinued. It has a length of 4.4", an aperture range from f/4 to f/22, meter coupling, a filter size of 72mm, an angle of view of 74 to 46 degrees, a weight of 21.2oz. Its price when introduced was quite high compared to other lenses, which prevented many from purchasing it. Those few who own the lens rave about its sharpness throughout its entire zoom range, but even this acclaim has not helped sales. In 1982 the 25-50f4 was closed out by Nikon at half the original price. It was not until then that many photographers experienced its qualities. Since that time, it has been hard to find because of its popularity and reputation.

The **28f2.8 Series E** is one of the better Series E designs and is still popular today. It has a length of 1.6", an aperture range from f/2.8 to f/22, meter coupling, a filter size of 52mm, an angle of view of 74 degrees, a weight of 5.3oz. It has the all plastic barrel and focusing ring common to the E series.

The **75-150f3.5 Series E** was so popular that many wanted it to be redesigned to a Nikon F lens. This is one E Series that would come close to becoming a legend. It has a length of 4.9", an aperture range from f/3.5 to f/32, meter coupling, a filter size of 52mm, an angle of view of 31.4 to 17 degrees, a weight of 18.3oz. For a time, this lens was "the" lens in New York for fashion work, especially in the studio. It has a macro mode at the 150mm setting which provides 1:5 magnification. The first version has an all black barrel and black lens attaching ring. This was not as mechanically strong as the second and final version which was fitted with a metal, chrome attaching ring. The box the lens came in had a green dot on the end to signify it was the newer model. The 75-150 is still much sought after and in wide use because it is a very good lens.

1981 saw only four new lenses introduced, three of which were very specialized and exciting additions. They were:

28f3.5 PC
120f4 Medical
200f4 Micro
135f2.8 E

The **28f3.5 PC** differs little from the 28f4 PC, having the same angle of coverage and sharpness but with a slight increase of coverage power when

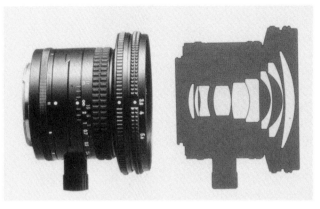

PC-Nikkor 28mm f/3.5.

shifted. It has a length of 2.7", an aperture range from f/3.5 to f/22, meter coupling-preset, a filter size of 72mm, an angle of view of 74 degrees, a weight of 13.4oz. The assembly and knob for the shifting movement have been improved and strengthened over that of the 28f4 PC. Some other cosmetic changes reduced the weight. The aperture is still preset, and works as all other preset lenses. It is not convenient for general shooting, but it is still an excellent lens.

The **120f4 Medical** is a rare lens even though it is still in production. It is extremely specialized, and only a select few have the job requirements needed to own this lens. It has a length of 5.9", an aperture range from f/4 to f/32, not meter coupled, a filter size of 49mm, an angle of view of 18.5 degrees, a weight of 31.4oz. The 120mm Medical has a built-in ringlight which provides approxi-

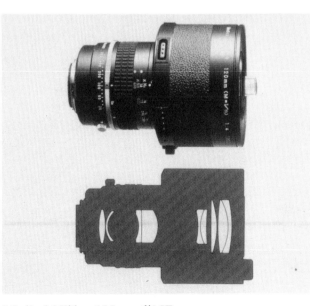

Medical-Nikkor 120mm f/4 IF.

mately 60W of power and a focusing lamp wrapped around the front element.

Power is provided by either an AC unit (**LA-2**) or DC unit (**LD-2**). The lens is capable of focusing 1:11 to 1:1 with an additional close-up lens reaching 0.8x to 2x magnification. It is not capable of focusing to infinity because it is designed specifically for close-up photography. It does have IF focusing for easy operation but is not capable of TTL flash connections. For calculating flash exposure, it employs an automatic guide number system like the 45GN. It can imprint data (optional) at the time a picture is taken imprinting the magnification at which the lens is set. It is an extremely sharp lens, extremely flat field, but there are better alternatives for close-up photography requiring a flash for lighting.

The **200f4 Micro** is a great lens many photographers never try. It can focus (IF focusing) from infinity to 1:2 by itself and down to 1:1 with the TC-301 (the TC-201 also works). It has a length of 7.1", an aperture range from f/4 to f/32, meter coupling, a filter size of 52mm, an angle of view of 12.2 degrees, a weight of 28.3oz. It also has a tripod collar with 360 degree rotation which is removable for hand holding. When focused down to 1:2, the 200mm has a working distance of 20" which is excellent for introducing extra light, etc.. The TC-14 is excellent with the 200 Micro, and maintains the flat field quality. This makes the 200mm a 280f5.6 that can focus to 1:9. When using the lens for general photography, it's a straight 200mm lens that can be used like any other 200mm. It is extremely sharp and its quality is comparable to that of the 180f2.8 but it lacks the faster f/stop.

The **135f2.8 Series E**, a new addition to the Series E line, was a popular lens with a well earned reputation for quality. It has the nicer rubber focusing ring, a built-in shade, and a compact size. It has a length of 3.5", an aperture range from f/2.8 to f/32, meter coupling, a filter size of 52mm, angle of view of 18 degrees, a weight of 14.8oz. This is one of the few E Series lenses that became popular and has remained so to this day, which makes it hard to find. It is a good lens for anyone, but especially those starting out on a tight budget.

In **1982** Nikon modified the metering coupling system and the AI system became AIS. The **AIS** (Automatic Indexing-Shutter) lenses have a small scoop removed from the lens mounting flange. This allows camera bodies to detect the focal length of the lens in use for program and shutter speed priorities. All lenses that were in production were converted to the AIS system. All new lenses introduced after this time were to have AIS coupling.

To determine if a lens is AIS, look at the aperture ring. The minimum aperture number will be bright orange. Not just the ADR number, but both sets of numbers need to be orange. The groove cut out of the back of the lens mounting ring does not necessarily mean it's AIS. Early E Series lenses, which have the groove, do not have the orange f/stop and so are not AIS.

Lenses retrofitted to AIS were (not including E Series):

6f2.8 Fisheye	**35f2.8**	**300f2.8 EDIF**
8f2.8 Fisheye	**50f1.2**	**300f4.5**
13f5.6	**50f1.4**	**300f4.5 EDIF**
15f3.5	**50f1.8**	**400f3.5 EDIF**
20f3.5	**58f1.2 Noct**	**400f5.6 EDIF**
24f2	**85f2**	**600f4 EDIF**
24f2.8	**105f4 Micro**	**800f8 EDIF**
28f2	**135f2**	**25-50f4**
28f3.5	**135f3.5**	**50-300f4.5 ED**
35f1.4	**200f2 EDIF**	**180-600f8 ED**
35f2	**200f4 Micro**	

With AIS, some lenses were dropped from the line while others received cosmetic and physical design change. One change that runs true for all the redesigned lenses is the slimming down of the lens barrel diameter, the same basic change that was made when the lenses became AI. This was especially true for the 200f4 and 300f4.5, both of which were substantially reduced in size.

The wide angles lost (or gained, however you want to look at it) the amount of throw required to focus the lens from infinity to its minimum focusing distance. For example, the AI version of the 24f2.8 had a throw of 180 degrees but the AIS version had a throw of only 90 degrees. This made the lens much faster and responsive to the photographer. The 200f4 Micro and 400f5.6 EDIF received wider tripod collars and narrower aperture rings. The AI versions of these lenses have wide aperture rings and narrower tripod collars which makes using them much easier to use. Many prefer the AI versions of these lenses for these reasons.

Nikon added nine more lenses to the line in **1982**. They were:

18f3.5
55f2.8 Micro
85f1.4
105f1.8
180f2.8ED
1200f11 EDIF
80-200f4
36-72f3.5E
70-210f2E

The **18f3.5** is an outstanding lens! It's a completely new design, having only the focal length in common with the older 18f4. It has a length of 2.9", an aperture range from f/3.5 to f/22, meter coupling, a filter size of 72mm, an angle of view of 100 degrees, a weight of 12.3oz. Two really nice features of the 18f3.5 are its ability to focus down to 9.8" and the presence of CRC which was missing in the 18f4. This compact wide angle is the favorite of many who want to get into ultra wides at a budget price. It's a really sharp outstanding lens.

"The **55f2.8**, the best of the 55 micros to date!" This claim has been the subject of many conversations since the lens was introduced, but shooting with the lens quickly proves the point. It has a length of 2.8", an aperture range from f/2.8 to f/32, meter coupling, a filter size of 52mm, an angle of view of 43 degrees, a weight of 10.2oz. The 55f2.8 focuses from 1:2 to infinity, but needs the PK-13 extension tube to go 1:1. The element design has been modified, but retains the deep-set front element. Whether used for general purpose photography or macro work, the 55f2.8 was a hit from day one and remains so today, despite its discontinuation.

The **85f1.4** is an incredibly sharp lens with a huge, sparkling front element. It has a length of 2.9", an aperture range from f/1.4 to f/16, meter coupling, a filter size of 72mm, an angle of view of 28.3 degrees, a weight of 21.9oz. Considered by many as the focal length of natural perspective, the exceptionally fast f/1.4 makes it a natural for photojournalists. It can be shot wide open at f/1.4 and maintain its edge to edge, corner to corner performance like no other lens. This is because it's the first telephoto to employ CRC. The Close Range Correction insures that no matter how close or far the subject, when using the lens at f/1.4 and employing selective focus, the subject will be tack sharp. If used with the TC-14A or TC-201 at f/11 and a fast shutter speed, uneven exposure is possible.

The **105f1.8** was overshadowed by the 85f1.4. It is slightly larger than the 85f1.4. It has a length of 3.5", an aperture range from f/1.8 to f/22, meter coupling, a filter size of 62mm, an angle of view of 23.3 degrees, a weight of 20.5oz. It's very sharp corner to corner, but attains this quality without CRC. It never has caught on with photographers and is not widely used.

The **180f2.8ED** is a remake of the earlier 180f2.8 with the exception of the ED glass front element and the ED gold band around the barrel. The dimensions of the 180f2.8ED are the same as those of the original 180f2.8. For the money, the original 180f2.8 is just as good (it probably had ED glass) and is a better buy. Only the front element is actually ED glass.

The **1200f11 EDIF** is a beautiful lens that has been somewhat ignored by the photographic community. It has a length of 22.7", an aperture range from f/11 to f/32, meter coupling, a filter size of 122mm (39mm filter drawer), an angle of view of 2 degrees, a weight of 8.1lbs. The first and second element are ED glass. Except for the front element assembly (5" long) which is 122mm in diameter, the remainder of the lens is just a long tube 70mm in diameter. It has a built-in shade and tripod collar with 360 degree rotation for vertical and horizontal shooting. Its slow f/stop discourages most photographers from taking it seriously. This is a great loss. There is one photographer who has become quite famous with the use of this lens to which he credits much of his success. It only focuses down to 45', but this can be easily cut to 30' with an extension tube which causes no loss of quality or light.

The **80-200f4**—a mistake? The legendary 80-200f4.5 had been off the market for only 1 year when the 80-200f4 was introduced. No matter how long it had been, the ghost of the 80-200f4.5 would always haunt it. The gain of 0.5 f/stop in speed increased the size of the 80-200f4 considerably. It has a length of 6.4", an aperture range from f/4 to f/32, meter coupling, a filter size of 62mm, an angle of view of 30.1 to 12.2 degrees, a weight of 28.6oz. The 80-200f4 never caught on with photographers. It's not that the 80-200f4 is not sharp (though not quite as sharp as the f/4.5), but it's physically large.

The 62mm front element size stopped many from even trying it. Today, the 80-200f4.5 still outsells the 80-200f4, which says a lot for the quality of the f/4.5.

The **36-72f3.5 Series E** is a nice, compact zoom. It has a length of 2.8", an aperture range from f/3.5 to f/22, meter coupling, a filter size of 52mm, an angle of view of 62 to 33.3 degrees, a weight of 13.4oz. Though a popular lens, it's not sharp throughout its zoom range and the corners are not as sharp as the center. For other than critical use, it's an excellent lens.

The **70-210f2 Series E** falls into the same category as the 36-72E as far as quality but was never as popular. It has a length of 6.1", an aperture range from f/4 to f/32, meter coupling, a filter size of 62mm, an angle of view of 34.2 to 11.5 degrees, a weight of 25.7oz. It has a macro mode at the 70mm setting that allows 1:6 magnification.

In **1983** four new lenses were introduced, two of which were autofocus designs. The four lenses were:

50f1.8N
80f2.8 AF
200f3.5 EDIF AF
80-200f2.8 ED

The **50f1.8N** is a new look for the 50f1.8, with the appearance and size of the 50f1.8E. It has a length of 1.4", an aperture range from f/1.8 to f/22, meter coupling, a filter size of 52mm, an angle of view of 46 degrees, a weight of 5.1oz. It went through three cosmetic changes before this final version, refining its cosmetic appearance and controls. Optically this is the best of the 50f1.8 designs, but its small size, feel, and look was not well received by buyers. Several changes corrected these faults, but the optics were the same. All of these models have a minimum focusing distance of 2'. A version of the 50f1.8N made for the Japanese market focused to 1.5' and is called the 50f1.8"S".

The **80f2.8 AF** is one of two special autofocus lenses designed to work with the F3AF. It is capable of working either autofocus or manually when attached to the F3AF or manually on all other Nikon bodies. It has a length of 2.5", an aperture range from f/2.8 to f/32, meter coupling, a filter size of 52mm, an angle of view of 30.2 degrees, a weight of 13.4oz. The autofocus motor is built into the lens. The finder on the F3AF connects to it

electronically telling it which way to turn for correct focus. It has a metal barrel and wide focusing ring. The F3AF did not do well, and the lenses for the camera shared the same fate.

The **200f3.5 ED AF** is the second lens introduced with the F3AF. It has a length of 5.9", an aperture range from f/3.5 to f/32, meter coupling, a filter size of 62mm, angle of view of 12.2 degrees, a weight of 30.6oz. Like the 80f2.8AF, the 200f3.5AF works in either autofocus or manual focus. The 200f3.5 has ED glass (the first and second element are ED glass) and IF focusing which makes it an outstanding lens. Both the 200f3.5 and the 80f2.8 receive their electricity as well as other information needed to autofocus from the body. These lenses are scarce on the used lens market and are a great buy for the price, as both are incredibly sharp. If a fast stop is not required, no better optics are available.

The **80-200f2.8 ED** is a massive lens for its focal length. It has a length of 9.2", an aperture range from f/2.8 to f/32, meter coupling, a filter size of 95mm, an angle of view of 30.1 to 12.2 degrees, a weight of 4.3lbs. It's a sharp lens (the second and third elements being ED glass), but its size makes hand holding difficult at best. It has a built-in tripod collar with a full 360 degrees of rotation. The zoom/focus ring has a lock enabling the entire ring to be locked into place. For long exposures or for photographing a subject over a long period of time in which the focus needs to be maintained, the lock prevents the weight of the zoom from changing the focus.

The 80-200f2.8 went through a number of design changes before the final version got on the market. Two years before this push-pull version was introduced, a two ring zoom prototype was displayed at Photokina. This version was never produced.

Nikon introduced thirteen new lens designs in **1984**. It was the year of the zoom, with five new models coming out. The new lenses were:

105f2.8 Micro
300f2 EDIF w/TC-14C
28-50f3.5
35-105f3.5-4.5
50-135f3.5
100-300f5.6
200-400f4 ED
500f8N Mirror

TC-14A
TC-14B
TC-16 AF
TC-201
TC-301

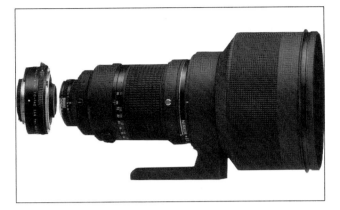

Nikkor 300mm f/2 IF-ED with Teleconverter TC-14C.

The **105f2.8 Micro** is an incredible lens—the best of the 105's. The 105f2.8 is more than a faster version of the 105f4, it's a complete remake. It has a length of 3.5", an aperture range from f/2.8 to f/32, meter coupling, a filter size of 52mm, an angle of view of 23.2 degrees, a weight of 17.7oz. Its design departs from a built-in shade, but comes instead with a reversible shade, the HS-14. It focuses from infinity to 1:2 by itself, and 1:2 to 1:1 with the PN-11 extension tube. The outstanding optical design delivers edge to edge sharpness but it's not flat field. It has a focus lock screw on the barrel to prevent the focus from slipping when a predetermined magnification ratio is required. Oddly the lock comes from the factory inoperable, and needs to be sent to Nikon for warranty repair. The focus is such that this feature is not really needed, so few photographers bother to have it fixed.

The **300f2 EDIF** lens is not only fast, it's also sharp. With a suggested list price of over $21,000 when discontinued, a defense department budget is needed to justify its purchase. It has a length of 13.6", an aperture range from f/2 to f/16, a filter size of 160mm (52mm drop-in filter drawer), an angle of view of 8.1 degrees, a weight of 16.6lbs. It is front heavy, but this is where the majority of the glass is housed. An extension shade can be added to the built-in one to provide maximum protection from flare as well as from damage to the front element.

It has a built-in tripod collar with full 360 degree rotation. There are also three holes to attach it to a tripod if necessary. The first, second, and forth elements are ED glass, one element more than the 300f2.8EDIF. The 300f2 comes with a matched teleconverter, the TC-14C. When attached, it transforms the lens to a 420f2.8. The TC-14B, TC-201 and TC-301 can be used with the 300f2, but at smaller f/stops with faster shutter speeds, uneven exposure is possible. Introduced in time for use in the 1984 summer Olympic games in Los Angeles, NPS made it available for loan. Many photographers took advantage of this and produced thousands of outstanding images with the lens.

The **28-50f3.5** is a small lens that came and went in a matter of two years but earned a loyal following during that time. It's small size was what attracted most to it. It has a length of 3", an aperture range from f/4 to f/22, meter coupling, a filter size of 52mm, an angle of view of 74-46 degrees, a weight of 13.9oz. Its zoom is a push-pull with not quite a 2x range. The f/stop is constant throughout the zoom range. It has a macro mode at the 50mm setting providing 1:5.2 magnification. The sharpness, too, remains constant throughout the entire range. This, combined with its compact design, makes it popular.

The **35-105f3.5-4.5** is an extremely popular zoom though it has been found not to be equally sharp at all focal lengths. Its small size is one of its biggest assets. It has a length of 3.9", an aperture range from f/3.5-4.5 to f/22, meter coupling, a filter size of 52mm, an angle of view of 62 to 23.2 degrees, a weight of 18oz. It has a macro mode at the 35mm setting that provides 1:3.8 magnification. This is the first of the new zoom designs that Nikon incorporated a variable f/stop into the optical formula. As the lens is zoomed out, the f/stop changes. The 35-105 starts at f/3.5 and when zoomed to the 105mm focal length, the f/stop changes to f/4.5. The variable f/stop lens design was not well received by a lot of photographers, but the flexibility this gives lens designers allows for greater zoom focal lengths in smaller packages.

The **50-135f3.5** was short lived, but its popularity grew once the lens was discontinued, keeping the lens hard to find today. It has a length of 5.6", an aperture range from f/3.5 to f/32, meter coupling, a filter size of 62mm, an angle of view of 46-18 degrees, a weight of 24.7oz. Its optics are excellent, the f/stop is constant, and it's a push-

pull design. It has a macro mode at the 50mm setting that provides 1:3.8 magnification. One feature that is quoted as being an asset in the 50-135 is the front filter does not turn as the focus ring is turned. If a polarizing filter is in use, once the filter has been turned for the desired effect, the lens can be focused and it will not change the polarizing effect.

The **100-300f5.6** is optically an excellent lens, but its size and slow f/stop kept it from being a popular lens. It has a length of 8.1", an aperture range from f/5.6 to f/32, meter coupling, a filter size of 62mm, an angle of view of 24.2 to 8.1 degrees, a weight of 31.7oz. It's a big lens, but is sharp throughout its entire zoom range. It has a macro mode at the 100mm setting that provides 1:4.4 magnification. Never a big seller, its optics are excellent and deserve more respect than they ever received.

The **200-400f4 ED** is an amazing lens! The optical quality of the lens is outstanding

Reflex-Nikkor 500mm f/8.

throughout its entire zoom range. This holds true even when the TC-14B is attached. It has a length of 13.6", an aperture range from f/4 to f/32, meter coupling, a filter size of 122mm, an angle of view of 12.2-6.1 degrees, a weight of 7.8lbs. The second, third, eighth, and tenth elements are ED glass! It has a built-in tripod collar with 360 degree rotation and is designed to handle the shift in weight caused by zooming. It has a reversible shade for maximum protection and a zoom collar lock as with the 80-200f2.8. Its ED glass provides outstanding results wide open and it can focus down to 13' which is excellent at the 400mm range. Its production life was short compared to most large ED lenses because it was still considered slow at f/4, especially at the 200mm end.

The **500f8N Mirror** is a completely new design for the 500 mirror. It's still a Catadioptric design with a fixed f/8 aperture, but the optical quality and versatility surpasses any earlier design. It has a length of 4.6", an aperture of f/8, meter coupling-fixed, a filter size of 82mm (39mm

screw-in rear mount), an angle of view of 5 degrees, a weight of 28.7oz. The redesigned 500f8N (N = New) compact design makes the lens easily hand held even at slower shutter speeds. The new design's added benefit is that it can focus down to 5', providing greater than 1:1 magnification. It has a built-in tripod collar with 360 degree rotation and click stops for vertical and horizontal positions. The TC-14A and TC-201 work with the 500f8N when the rear filters are attached. The TC-14B can be used if the rear filter is removed.

The **TC-14A** was introduced in response to the overwhelming demand for a 1.4x teleconverter that would work with "shorter focal length" lenses. It's small, 1" long, meter coupled, and weighs 5.1oz. The "A" on the converter signifies it works on lenses whose rear element is flush in the back. The front element of the TC-14A is inset so the rear element of the lens can fit into the converter, maintaining even illumination and the flat field quality inherent in the lens. The TC-14A meter couples with the AI and AIS systems. There is 1 stop of light loss when used, but depth-of-field is as described for the TC-1. The optical quality is outstanding. This is a very viable tool, so don't hesitate to use it.

The **TC-14B** is the same as the TC-14 but has the AIS coupling hence the "B". The lens specs and applications are the same as those of the TC-14, refer to it for specifics. The **TC-201** and **TC-301** have been updated (TC-200/TC-300) just as the TC-14B to the AIS system. Refer to the TC-1 and TC-2 for specifics.

The **TC-16 AF** is a curious teleconverter designed to work with the F3AF. It allows non-AF lenses to work on the F3AF in a semi autofocus mode. It's compact in design, increasing the effective focal length by 1.6 and adding only 1 1/3 stops. The element in the converter moves to focus the image on the film plane, but its small degree of movement limits the range the converter can focus. Refer to TC-16A for methods of use.

After the incredible release of new optics the previous year, Nikon had only four new lenses to offer in **1985**. They were:

20f2.8
35-70f3.3-4.5
35-135f3.5-4.5
400f2.8 EDIF

The **20f2.8** is the best 20mm made by Nikon to date and is the first to feature CRC technology. It has a length of 2.1", an aperture range from f/2.8 to f/22, meter coupling, a filter size of 62mm, an angle of view of 94 degrees, a weight of 9.2oz. This is a magnificent lens, of legendary status and optical quality. The 20f2.8 CRC technology and its ability to focus to 0.85' makes it an excellent lens for wide angle work. Wide open at f/2.8, it isolates the subject and maintains edge to edge quality.

The **35-70f3.3-4.5** is a very short version of the earlier 35-70 that Nikon introduced to complement the smaller camera bodies. It has a length of 2.7", an aperture range from f/3.3-4.5 to f/22, meter coupling, a filter size of 52mm, an angle of view of 62 to 34.24 degrees, a weight of 9oz. Its variable f/stop design allowed Nikon to produce the lens in such a small package. The amazing thing about this lens is its incredible sharpness. Even when in macro mode at the 70mm setting with 1:4.4 magnification, the lens retains its sharp image quality. Many photographers did not give it much thought because of its low price, but those who use it swear by it.

The **35-135f3.5-4.5** is a lens that has received mixed reviews since its introduction. It has a length of 4.5", an aperture range from f/3.5-4.5 to f/22, meter coupling, an angle of view of 62-18 degrees, a weight of 21.4oz. It's a variable f/stop model, changing from f/3.5 to f/4.5 as the lens is zoomed from 35mm to 135mm. The optical quality is good for a zoom lens, but this lens is not widely used for critical work. It has a macro mode at the 135mm setting that provides 1:3.8 magnification.

The **400f2.8 EDIF** is a legend of speed and optics. This lens is slightly smaller than the 300f2. It has a length of 15.2", an aperture range from f/2.8 to f/22, meter coupling, a filter size of 160mm (52mm filter drawer), an angle of view of 6.1 degrees, a weight of 10.1lbs. The first and second elements are ED glass. The 400f2.8 does not accept a filter in the front because it has a hardened front, built-in protective glass filter that can be replaced if damaged. It accepts 52mm filters except for a polarizing filter in the filter drawer. The edge to edge quality of the 400f2.8 shot at f/2.8 can be matched against the best lenses on the market and probably comes out ahead. The price tag and the weight keep the majority of photographers from owning this lens.

In **1986** Nikon introduced three more lenses to fill in its manual lens line. They were:

800f5.6 EDIF
28-85f3.5-4.5
35-200f3.5-4.5

Nikon surprised their loyal lens users in **1986** with the introduction of an Autofocus (AF) lens line. The original eleven Autofocus lenses have a completely different feel and appearance than that to which Nikon users were accustomed. This created a lot of resistance to these lenses from the start. They were:

24f2.8 AF
28f2.8 AF
50f1.8 AF
50f1.4 AF
55f2.8 Micro AF
180f2.8 EDIF AF
28-85f3.5-4.5 AF
35-70f3.3-4.5 AF
35-105f3.5-4.5 AF
35-135f3.5-4.5 AF
70-210f4 AF

If that were not enough innovation for one year, Nikon introduced four remodeled EDIF lenses: 200f2N EDIF, 300f2.8N EDIF, 600f5.6N EDIF and 600f4N EDIF. These lenses have the same optical formula and specifications as the previous versions but now have a permanent front filter (which can be replaced if scratched) and no front filter threads. In the optical formula this is not counted as an element or element group. The "N" versions also have reversible lens shades in addition to the shades previously built-in to the lens to provide extra flare protection. The 200f2N also gained a gel filter holder at the rear, in front of the aperture ring.

The **800f5.6 EDIF** is one of the sharpest but least known telephoto lenses in production. It has

a length of 21.8", an aperture range from f/5.6 to f/32, meter coupling, a filter size of 160mm (52mm filter drawer), an angle of view of 3 degrees, a weight of 10.6lbs. The second, third and eighth elements are ED glass. The 800mm has the same hardened front element as the 400f2.8 and all current telephotos. The edge to edge quality of the 800mm at f/5.6 is excellent even when focused down to its minimum focusing distance of 30'. Introduced when fast f/stops lenses were the main selling point of lenses, the f/5.6 of this lens discouraged many photographers from trying it.

The **28-85f3.5-4.5** is a popular focal length lens that many enjoy using. It has a length of 3.9", an aperture range from f/3.5-4.5 to f/22, meter coupling, a filter size of 62mm, an angle of view of 74 to 28.3 degrees, a weight of 18.5oz. It has a macro mode providing 1:3.4 magnification. Its popularity has always been good, but increased tremendously when it was discontinued.

The **35-200f3.5-4.5** is an outstanding lens with excellent optics. There has been resistance to the lens from photographers because of its variable aperture design, but that's what makes the lens design possible. It has a length of 5", an aperture range from f/3.5-4.5 to f/22, meter coupling, a filter size of 62mm, an angle of view of 62 to 12.2 degrees, a weight of 25.9oz. It is a push-pull operation. Like most of the variable zooms, it has a macro capability of 1:4 with the turn of a ring. The sharpness of the lens is incredible, but the lens' lack of popularity will keep it from attaining its proper place in Nikon history.

The Autofocus lenses are a radical departure from the Nikon lenses of the previous thirty years. The first noticeable difference is their polycarbonate lens barrel, which replaced the metal barrel of Nikkor past. It has a totally different feel to it, smooth and tinny. The original model autofocus lenses also had a narrow manual focusing ring which was very unpopular. The feel of the focusing was even more disliked when used manually because the focusing ring does not have the same drag (stiffness), giving the impression of inferior quality in construction. These perceptions of the lens are erroneous, and overshadow the quality in the construction and performance of autofocus lens optics.

There are benefits to the autofocus lens designs that the manual lenses cannot touch, in most cases making them superior. The non-metal lens

barrel allows for a focusing mechanism to be used that is not a helicoid design. The weight and cost of producing a helicoid can be prohibitive if it were used in autofocus lenses. In place of the conventional helicoid, Nikon designed a new system for moving the elements through the lens barrel. The system is basically (small differences for each lens) a plastic sleeve with vertical-diagonal slots cut in it. These are tracks in which the elements ride. As the lens barrel is turned, the elements move.

The drag of the conventional helicoid focusing system is too great for the autofocus motor in autofocus cameras. The focusing motor necessary to move a conventional helicoid mechanism would have required tremendous torque, requiring a bigger motor and adding greatly to the weight of the body and demanding more voltage to make it all work. This new focusing system allowed autofocus lenses to be developed, with the added benefit of lower production costs (eliminating milling cost of the helicoid).

Looking over the autofocus lenses, the changes that have been made in their design is obvious. The zooms do not have depth-of-field engraving on the barrel. Rather, it's necessary to cut the depth-of-field chart out of the instruction sheet that comes with the lens and hold it on the barrel. Fixed focal length lenses have a depth-of-field engraving on their barrel, but have a distance scale enclosed under a plastic window which rotates as the lens is focused.

At the rear of the lens near the lens mounting ring are brass contacts which connect the **CPU** (**C**entral **P**rocessing **U**nit) in the lens to the computer in the body. The CPU is the latest in the evolving communications between the body and lens. These contacts transfer various lens data as well as commands regarding aperture control and focusing. Also at the rear lens mount is a small circle with a cut through its middle. This is the autofocus coupling to which the body connects and turns to focus the lens.

The non-AI coupling prong is omitted from autofocus lenses preventing them from coupling with the older non-AI system. This prong can be retrofitted to the aperture ring by a number of repair facilities. The autofocus lenses aperture rings have a lock on them so that they can be locked at their minimum f/stop for use with program and shutter priority modes. The shade system has also been changed on the autofocus lens, as they have

a bayonet shade system although they can still accept screw-in shades.

This first generation of autofocus lenses (AF for the F3AF are completely different) released with the N2020 camera were not welcomed with open arms, but with time their extremely fine optics and smaller, lighter design have been accepted to the point that they have became hard to find at many retail outlets. As a general rule of thumb, the autofocus lens is as good if not better than its manual focus counterpart.

The **24f2.8 AF** is an excellent lens! It is not a radical departure from the original 24f2.8. It has a length of 1.8", an aperture range from f/2.8 to f/22, meter coupling, a filter size of 52mm, an angle of view of 84 degrees, a weight of 8.9oz. The 24f2.8 has CRC and its optical design is the same as its manual counterpart but Nikon's written description omits this point. It maintains the same edge to edge performance as the manual lens design which speaks very well for its design.

The **28f2.8 AF** is the most popular 28mm Nikon has ever produced. Its extremely small size and price tag combined with excellent quality accounts for its popularity. It has a length of 1.5", an aperture range from f/2.8 to f/22, meter coupling, a filter size of 52mm, an angle of view of 74 degrees, a weight of 6.8oz. It does not have CRC (no 28f2.8 has), but has excellent edge to edge picture quality.

The **50f1.8 AF** is another very small lens with a very small price tag. Its performance is excellent. It has a length of 1.5", an aperture range from f/1.8 to f/22, meter coupling, a filter size of 52mm, an angle of view of 46 degrees, a weight of 7.4oz. It's a simple lens, designed for beginning photographers. Performance and price have endeared it to a wide range of users. It is excellent reversed.

The **50f1.4 AF** is the best of the 50f1.4 designs to date. Extremely bright and sharp, it's an excellent choice to include in any camera bag. It has a length of 1.6", an aperture range from f/1.4 to f/16, meter coupling, a filter size of 52mm, an angle of view of 46 degrees, a weight of 7.4oz. This is one of the more expensive autofocus lenses to be introduced and has been hard to get since its release. Its optical quality is of Nikon's legendary standards.

The **55f2.8 Micro AF** is outstanding, with a radically new feature for a 55mm micro. It can focus to 1:1 magnification without extension tubes, a first since 1959. It has a length of 2.9", an aperture range from f/2.8 to f/32, meter coupling, a filter

size of 62mm, an angle of view of 43 degrees, a weight of 14oz. It is bigger than the manual 55mm, both in length and filter size. The first reports of its being sharper than the manual version were dismissed by most photographers, but experience has converted many early sceptics.

Its gaudy appearance when focused out to 1:1 and the barrel's movement (but not the elements) when extended was very unpopular. On the front of the lens barrel is a moving ring that, when pushed down and turned, changes the lens from autofocus operation to manual. Though it can work in either mode when the ring is set to either setting, using the lens in the "A" mode when using autofocus reduces the torque to the camera's autofocus motor.

The **180f2.8 EDIF AF** is by far the best 180mm ever produced. This lens received a cold reception from photographers when introduced, probably because it was going up against a legend. It has a length of 5.6", an aperture range from f/2.8 to f/22, meter coupling, a filter size of 72mm, an angle of view of 13.4 degrees, a weight of 25.2oz. The second element is ED glass. It has a completely new element design over the manual version. The 180f2.8AF includes IF focusing. The rear element is placed further up in the lens barrel instead of flush in the back as with manual versions. It was not until a very well known and respected photographer wrote an article applauding the 180AF that the photographic community took notice of it. The first version of the 180Af had a plain focusing ring one inch wide. This was replaced by a version with a rubberized focusing ring.

The **28-85f3.5-4.5 AF** is a good lens, but it has received mixed reviews. It has a length of 3.5", an aperture range from f/3.5-4.5 to f/22, meter coupling, a filter size of 62mm, an angle of view of 74 to 28.3 degrees, a weight of 18.9oz. It's a two ring zoom, the rear ring zooms and the front ring focuses. It has a macro feature providing 1:3.4 magnification. Its focal length is very popular. This is a fine lens for the traveling photographer who does not want to carry many lenses, but not particularly great as a professional's tool.

The **35-70f3.3-4.5 AF** is an amazing little lens. It has a length of 2.4", an aperture range from f/3.5-4.5 to f/22, meter coupling, a filter size of 52mm, an angle of view of 62 to 34.2 degrees, a weight of 9.6oz. It's amazingly sharp throughout its entire zoom range as well as having excellent

edge to edge sharpness. Its small size and price tag kept it from being taken seriously for quite a while. It wasn't until a number of photographers had used it and written about its quality was it given due credit.

The **35-105f3.5-4.5 AF** has always been a very popular focal length, so the autofocus 35-105 fell right into step. It has a length of 3.4", an aperture range from f/3.5-4.5 to f/22, meter coupling, a filter size of 52mm, an angle of view of 62 to 23.2 degrees, a weight of 16.1oz. The autofocus version is superior to the manual version, being more consistent in sharpness throughout its zoom range. It has a macro mode providing 1:3.5 magnification. It's a two ring system, the rear ring for zooming, the front ring for focusing.

The **35-135f3.5-4.5 AF** is a nice lens. One of the larger autofocus lenses to be introduced, it has been popular from the start. It has a length of 4.4", an aperture range from f/3.5-4.5 to f/22, meter coupling, a filter size of 62mm, an angle of view of 62 to 18 degrees, a weight of 21oz. It has a macro mode providing 1:3.5 magnification. It's a two ring design operating as the 28-85 and the 35-105.

The **70-210f4 AF** is an outstanding lens optically although its mechanical design is unconventional. It has a length of 5.9", an aperture range from f/4 to f/32, meter coupling, a filter size of 62mm, an angle of view of 34.2 to 11.5 degrees, a weight of 25.9oz. It's a two ring zoom working as the others do. Its optics are excellent but it is not given much attention by photographers.

The **TC-16A** is called an autofocus teleconverter, but this is misleading. It does magnify the image by 1.6x (loss of 1 1/3 stops) but it's not a full-range autofocus converter. It must be used on an autofocus body with the autofocus switched to the "C" mode. When attached to the body, the TC-16A provides critical focus only, it cannot focus the lens from infinity to its minimum focusing distance. To use the converter to its fullest, first focus the lens manually on the subject, then touch the shutter release to activate the camera's autofocus operation. The teleconverter will now critically focus the image. With longer lenses, 400mm or longer, vignetting occurs when this converter is in use. This converter works extremely well within its limitations. It does deliver a sharp photograph, the quality equal to that of the TC-14B.

In **1987** Nikon added to its autofocus inventory by introducing three new lenses. Only two of these lenses ever saw the market. At the PMA show Nikon had a 600f4 EDIF AF on display in a glass case. This lens was said to be coming on the market the following fall and was even pictured in the full page N2020 brochure. For reasons unknown, the lens never made it to the production line. It's sorely missed in the line. The two lenses which were released are:

300f4 EDIF AF
300f2.8 EDIF AF

The **300f4 EDIF AF** is a beautiful lens! The optical design provides better quality when matched with the TC-14B than a straight 400f5.6 EDIF. It has a length of 10", an aperture range from f/4 to f/32, meter coupling, a filter size of 82mm (39mm filter drawer), an angle of view of 8.1 degrees, a weight of 46.6oz. The second and seventh

Nikkor 300f/4 EDIF AF

elements are ED glass. Unlike most autofocus lenses, it has an all metal lens barrel construction. The 300f4 has outstanding edge to edge quality, even when used with a TC-14B or an extension tube shot wide open at f/4.

The wide rubber focusing ring has a lever on it, "A" for autofocus use, and an "M" for manual. If the body is in autofocus mode and the lens in "M" mode, it will still all work, but the focusing ring will turn and cannot be held when shooting. If in the "A" mode when shooting autofocus, the ring will not turn so and can be held for better camera system balance. In front of the focus ring is a focus range limiter. This can be selected so that the lens will only focus on subjects within a certain range, such as from 25-50 feet. It can be set on a number of choices or left for complete operation when set at "Full." It has a built-in lens shade and a 360 degree rotating tripod collar. Its 82mm filter size is a bit big by Nikon normal lens standards, but that has not stopped it from being a major selling lens.

The **300f2.8 EDIF AF** is an amazing lens! Like the 180AF when is was introduced, the 300f2.8 EDIF AF was going up against a legend in the manual version. But the 300f2.8AF has proved itself a better lens. It has a length of 9.8", an aperture range from f/2.8 to f/22, meter coupling, a filter size of 122mm (39mm filter drawer), an angle of view of 8.1 degrees, a weight of 89oz. Its first and second element are ED glass. It has a built-in shade as well as a reversible shade for extra flare protection. It has a 360 degree rotating tripod collar for vertical and horizontal shooting. It has a ring that must be turned and set for either "M" or "A" shooting as with the 300f4. It has the same focus range limit system as the 300f4AF.

The 300f2.8 EDIF AF was not accepted very well by photographers even though its optical quality was superior to the manual version. The main complaint was the lens' manual focus feel when focusing. It has the normal autofocus drag that is looser than the manual version, which drove photographers crazy. Users have complained that the focus doesn't change instantly when the lens focus ring is turned. Within 18 months, a new version, the 300f2.8N EDIF AF came on the market. Cosmetic changes were made which addressed these complaints. No matter which version is used, it's a fantastic lens that is now preferred over the manual version, even at a higher price.

Four new autofocus lenses, three new versions of autofocus lenses and one manual lens made up the new releases for **1988**. This would be the last year that a manual lens would be introduced into the Nikon lens line for some time. The new lenses were:

35f2 AF
85f1.8 AF
180f2.8N EDIF AF
300f2.8N EDIF AF
24-50f3.3-4.5 AF
35-70f2.8 AF
70-210f4-5.6 AF
80-200f2.8 ED AF
500f4 P

The **35f2 AF** is an outstanding lens, surpassing its manual version. It has a length of 2.1", an aperture range from f/2 to f/22, meter coupling, a filter size of 52mm, an angle of view of 62 degrees, a weight of 7.5oz. It has excellent edge to edge quality rivaling that of the 35f1.4. It focuses 6" closer than the manual version and retains its edge to edge quality when focused close. Its size and sharpness makes this lens extremely popular.

The optical quality of the **85f1.8 AF** rivals that of the 85f1.4. This small, compact lens is easily hand held, and allows one to take full advantage of its f/1.8 for available light photography. It has a length of 2.7", an aperture range from f/1.8 to f/16, meter coupling, a filter size of 62mm, an angle of view of 28.3 degrees, a weight of 14.6oz. It is sharp edge to edge when shot wide open at f/1.8, improving only slightly when closed down, which speaks well for its optical design. It has a wide rubberized focusing ring. With the market resistance to the narrow ring, all AF lenses from this time on would have the new feature. The 85f1.8 comes with the HN-23 shade when purchased new and it can be kept on the lens at all times using a 77mm snap cap for protection.

The **180f2.8N EDIF AF** has the same construction as the 180f2.8 AF except for minor cosmetic changes. The lens barrel is now constructed of metal (rather than polycarbonate materials) and has the crinkle finish of the large EDIF lenses. The focus ring is twice as wide as on the original model with a rubberized ring. The optical formula and performance remain the same but have been redone in a more traditional Nikon lens package.

The **300f2.8N EDIF AF** has the exact same optical formula and specifications as the 300f2.8AF. The biggest difference is that the lens, when focused manually, now has a stiffer drag as well as a few other cosmetic changes. The small knobs that are used on the focus lock and focus range lock are bigger and sturdier.

The **24-50f3.3-4.5 AF** is an excellent lens with outstanding optics. Its compact size makes it a great choice for travel photography. It has: a length of 3.2", an aperture range from f/3.3-4.5 to f/22, meter coupling, a filter size of 62mm, an angle of view of 84 to 46 degrees, a weight of 13.2oz. It's a two ring zoom, the rear ring working the zoom and the front, wide, rubberized ring operating the focus. It has a macro mode at all focal settings with a maximum magnification at the 50mm setting of 1:8.5. The edge to edge performance of the lens is excellent. It's at its best at f/5.6 to f/8.

The **35-70f2.8 AF** is an incredibly sharp lens, shot wide open at any focal length. It has a length of 4.1", an aperture range from f/2.8 to f/22, meter coupling, a filter size of 62mm, an angle of view of 62 to 34.2 degrees, a weight of 23.5oz. It has a macro mode at the 35mm setting providing 1:4 magnification. This can be increased to almost 1:1 with the addition of a 6T filter without any optical loss, even at the corners. It is a push-pull zoom design, but only the front focus ring turns, the main zoom barrel stays fixed. This is a true zoom that allows the focus to be set with the zooming action, not affecting the focus setting. Its zooming is the reverse of most Nikon zooms, starting at 70mm and pushing out to 35mm. The sharpness of this lens wide open assures it a place in the Nikon history of optical designs.

The **70-210f4-5.6 AF** is a completely new remake of the 70-210f4 AF. It has a length of 4.3", an aperture range from f/4-5.6 to f/32, meter coupling, filter size of 62mm, an angle of view of 34.2 to 11.5 degrees, a weight of 20.6oz. The first noticeable difference is its smaller size. The reduction in size comes from the use of a variable f/stop design which was not present in the 70-210f4. The second difference is it's a push-pull zoom with the same zoom design as the 35-70f2.8. It has a macro mode that provides 1:4.5 magnification. The optical quality of this new version is just as good if not better in the corners compared to the original version.

The **80-200f2.8 ED AF** is beautiful lens with an outstanding optical design. It has a length of 7.3", an aperture range from f/2.8 to f/22, meter coupling, a filter size of 77mm, an angle of view of 30.1 to 12.2 degrees, a weight of 42.3oz. The second, third, and thirteenth elements are ED glass. It has a macro mode providing 1:5.9 magnification at the 200mm setting. The lens barrel is of the all-metal construction with a partial crinkle finish. It's a push-pull zoom with the same ring doing the zooming and focusing. The 200mm setting is at the rear of the zoom and pushes out to the 80mm setting.

At the back of the zoom barrel are the "A" and "M" settings which must be set to the correct setting for use in either autofocus or manual modes. The recommended 1.4x converter is the TC-14A, but the TC-14B can also be employed without mechanical problem or optical loss. The 80-200f2.8 AF has been criticized for its lack of a tripod collar, but a collar would have necessitated an even larger lens to accommodate the additional size the collar would have added. Though large, this is a smaller and sharper zoom than the manual 80-200f2.8. It should be noted that its autofocus speed is slower than that of any of the other autofocus lens and that it's not particularly recommended for fast action.

The **500f4 P EDIF** is the first addition to Nikon's long glass in a decade. It has a length of 15.5", an aperture range from f/4 to f/22, meter coupling, a filter size of 122mm (39mm filter drawer), an angle of view of 5 degrees, a weight of 6.6lbs. The first and second elements are ED glass. The "P" in the nomenclature indicates that the lens has a CPU incorporated into its design. When used on the N8008 and F4s, it completely integrates with their matrix metering systems. It has a built-in tripod collar with a full 360 degree rotation. It has the deepest reversible shade available for any telephoto lens providing maximum flare protection. It also incorporates the protective front filter design found in all large telephotos. The balance of the 500f4 P is excellent; many photographers use it on a gunstock with little effort.

In **1989** Nikon introduced three new lenses and two new versions of older AF lenses. They were:

20f2.8 AF
50f1.8N AF
60f2.8 Micro AF
35-70f3.3-4.5N AF
75-300f4.5-5.6 AF

The **20f2.8 AF** is the exact same optical design as the manual version except that it's an AF lens. It has a length of 1.7 ", an aperture range from f/2.8 to f/22, meter coupling, a filter size of 62mm, an angle of view of 94 degrees, a weight of 9.2oz. It incorporates all the same features of the manual 20 including the CRC. It's a sharp lens and is extremely popular. Because of its angle of view, it's a difficult lens to polarize. The Nikon 62mm polarizer even with its built-in step-up ring cannot be used on the 20 when another filter is already attached without causing vignetting. When using filters, be sure to check for vignetting by closing the lens to f/22 and pressing the depth-of-field button on the camera body. Then look at the corners of the viewfinder for darkening. The 20AF has the new aperture locking switch which is a small lever that is pushed in to lock the aperture at f/22.

The **50f1.8N AF** is the same lens as the 50f1.8 AF, except that it has a wide, rubberized, focusing ring. It has a length of 1.9", an aperture range from f/1.8 to f/22, meter coupling, a filter size of 52mm, an angle of view of 46 degrees, a weight of 5.4oz. It's interesting that Nikon chose this lens to receive the cosmetic update of the wide focus ring while ignoring the 50f1.4AF.

The **60f2.8 Micro AF** is a radical new design that exceeds the optical quality of the 55 micros of the past. It has a length of 3", an aperture range from f/2.8 to f/32, meter coupling, a filter size of 62mm, an angle of view of 39.4 degrees, a weight of 16oz. It focuses from infinity to 1:1 without extension tubes; the length of the lens only grows an additional 23mm when focused to 1:1. The way Nikon got around the physics of getting to 1:1 without adding 60mm of extension is by a radical new design in which the elements realign themselves as the lens is focused closer. This permits the magnification without the lens extension. At 1:1 magnification, the working distance between the lens and subject is 70mm (2.8").

The 60mm can work either in manual or autofocus modes but must be set to the proper setting on the lens for correct operation. The 60f2.8AF also has a limit switch which allows either full operation from infinity to 1:1 or just a partial range. The 60 has the new aperture lock lever. The distance scale has a reproduction scale (as with the original 55 micros) so setting the lens for a particular ratio is possible, moving in physically to focus on the subject. Whether used at infinity, 1:1 or any spot in between, the 60f2.8 micro is sharp. The optical design and performance is beyond words to describe.

The **35-70f3.3-4.5N AF** is a remake with only cosmetics changes. It has a length of 2.2", an aperture range from f/3.3-4.5 to f/22, meter coupling, a filter size of 52mm, an angle of view of 62 to 34.2 degrees, a weight of 8.5oz. The lens is slimmer in diameter and has a rubberized, wide focus ring and zoom ring.

The **75-300f4.5-5.6 AF** is very sharp and handles extremely easily considering its focal length. It has a length of 6.8", an aperture range from f/4.5-5.6 to f/22, meter coupling, a filter size of 62mm, an angle of view of 31.4 to 8.1 degrees, a weight of 29.1 oz. It remains f/4.5 until the 200mm mark, then switches to f/5.6. It has a macro mode and built in tripod collar with full 360 degree rotation for vertical and horizontal shooting. It has a

Nikon N6006 with Nikkor 35-70mm f/3.3-4.5N AF.

Micro-Nikkor 60mm f/2.8 AF.

limit switch for the autofocusing range as on the 60 micro. Its compact size can be attributed to the variable f/stop design which aids in making it easy to hand hold. An added feature of this remarkable lens is its "macro". Active throughout its zoom range, it focuses down to just four feet. No other 300mm lens is capable of this. Its popularity with photographers tells the story as to the quality of the lens.

In **1990** there was only two new lenses added to the Nikon line and they were exciting new autofocus lenses. They were:

105f2.8 Micro AF
135f2 AF DF

The **105f2.8 Micro AF** seems likely to join the ranks of legends. It has a length of 4.2", an aperture range from f/2.8 to f/32, meter coupling, a filter size of 52mm, an angle of view of 23.2 degrees, a weight of 22.3oz. It is a big lens when compared to the manual 105f2.8 micro, but unlike the manual version, it can focus to 1:1 without extension tubes. It employs the same moving element system as the 60 micro so the overall length barely changes. The working distance between the lens and the subject at 1:1 magnification is 136mm (5.4") which is less than with the 105f2.8 manual at the same magnification. The 105f2.8 AF has the same "A" and "M" switch, aperture lock, and limit switch as the 60 micro. Be forewarned though, the lens is not flatfield. Even with this limitation it delivers outstanding results.

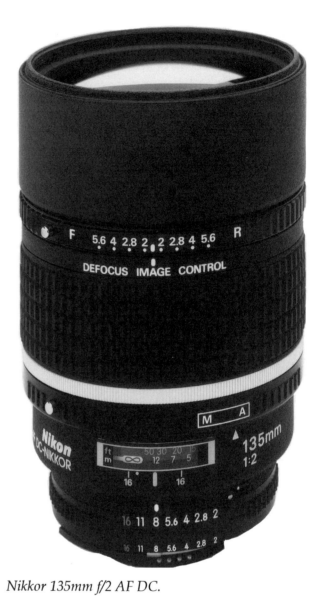

Nikkor 135mm f/2 AF DC.

The **135f2 AF DC** is a radical new design in lens construction. It has a length of 5.2", an aperture range from f/2 to f/16, meter coupling, a filter size of 72mm, an angle of view of 18 degrees, a weight of 30.4oz. The "**DC**" stands for "defocus". By turning a dial on the lens once the subject has been focused, the foreground or background will be "de-focused"—out of focus. The amount of out-of-focus can be lessoned or magnified by the amount selected with the "DC" ring in combination with the aperture in use. This lens also has a rear-focus (RF) design. The rear elements move internally to focus the subject therefore giving the lens IF focusing. It features a round diaphragm to assure agreeably rounded, soft blur at any f/stop.

At the 1990 Photokina, Nikon displayed a

Micro-Nikkor 105mm f/2.8 AF.

working Prototype **1200-1700f5.6-8 P EDIF** lens. It was shown to prove that such a lens could be manufactured but it's not scheduled to be manufactured. It weighs 35.5lbs, is 33.8" long, 9.1" diameter, and a built-in handle for easy handling (who's kidding who).

The spring of **1991** saw the long awaited update of two of the original autofocus lenses. They were:

28-85f3.5-4.5N AF
35-105f3.5-4.5N AF

The **28-85f3.5-4.5N AF** is a total remake of the original version and it shows. It has a length of 3.5", an aperture range from f/3.5-4.5 to f/22, meter coupling, a filter size of 62mm, an angle of view of 74 to 28.3, a weight of 17.7oz. The cosmetics and optical quality have been vastly improved over the original version. The zoom and focus ring are wider, rubberized, and stiffened. The lens is now of legendary status which this version will prove out it short time.

The **35-105f3.5-4.5N AF** received the same remake job as did the 28-85. Its cosmetics and optical quality were improved in the same fashion.

The spring of 1991 saw one odd addition to the Nikon lens line and three revisions. The new lens was:

28-70f3.5-4.5 AF

The 28-70f3.5-4.5 AF is a curious little lens made specifically to work with the built-in flash

Nikkor 50mm f/1.4 AF.

Nikkor 28mm f/2.8 AF.

Zoom-Nikkor 28-70mm f/3.5-4.5 AF.

Nikkor 24mm f/2.8 AF.

on the N6006. It has a length of 2.8", an aperture range of f/3.5-4.5 to f/22, meter coupling, angle of view of 74-34.2 degrees, 52mm filter size, a weight of 12oz. This lens's small physical size will not impair the flash of the N6006. The 28-85 AF because of its physical size, actually blocks light from the flash at 28mm.

The 28-70 has something in common with the 58f1.2. The 28-70's second element is of an aspheric design just as in the 58f1.2. The 28-80 element is manufactured by a new process which reduces the cost dramatically. The addition of an aspheric element in the lens design allowed Nikon to make the lens so small while maintaining image quality. No personal results from the lens are available so image quality is an unknown.

Nikon finally brought the 24f2.8N AF, 28f2.8N AF and 50f1.4N AF up to par with the addition of a rubberized focusing ring. No other changes were made in the lens specs with this modification. Now, all Nikon autofocus lenses have rubberized focusing rings.

New Lens Designs

Lens	"Non-N" 1st SN	"N" 1st SN
"N" Lenses AF		
50f1.8AF	2000000	3000001
180f2.8AF	200001	250001
300f2.8AF	200001	300001
35-70f3.3-4.5	3000001	4000001 1st model #2,..
35-135f3.5-4.5AF	200001	300001
70-210f4AF	N.A.	*became 70-210f4.5-5.6
"N" Lenses AIS		
35f2.8PC	N.A.	N.A.
200f2	N.A.	200001
300f2.8	N.A.	620001
500f8	501001	N.A.
600f4	N.A.	200001
600f5.6	N.A.	200001
1000f11	111001	142361

N.A. = Data Not Available

Metered Coupling Serial Number History

Lens	Non AI	AI	AIS
Fixed Focal Lengths			
6f2.8	N.A.	628001	629001
6f5.6	656001	NM	NM
7.5f5.6	750011	NM	NM
8f2.8	230011	242001	243001
8f8	880101	NM	NM
10f5.6	180011	NM	NM
13f5.6	N.A.	175021	175901
16f3.5	272281	280001	NM
16f2.8	NM	178051	185001
15f5.6	321001	340001	NM
15f3.5	NM	177051	180001
18f4	173111	190001	NM
18f3.5	NM	NM	180051
20f3.5 (72mm)	421241	NM	NM
20f4	103001	130001	NM
20f3.5 (52mm)	NM	176121	210001
20f2.8	NM	NM	N.A.
21f4	220111	NM	NM
24f2	NM	176021	200001
24f2.8	242821	525001	700001
28f2	280001	450001	575000
28f2.8	382011	430001	635001
28f2.8 E Series	NM	NM	1790601
28f3.5	195531	1760201	2100001
28f3.5PC	179121 (never metered coupled)	NM	NM
28f4PC	174041 (never metered coupled)	NM	NM
35f1.4	350001	385001	430000
35f2	690101	920001	210001
35f2.5 E Series	NM	NM	1780801
35f2.8	255311	773111	521001
35f3.5PC	102105	NM	NM
35f2.8PC	851001/1st version	900001/2nd version	179091/current
45f2.8GN	710101	NM	NM
50f1.2	NM	177051	250001
50f1.4	532011	3940001	5100001
50f1.8	NM	1760801	2050001
50f1.8N	NM	NM	3135001
50f1.8 E Series	NM	NM	1055001
50f2	742111	3500001	NM
55f1.2	184711	400001	NM
55f2.8 Micro	NM	NM	179041
55f3.5 Compensating	N.A.		
55f3.5 Micro	211001	940001	NM
58f1.4	N.A.	NM	NM
58f1.2 Noct	NM	172011	185001
80f2.8AF	NM	NM	182501
85f1.8	188011	410001	NM
85f2	NM	175111	270001
85f1.4	NM	NM	179091
105f1.8	NM	NM	179091
100f2.8 E Series	NM	NM	1780701
105f2.5 Rangefinder	N.A. (never metered coupled)	NM	NM
105f2.5	194011	740001	890001
105f4 Bellows Lens	910001 (never metered coupled)	NM	NM
105f4	174011	186956	232001

NM = Never Manufactured N.A. = Data Not Available

Lens	Non AI	AI	AIS
105f2.8	NM	NM	182061
135f2	175011	190001	201001
135f2.8	163011	770001	900001
135f2.8 E Series	NM	NM	180031
135f3.5	111111	193501	290001
180f2.8	312011	360001	NM
180f2.8 ED	NM	N.A.	380001
200f2 EDIF	NM	176111	178501
200f3.5 AF EDIF	NM	NM	182501
200f4	270011	710001	900001
200f4 Micro IF	NM	178021	200001
300f2	NM	NM	182121
300f2.8 ED	601011	605101	604001
300f4.5	173101	510001	550001
300f4.5 ED	NM	190001	NM
300f4.5 EDIF	NM	200001	210001
400f2.8	NM	NM	N.A.
400f3.5	175121	176091	181501
400f4.5	400111 (never metered coupled)	NM	NM
400f5.6	256031	NM	NM
400f5.6 ED	260001	261178	NM
400f5.6 EDIF	NM	280001	287601
600f4 EDIF	NM	176121	178001
600f5.6	600111 (never metered coupled)	NM	NM
600f5.6 ED	650001 (never metered coupled)	NM	NM
600f5.6 EDIF	176011	176091	178501
800f5.6 EDIF	NM	NM	200001
800f8	800111 (never metered coupled)	NM	NM
800f8 ED	850001 (never metered coupled)	NM	NM
800f8 EDIF	NM	178041	179001
1200f11	120011 (never metered coupled)	NM	NM
1200f11 ED	150001 (never metered coupled)	NM	NM
1200f11 EDIF	NM	178051	179001

Zoom Lenses

Lens	Non AI	AI	AIS
25-50f4	NM	178041	201001
28-45f4.5	174011	210001	NM
28-50f4	NM	NM	N.A.
28-85f3.5	NM	NM	N.A.
35-70f3.5	NM	760701	821001
35-105f3.5-4.5	NM	NM	1820869
35-135f3.5-4.5	NM	NM	N.A.
35-200f3.5-4.5	NM	NM	N.A.
36-72f3.5 E Series	NM	NM	1800701
43-86f3.5	438611	810001	NM
50-135f3.5	NM	NM	811000
75-150f3.5 E Series	NM	NM	1790801
70-210f4 E Series	NM	NM	2000001
80-200f4.5	101911	270001	NM
80-200f4	NM	NM	180081
80-200f2.8 ED	NM	NM	181000
85-250f4-4.5	184711	NM	NM
85-250f4	157911	NM	NM
50-300f4.5	740101	980001	NM
50-300f4.5 ED	NM	175111	183001
100-300f5.6	NM	NM	N.A.
200-400f4 ED	NM	NM	182121
180-600f8 ED	NM	174041	174701
200-600f9.5	170111	N.A.	NM
200-600f9.5 ED	NM	N.A.	305001
360-1200f11 ED	NM	170431	174701

NM = Never Manufactured N.A. = Data Not Available

Lens Introduction Dates

Lens Model	Introduction	Discontinued
6f2.8	1969	S.I.P.
6f5.6	1972	1977
7.5f5.6	1967	1971
8f2.8	1970	S.I.P.
8f8	1963	1966
10f5.6 OP Fisheye	1969	1976
13f5.6	1976	S.I.P.
16f3.5	1973	1978
16f2.8	1979	S.I.P.
15f5.6	1973	1979
15f3.5	1980	S.I.P.
18f4	1974	1981
18f3.5	1982	S.I.P.
20f3.5 (72mm)	1969	1973
20f4	1974	1978
20f3.5 (52mm)	1979	1984
20f2.8	1985	1990
21f4	1959	1967
24f2	1978	S.I.P.
24f2.8	1967	1990
28f2	1971	S.I.P.
28f2.8	1974	1990
28f2.8 E Series	1980	1986
28f3.5	1959	1985
28f3.5PC	1981	S.I.P.
28f4PC	1974	1980
35f1.4	1970	S.I.P.
35f2	1965	1990
35f2.5 E Series	1979	1983
35f2.8	1959	1985
35f3.5PC	1961	1967
35f2.8PC	1974	S.I.P.
45f2.8GN	1969	1977
50f1.2	1979	S.I.P.
50f1.4	1963	1990
50f1.8	1979	1983
50f1.8N	1983	1990
50f1.8 E Series	1979	1986
50f2	1959	1980
55f1.2	1965	1978
55f2.8 Micro	1982	1990
55f3.5 Compensating	1963	1964
55f3.5 Micro	1964	1978
58f1.4	1959	1960
58f1.2 Noct	1978	S.I.P.
80f2.8AF	1983	1988
85f1.8	1964	1977
85f2	1977	1988
85f1.4	1982	S.I.P.
105f1.8	1982	S.I.P.
100f2.8 E Series	1979	1981
105f4 Rangefinder	1959	1961
105f2.5	1959	S.I.P.
105f4 Bellows Lens	1969	1976

S.I.P. = Still in Production

Lens Model	Introduction	Discontinued
105f4 Micro	1974	1984
105f2.8	1984	1990
135f2	1976	S.I.P.
135f2.8	1965	1984
135f2.8 E Series	1981	1984
135f3.5	1959	1985
135f4 Short Mnt	1961	1967
180f2.5 Short Mnt	1955	1966
180f2.8	1970	1981
180f2.8 ED	1982	1989
200f2 EDIF	1980	S.I.P.
200f3.5 AF EDIF	1983	1988
200f4	1963	1990
200f4 Micro IF	1981	S.I.P.
250f4 Short Mnt	1955	1963
300f2	1984	1990
300f2.8 ED	1975	1977
300f2.8 EDIF	1978	1990
300f4.5	1964	1990
300f4.5 ED	1975	1978
300f4.5 EDIF	1979	1989
350f4.5 Short Mnt	1958	1964
400f2.8 EDIF	1985	S.I.P.
400f3.5 EDIF	1978	S.I.P.
400f4.5	1966	1979
400f5.6	1973	1974
400f5.6 ED	1975	1978
400f5.6 EDIF	1978	S.I.P.
500f5 Short Mnt	1955	1961
600f4 EDIF	1979	S.I.P.
600f5.6	1964	1978
600f5.6 ED	1975	1978
600f5.6 EDIF	1978	S.I.P.
800f5.6 EDIF	1986	S.I.P.
800f8	1964	1978
800f8 ED	1975	1978
800f8 EDIF	1979	1989
1000f6.3 Shor Mtn	1958	1965
1200f11	1964	1978
1200f11 ED	1975	1978
1200f11 EDIF	1984	1988

Zooms

25-50f4	1980	1985
28-45f4.5	1974	1977
28-50f4	1984	1986
28-85f3.5-4.5	1986	1990
35-70f3.5	1978	1984
35-70f3.3-4.5	1985	1989
35-105f3.5-4.5	1984	1990
35-135f3.5-4.5	1985	1989
35-200f3.5-4.5	1986	S.I.P.
36-72f3.5 E Series	1982	1984
43-86f3.5	1963	1981
50-135f3.5	1984	1985
75-150f3.5 E Series	1980	1984
70-210f4 E Series	1982	1986
80-200f4.5	1970	1981

S.I.P. = Still in Production

Lens Model	Introduction	Discontinued
80-200f4	1982	1990
80-200f2.8 ED	1983	1986
85-250f4-4.5	1959	1969
50-300f4.5	1965	1980
50-300f4.5 ED	1978	S.I.P.
100-300f5.6	1984	1990
200-400f4 ED	1984	1988
180-600f8 ED	1974	S.I.P.
200-600f9.5	1963	1976
200-600f9.5 ED	1977	1981
360-1200f11 ED	1974	1981
120f4 Medical	1981	S.I.P.
200f5.6 Medical	1963	1984
500f5	1963	1969
500f8	1969	1984
500f8N	1984	S.I.P.
1000f11	1965	1976
1000f11	1977	S.I.P.
2000f11	1969	1988

Teleconverters

TC-1	1978	1981
TC-2	1978	1983
TC-14	1979	1983
TC-14A	1984	S.I.P
TC-14B	1984	S.I.P.
TC-14C	1984	1990
TC-16AF	1984	1987
TC-16A	1986	1991
TC-200	1978	1983
TC-201	1984	S.I.P.
TC-300	1978	1983
TC-301	1984	S.I.P.

Autofocus

20f2.8 AF	1989	S.I.P.
24f2.8 AF	1986	1991
28f2.8 AF	1986	1991
24f2.8N AF	1991	S.I.P.
35f2 AF	1988	S.I.P.
28f2.8N AF	1991	S.I.P.
50f1.8 AF	1986	S.I.P.
50f1.8 N AF	1989	S.I.P.
50f1.4 AF	1986	1991
55f2.8 Micro AF	1986	1989
60f2.8 Micro AF	1989	S.I.P.
85f1.8 AF	1988	S.I.P.
50f1.4N AF	1991	S.I.P.
135f2 AF DC	1990	S.I.P.
105f2.8 Micro AF	1990	S.I.P.
180f2.8 EDIF AF	1986	1989
180f2.8 N EDIF AF	1988	S.I.P.
300f4 EDIF AF	1987	S.I.P.
300f2.8 EDIF AF	1987	1989
300f2.8 N EDIF AF	1988	S.I.P.
600f4	1987	

S.I.P. = Still in Production

Lens Model	Introduction	Discontinued
Autofocus-Zooms		
24-50f3.5-4.5 AF	1988	S.I.P.
28-70f3.5-4.5 AF	1991	S.I.P.
28-85f3.5-4.5 AF	1986	1991
28-85f3.5-4.5N AF	1991	S.I.P.
35-70f3.3-3.5 AF	1986	1989
35-70f3.3-4.5 N AF	1989	S.I.P.
35-70f2.8 AF	1988	S.I.P.
35-105f3.5-4.5 AF	1986	1991
35-105f3.5-4.5N AF	1991	S.I.P.
35-135f3.3-4.5 AF	1986	1989
35-135f3.3-4.5 N AF	1989	S.I.P.
70-210f4 AF	1986	1988
70-210f4-5.6 AF	1988	S.I.P.
75-300f4.5-5.6	1989	S.I.P.
80-200f2.8 ED AF	1988	S.I.P.

S.I.P. = Still in Production

NIKON ACCESSORIES:
THE EVOLUTION

Through the evolution of the rangefinder camera, Nikon learned the importance of a complete system of accessories to complement their bodies. By developing a complete line of accessories to aid the photographer in solving problems, Nikon extended the range of photographic possibilities with its equipment. Starting with the F, the company spent as much time developing system accessories as lenses and bodies. It's because of this dedication to a complete system from the beginning that so much has been developed, resulting in the systems available today. The Pro models have always had the widest assortment of accessories. The accessories were designed to be integrated with the bodies since they need to have the flexibility and problem solving capabilities required by photographers. At the same time, the other bodies have their own special and unique accessories, providing a variety of special functions.

The F, with its slide-down back design, utilized a motor drive very similar to that designed for the rangefinder cameras. The motor drive for the F is the **F-36**. It can use two different portable power sources, **Cord Pack** and **Cordless**. The motor itself, the F-36, is the same in either case and was originally fitted to the body at the factory. There is a special **Motor Drive Plate** required (bottom of camera when the back is removed) that is fitted to the base of the camera. It looks like the original plate but has two holes and a lever that synchronize the body's film transport and mirror box operation with that of the motor cocking mechanism. It's possible to add a motor drive to the body that was not factory mated, but there is only a 50/50 chance that it will sync properly. If they fail to do so, a repair technician must be found to make the internal adjustments required to synchronize the two units.

The **Standard Battery Case** (known by most as the Cord Pack with Connecting Cord) uses six "C" batteries and connects to the F-36 via a connecting cord (3'length or 30'length available). The top of the battery pack has a firing button that can operate as a remote cable release, with settings for "S" (single frame firing), "C" (continuous frame firing) or "L" for lock. The F-36 also has a firing button on its back at the center of the motor drive. The outside ring sets the drive to either "S", "C" or "L". Directly to the right of the firing button on the motor drive is the film counter which counts down the number of frames left on the roll of film. When a fresh roll of film is inserted into the camera, the thumb dial must be turned in the direction of the arrow, setting the counter to 36. Once the counter hits "0", the drive will stop firing and must be reset before it will fire again. This dial can also be set to another number if a limited burst of shooting is desired.

To the left of the firing button is the firing rate dial that must be set to match the shutter speed in use. There is a printed chart on the back of the F-36 that provides the correct setting for the firing rate as related to the shutter speed. When the cordless battery pack is added, the motor drive gains two features. There is a firing button on the top of the handle for easier operation and handling with a locking collar for the firing button. There is a "S"/"C" button on the side of the handle that overrides the S/C around the firing button on the back of the drive.

The camera can be fired from either the back or top buttons, but must still have the firing rate set on the back for proper operation. There are two

models of the cordless battery. The second model has the addition of a front locking pin (missing on the first model) that locks the handle of the cordless pack against the body for extra security when the body is attached to the drive. Nikon made special film cassettes to use with the motorized F. The **F Cassette** is a reloadable 36exp cassette that only works in the F body because its film gate is operated by the O/C key on the F back.

The F-36's top speed is 4FPS with the mirror on the body locked up, which in the early sixties was fast. To do any remote work, a **Relay Box** is needed which boosts the power signal to the drive from the remote device. This same relay box is required when using the intervalometer (**NC-1**), **Nikon Wireless Control** (Model 2), Special AC Unit (**MA-1**) or when doing extremely remote work via a number of connecting cables linked together. This same relay box is used when operating the F-250, 250 exposure film back.

The **F-250 Exposure Back** uses the same F-36 motor drive, but it's permanently mounted to the F-250 chassis. The Cordless pack will not mount on the unit and cannot power it, so the Standard Battery Case is the main power supply. The **MZ-1 250 Exposure Cassette** is required in the F-250 and accepts 33' of film. Two are required, one for the unexposed and the other for exposed film. The first 12" of film are lost in the loading. The process must be done in daylight to get the leader into the take up cassette properly. There are special gates on the MZ-1, operated by the controls on the F-250. They open and close the gates, preventing fogging of the film during the loading process.

Nikon makes a **Bulk Film Loader** (must be used in the darkroom) for loading the MZ-1 directly from bulk film. The Bulk loader can be preset to load 36 to 250 frames of film. Practice is required to use this loader before going into the dark. The loader comes with an extra bulk spool which can be removed as long as the bulk film purchased already has its own reel as most do.

There are two **Pistol Grips** for the F, one model for firing a non-motorized body and a second model for firing a motorized body. The normal pistol grip has a cord that directly connects to the camera shutter release button from the pistol grip. The motorized pistol grip can have either two cords, one going to the battery and then to the motor with a cord pack, or one cord going directly to a cordless pack if it's connected to the pistol grip.

The Nikon F is also capable of doing large format photography with the aid of the Speed Magny system. This is an awkward system at best. The slide-down back of the F is removed and the F body is mounted directly to the Speed Magny. When a picture is taken, the light passes through the camera lens and off mirror, then through a field lens to a mirror where it's bounced 90 degrees directing it to an EL Nikkor 50f2.8 enlarging lens. The enlarged light path hits another mirror at 90 degrees and then strikes the film. During this process, there are 4 stops of light lost.

An image that's 3 1/4" X 4 1/4" or 4"X5" is possible, depending on the model of Speed Magny used. The **Speed Magny Model 100** works only with Polaroid Film 107, 108 while the **Speed Magny Model 45** has a Graflox back for 4x5 film holders. Not all lenses can be used with this system perfectly; on some focal lengths there can be severe vignetting. The Speed Magny also changes the effective focal length of the lens in use by as much as 200%.

The F had 14 interchangeable viewing screens when first introduced, with more added to the system later bringing the total to 19 (see F4 section for listing as they did not change). There are also viewing aids for the camera, the **Right Angle Finder** and **Eyepiece Magnifier**. When used with the original F Eyelevel Finder, an adapter is needed to convert the square to a round viewing hole. This design was later dropped when all finder view ports were converted to round holes. The Right Angle Finder provides 90 degrees of relief so that the camera can be on the ground, for example, and allow for viewing through the camera. This provides complete screen viewing but the Eyepiece Magnifier does not; it only magnifies the center portion of the screen, coming straight back from the finder providing no angle of relief. The F has other interchangeable finders which are described in its body chapter.

There are other prism accessories such as the **SF-1 Ready Light Adapter** and F **Hot Shoe adapter** that allows ISO flash units to be mounted to the body and synchronize without the use of a PC cord. An eyecup is available for the F to aid in keeping extraneous light from hitting the eyepiece. The F has diopters for those who wear prescription eyeglasses but do want to wear them when using the camera. The diopters and eyecup originally manufactured for the F are discontinued. The Re-

placement Eyepiece for the FA and its eyecup DK-3 can be used on the F as a substitution.

The F was probably the most custom modified camera ever made by Nikon. Coming as it did early in the development of the modern photographic system, it was subject to much experimentation and modification. Many of these modifications were done at the factory as custom orders (rarely done today), some where done by independent technicians. Many of these modified cameras are available on the used market but have been left unmentioned in this book. This is one reason why the F camera is now becoming quite collectable and whole books are devoted to just the F.

The Nikkormats do not have as many accessories as the F since they were designed with simplicity in mind. They share the same Right Angle Finder and Eyepiece Magnifier as well as cable release AR-2. The **AR-2** is an extremely well made 9" cable release with a locking plunger that fits the special Nikon cable release threads. The only accessory specifically for the Nikkormats, (and it's for the FTn only) is the **Accessory Shoe**. This allows a flash to be mounted to the camera above the eyepiece but doesn't provide for hot shoe connection. The flash is still required to be plugged into the PC socket for operation. The Nikkormat shared eyecups and diopters with the F since the eyepiece diameter and eyepiece-to-camera-back distances are the same. The Nikkormat accessory line did not change until the ELw and EL-2 came on the market. Then a winder, the **AW-1**, was introduced. This is a simple winder that will advance the film as fast as the shutter release button is depressed.

When the F2 came on the market, an exciting new set of accessories came with it. Nikon probably spent as much time designing the accessories for the F2 as they did the F2 itself. The most prized accessory for the F2 was the motor drive.

Three different motor drives were manufactured for the F2, the MD-1, MD-2 and MD-3. The **MD-1** was the first introduced and is exactly the same as the MD-2 (the second) except for two features. The MD-1 is missing two contacts on the back of the drive (these mate with MF-3 back) and its SC firing button is a large, square lever. This was later changed to a smaller, round firing button on the MD-2. The MD-1 was replaced within two years by the MD-2, and both units have the following features in common.

The most common power source is the **MB-1**

battery pack. It can use either ten AA batteries (held in the **MS-1** battery clip) or optional **MN-1** Nicads (which require the **MH-1** charger). It can also be powered by the **MB-2** battery pack which uses eight AA batteries (held in the **MS-2** battery clip). The MB-1 is the standard battery pack for the MD-2 because its greater voltage gives the MD-2 a faster firing rate. The MB-1 with AA batteries has a top speed of 4FPS. The MN-1 Nicad provides 5FPS. The MB-2 provides only 2.7FPS. NOTE: the battery holders for the MB-1 (the MS-1) are long discontinued and hard to find. This holds true for the MS-2, battery holders for the MB-2.

The MB-1 can be detached from the MD-2 and operated via the **MC-7** cord. This allows the MB-1 to be left in your pocket for cold weather operation. There is also an AC power source, the **MA-4** and a cold weather Battery Pack Jacket **MA-3** that connects to the motor drive via a **MC-2** cord.

Attaching the MD-2 to the F2 body requires the removal of the **O/C key** on the base of the camera. A spot on the inside of the MD-2's handle accepts the O/C key when the camera is attached to the motor drive so it can't get lost. There are no other modifications required to attach the F2 body to the MD-2, a vast improvement over the F.

The MD-2 has a power film rewind. Push up on a lever on the back-right of the drive next to the film counter; the button in the middle must be depressed first. This lever also clears the counter on the MD-2 while disengaging the film take-up spool. On the far left there are two levers and one button. The left-side lever which lifts up and slides to the left opens the camera back. To the right of this is a small button that must be pushed while cocking the right hand lever to the right. This procedure rewinds the film. Like the F-36, the film counter dial can be set to fire off either the whole roll of film or a given number of frames. The MD-2 also has a firing rate dial on the back which must be set like that on the F-36 to match the shutter speed with the FPS rate.

The firing button on the top of the handle (the **SC Button**) controls the "S"(single frame), "C"(continuous) and "L"(lock) feature which is the same as that on all Nikons. The SC button can be removed from the drive handle by depressing the two little buttons on the side and pulling up. The SC Button can then be attached to the **MC-1** cord (available 3', 10' or 33' long) for remote firing. There is also a terminal on the front of the drive

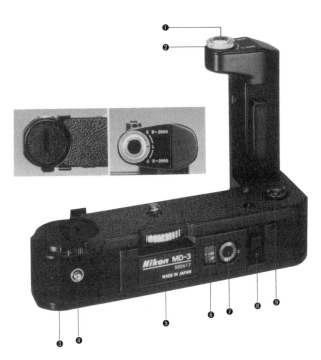

Motor Drive MD-3.

that will accept the **MC-10** cord (10' long with its own firing button) for remote firing.

The **MD-3** motor drive is a simplified unit with a slower firing rate. It has no film rewind but a smaller price tag than the MD-2. With the MD-3 there is no need to remove the O/C key from the body for connecting the motor and body. The key folds down and slips into a slot in a ring on the MD-3. This ring turns when released by a button, opening the camera back. There is no firing rate converter on the MD-3, which always provides the same firing rate depending on the power source. It will provide 3.5FPS with the MB-1 powered by AA batteries, 4FPS with MN-1 Nicads or 2.5FPS with the MB-2 attached. The MD-3 was sold with the MB-2 because it was meant to be a lighter outfit providing simple performance. The MD-3/MB-2 weighs 5.4oz less than the MD-2/MB-1. The MD-3 uses the same remote units as the MD-2 except it does not accept the MC-1 cord.

The MC-1 fires the drive in the mode set on

the SC button as does the MC-10 when it's in use. The **MC-3** cable and the **MR-1** button attach to the terminal on the front of the drive and provide a second firing button as well as a port for the AR-2 cable release. Later, the **MR-2** would take the place of the MR-1 providing the same function.

Other remote firing devices are the **ML-1 Infrared Remote**, the **MT-1 Intervalometer**, the **MW-1 Radio Remote** and the **Pistol Grip II**. The ML-1, MW-1 and MT-1 are unique remote triggering systems that only Nikon could have developed. The **ML-1** Modulite is an infrared wireless remote with a transmitter and receiver unit. They work via modulated light signals and are powered by AA batteries, four in each unit. The receiver stays with the camera and is connected to the camera's motor drive via the **MC-8** cord. It has a range of 200'. This is a line-of-sight unit and limited by the requirement of keeping the transmitter and receiver in sight of each other.

The **MW-1** is a solid-state radio control remote firing unit capable of firing up to 3 motorized cameras. It works on the CB band (no permits required) at 80 MW, hence the name MW-1. It can operate up to 2300 feet and does not have to be in sight; powered by AA batteries, each unit requires eight.

The **MT-1** Intervalometer can fire motorized cameras at precise intervals and is powered by 8 AA batteries for remote use. The trick with this unit is to calculate and set the interval timing desired. There is a pulse setting and a frame setting. The pulse setting regulates the number of frames fired and is related to the shutter speed and firing rate of motor drive. The MT-1 cannot easily be set to fire 3 frames every 5 minutes, rather experimentation with the pulse and frame settings is required to achieve the desired firing. It can work with the MW-1.

The F2 accepted a number of accessory backs. The **MF-3** attaches to the camera and when used in

Camera Back MF-3.

conjunction with the MD-2 (not the MD-1), stops the film rewinding process in time to leave the film leader sticking out of the cassette.

The **MF-1 250 Exposure Back** requires the MD2/MB-1 to drive and power it. The MF-1 can shoot up to 250 exposures (33' of film) and uses the same MZ-1 cassettes as the F-250. Unlike the F-250, it does not contain its own motordrive.

Mounting the MF-1 to the camera is a slow procedure. First, the camera back must be removed from the F2. Then the F2 and MD-2 (minus the battery pack), which have been connected together, are fitted into the MF-1 and locked into place. Next the power lead of the MF-1 is plugged into the base of the MD-2 handle. Finally, the MB-1 is attached to power the whole assembly.

The **MF-2 750 Exposure** can accept an entire 100' roll of bulk film, exposing as many as 750 exposures. It requires the **MZ-2 750 Exposure Cassette** that accepts an entire 100' roll of film. There is no need of a bulk loader since the bulk film can be placed directly into the cassette. The MF-2 has a cutter built into the unit allowing smaller amounts of film to be fired and removed from the back. It mounts in the same fashion as the MF-1.

The **MF-10 Data Back** came with a matched F2 body, MD-2/MB-1 motor drive and AH-1 hand strap. The setup is the **F2 Data**. The F2 body is not specially modified to accept the MF-10 but does come with an "S" screen which shows where the data will be imprinted on the frame. It has a small masking plate (it's removable) located on the right side frame of the shutter opening. It creates a shadow on the picture to allow info to be imprinted.

The MF-10 will imprint the date (via the **Dating Unit**), the time (via the **Timepiece Unit**) and a hand written message via the **Memo Plate**. The Timepiece is a little clock that slips into the side of the MF-10 right above the Dating Unit. The camera triggers the MF-10 into action via a cord connected to the PC socket, firing the back in the same manner that it fires a flash. The **MF-11** is the data back for the MF-2 750 exposure back, performing the same functions as the MF-10.

The F2 has a Speed Magny system similar to the F's. The **Speed Magny 100-2** is the same as the Model 100 for the F but accepts the F2 body. The **Speed Magny 45-2** accepts a 4x5 film holder.

The F2 has interchangeable prims (described in the body chapter) and screens; the screens are the same as those for the F. It also accepted the Right Angle Finder and Eyepiece Magnifier as the F. During the production of the F2, the Right Angle Finder was replaced with the **DR-3**, a nicer unit with a lockable diopter correction. The F2 has the **DL-1 Illuminator** available for the DP-1 and DP-11. It attaches to the eyepiece and goes over the prism to shine a small wheat lamp over the needle enabling the photographer to read it in low light when viewing through the prism.

The FM was the first non-Pro body to be motorized. The **MD-11** is a clean design. It's a one piece unit with the battery box contained in the base of the drive with a well formed handle on the right side. The firing button and mode selector ("S" and "C") switch are on top of the handle. At the base of the handle is a terminal socket to accept the same remote firing devices used with the MD-2.

The MD-11 quickly attaches to the base of the FM without any alterations or modifications; there are no levers or keys to be turned. The MD-11 offers no film rewind but does offer 3.5FPS advance. It uses eight AA batteries and is turned on by a switch on the back of the motor. As long as the motor drive remains on, the camera's meter is on, so the camera's batteries can drain during operation if care is not taken. If the camera is removed from the motor drive with the power switch left on, it's possible to short out the drive and charge the mechanism through half its cycle. If this occurs, use a quarter and short out the four brass contacts on the drive to reset. The winding key on the drive will turn, stopping it when it's parallel to the drive. Cock and fire the body and place back on the drive. They should both be in sync now. Remember to change the collar surrounding the shutter release on the FM for motorized operation. It must be set with early models, refer to FM body chapter for more information.

The FE also accepts the MD-11, but the MD-11 was replaced with the **MD-12** shortly after the FE came out. The only difference between the two units is that the MD-12 has a strengthened handle with a microswitch which shuts the camera's meter off after 16 seconds. To turn the meter back on, depress the firing button on the drive. This is a battery saving feature. If the camera is placed in a camera bag with the drive left on, movement in the camera back can hit the firing button and effectively keep the camera on, draining the batteries.

The FE accepts the **MF-12 Data Back** that

imprints the date/time/frame number. This is connected to the camera via a connecting cord plugged into the PC Cord. The connecting cord is the weak link in the system and is often lost or broken. It can still be obtained, but with much difficulty. The MF-12 has a external battery pack, the **DB-3**.

The EM has its own winder, the **MD-E**. It provides 2FPS and no film rewind. It's a small unit that fits under the EM. The EM can also utilize the **MD-14** drive made for the FG. The FG's own specialized motor drive, the MD-14, delivers 3.2FPS on the "HI" setting or 2FPS on "LO" when attached to the FG. These speeds are not available to the EM.

The handgrip on the FG must be removed to accept the MD-14, otherwise no other modifications are necessary. There is no firing button on the drive; the shutter release button on the body is used. There is no film rewind with the MD-14.

The FG has the **MF-15 Data Back**. The MF-15 can imprint date/time/or a sequential number up to 2000. The MF-15 also has a quartz clock and provides an alarm feature. It does not require an auxiliary cord to connect the back and body. It fires via contacts on the inside-back of the body and back.

The FM-2 and FE-2 use the same motor drive as the FE/FM, the MD-12. Neither body requires any special modifications to accept the drive. Removing the body from the drive with the drive's power on can cause problems. Refer to MD-11 for cure of drive out of cycle. The MD-12 accepts all the accessories that remotely fire the MD-2.

The FE-2, FM-2 and FA accept the same data back, the **MF-16**. It can imprint date/time or a sequential number up to 2000. There is no cord required between the back and body because the contacts are built into the body. The FA can accept the MD-12 motor drive, but it only provides motorized operation and meter-off microswitch features.

Its own special motor drive is the MD-15. The **MD-15** requires that the handgrip and the small cap on the base of the FA be removed for the two

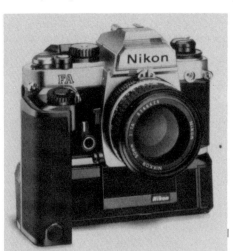

Motor Drive MD-15.

units to be connected. There is a small hole on the MD-15 to hold the cap removed from the body so it won't be lost. The MD-15 powers (takes 8 AA batteries) the camera's as well as its own operations, so the batteries do not need to be in the body for operation.

The MD-15 design is different from that of the other small drives made by Nikon with the base portion being slightly kicked out for more balance. It fires up to 3.2FPS and has an "S" and "C" switch. The firing button has a microswitch like that of the MD-12 that turns off the camera's meter after 16 seconds to save batteries.

The F3, being a Pro-model, had an assortment of accessories developed to increase its versatility. The motor drive, **MD-4**, was a masterful design utilizing many new advances in technology. The MD-4 can deliver 5.5FPS in normal operation with 8 AA batteries and 6FPS with the mirror locked-up using the **MN-2** rechargeable nicad (requires **MH-2** for charging). This same source also powers the F3 body.

To attach the MD-4 to the F3, a small motor drive cap on the base of the F3 must be removed and can be stored in a small slot in the **MS-3** AA battery holder or MN-2. The MD-4 has an "S", "C" and "L" collar around the firing button which is at the top of the handle. The MD-4 does not need an additional battery compartment, as it's built into the motor drive. This feature caused the tripod socket to be placed to the far right of the drive, but it can be centered with the **AH-2** or **AH-3** tripod adapter plate. The MD-4's battery compartment is kicked out giving the F3 good balance when hand held.

The operation of the MD-4 is very clean and easy. The back of the motor drive holds the few controls it requires. The drive has film rewind which takes two steps to operate. First, push the lever to the left on the back of the MD-4 marked number "1"; this requires pushing in a button to disengage the lever. Next, push up the lever on the far left marked number "2". This starts the film rewinding which must be terminated by returning the number "2" lever to its original po-

PORTFOLIO

Right

These Tufa towers were photographed with a 16f/2.8 and F3HP. Keeping the horizon going through the center of the photograph minimized the fisheye effect.

Below

This Peregrine Falcon was photographed with a 200f/4 micro and F3HP. This is an endangered species and through my work with the species, I was able to get within two feet of the bird.

B. MOOSE PETERSON

B. MOOSE PETERSON

B. MOOSE PETERSON

B. MOOSE PETERSON

Above
Famous Half Dome in Yosemite Valley was photographed with a 20f/2.8AF and F4s. The lens was set to manual focus and the body to matrix metering. Aperture priority took care of the quick, changing light.

Left
The San Joaquin Kit Fox was photographed with a 300f/2.8AF and F3HP. This endangered species was photographed outside its den entrance only 10 feet away.

The Snowy Egret was photographed with an 800f/5.6 and F3T. A PK-11 extension tube was used because the egret was closer than the lens could focus.

The sunset being reflected by on of the ponds at Gray Lodge Wildlife Refuge was taken with a 20f/2.8AF and F4s hand held. The focus was set to manual and camera set to aperture priority.

These Elegant Terns were photographed at their nesting colony with an 800f/5.6 and a N8008. I was working in a blind on the edge of these nesters, needing the 800mm to get the cropping I desired. Matrix metering took care of the tricky exposure.

These long Tufa towers are silhouetted by the rising sun at Mono Lake and were photographed with a 15f/3.5 and F3HP. The camera was set at aperture priority, shooting at 1/8 second.

These Greater Sandhill Cranes were photographed with a 300f/4AF (set on manual focus) and F4s. This early morning flight was photographed with the camera set on aperture priority. The camera taking care of exposure as I panned. Matrix metering rendered quick and accurate exposure for the changing scene.

These sunning White Pelicans were photographed with an 800f/5.6, TC14B and F4s. The pelicans were very friendly, but were 40 yards away in the shallow marsh. The matrix metering and aperture priority helped with the sun coming and going out of the fog.

This close call with bicycle racers was photographed with an 18f/3.5 and F3HP. Because an 18mm was used, the photographer had to hang out in the street to get the photograph.

MICHAEL A. PLISKIN

MICHAEL A. PLISKIN

Above
This army parachute team performance at an air show at Edwards Air Force Base was photographed with a 300f/2.8 and N2020. The speed of the 300f/2.8 allowed for a fast shutter speed to freeze the action.

Left
The famous fire at the Pan Pacific Auditorium was photographed with a 24f/2.8, N8008 and SB-24. The 24mm lens helps to heighten the action by bringing the hoses into the picture.

This nesting Flammulated Owl was photographed with an 800f/5.6, F4s, two SB24's (working TTL) and a PK-11A. This owl is the size of a dollar bill and the extension tube let me focus down to 14 feet.

sition when the film has been rewound. Two red LED's on the back of the MD-4 serve as battery checks (two lights mean there is full power); one light lights up every time the camera is fired. When using the camera remotely, this provides a visual indication of firing.

There is also a subtractive film counter like those on the MD-2, 3 and F-36. It operates similarly but has been improved with the ability to neutralize the counter. Simply turn the counter until the orange circle is aligned with the arrow and the counter is locked. This permits unlimited firing without the need to reset the counter.

The F3 has the **MF-4 250 Exposure Back**, but Nikon never introduced a 750 exposure back for the F3. The MF-4 gets its power from the MD-4 via a connection at the base of the handle on the drive. The MF-4 is a lot easier to attach to the camera. Just remove the back from the camera and attach the MF-4. It uses the same MZ-1 cassette and has the same basic operation as the MF-1.

The **MF-17** is the data back for the MF-4. This is a clone of the MF-11 data back system, modified to fit the MF-4. There are three other backs for the F3, the MF-6(6B), MF-14 and MF-18. The **MF-6B** (originally called the MF-6) if attached to the F3 with the MD-4, leaves the film leader sticking out of the cassette after the film has been rewound.

The **MF-14** is a data back that imprints date/time or sequential numbers up to 2000 in the lower right corner of the film frame. The **MF-18** does the exact same thing but imprints between the frames rather than on the film frame. The MF-18 can also leave the leader out of the cassette once the film is rewound. On the MF-6B or MF-18, this leader control can be cancelled by placing a small piece of electrical tape on the two gold contacts above the film counter on the MD-4.

The MD-4 has one additional accessory, the **MK-1** firing rate converter. The MD-4 does not have a firing rate button on the back of it like the F-36 or MD-2 because the MD-4's computer sets the firing rate automatically according to the shutter speed in use. For times when exact firing rates are required, the MK-1 is needed. It attaches to the base of the MD-4, plugging into the same terminal as the MF-4. The MK-1 can be set to fire the camera at either 1FPS (C1), 2FPS (C2), 3FPS(C3) or "CS" neutral. It also centers the tripod socket as with the AH-2 and AH-3.

One other accessory plugs into the terminal at the base of the handle, the **MC-17** or **MC-17s**. When plugged into the MD-4, either will simultaneously fire another motorized camera. There is a slight delay in the firing of milliseconds, just enough to disallow the use of one flash for both cameras. The MC-17s is 15 inches long and the MC-17 it 10 feet long.

In the mid 1980's the accessory cord to fire the motordrives was changed. The **MC-12** is the ten foot release cord that plugs into the remote terminal of motor drives. It replaces the MC-10. It has a two pole switch that when pushed half way down, activates the meter and when pushed all the way down, fires the camera. This in turn, was replaced with the **MC-12a**, similar to the MC-12 but with a locking button to lock it in the firing position for time exposures. The AR-2 was replaced with the **AR-3** (9" long). This is the standard cable release with a locking collar. The MR-2 was replaced by the **MR-3**, the only difference being that it accepts a standard cable release.

With the introduction of the N2000 and N2020, a number of accessories were changed slightly. All connecting cords for the accessories received an "A" after their name (example MC-3A) signifying that they work with the automatic cameras.

The **MW-2 Radio Remote** was introduced at this time. It's smaller and lighter in design. The transmitter and receiver are powered by 4 AA batteries, reducing their weight and operating range. The operating range is also reduced by the single-action, two pole switch. Depressing partially focuses an autofocus camera and full depression fires the camera. It can still fire up to three cameras and retains the other features of the MW-1.

The **MF-19 Multi Data Back** is a new style of data back introduced with the N2000/N2020. The MF-19 has five possible imprints, sequential number up to 99999 or year/month/day/hour/minute. It has a built-in intervalometer which can be set to take a specific number of frames at a specific interval. It can be set to take a picture at the same time each day for up to 99 days. Though desirable, this feature has one drawback, the camera itself. The N2000 and N2020 are excellent cameras, but there is some slack in the transport of film across the film plane. They cannot deliver exact film registration, so if used in the intervalometer mode, the photographs can be off by as much as 20%.

Nikon MF-20 Data Back.

The N8008 changed everything with its internal computers; accessories would never be the same again. The basics, such as the MW-2, MT-2 or other units and cords did not change, but the camera backs revolutionized the capabilities of the photographer. The **MF-20 Data Back** is pretty basic with simple date/time/year imprinting. The **MF-21 Multi-Control back**, however, excited the photographic community with its remarkable capabilities. It has Data Imprinting, Interval Timer, Long Time Exposure, Auto Exposure Bracketing, Freeze Focus, and can combine these functions.

The key to successful use of any data back, especially on a Multi-Control back such as the MF-21, is setting the original data correctly. The display should show correct Day/Month/Year (or combination of these) and Day/Hour/Minute. This is accomplished by first pushing the "MOD" button until a date setting appears in the display. Then push the "SEL" button until the correct number is reached. It will start blinking to indicate it has been selected. Next push the "ADJ" button to

select the correct number. This same method is used to reset any of the available functions.

This written text is not a replacement for the instruction book which should be read for complete explanation of the MF-21 functions, but is written to clarify some points and suggest others. Two important symbols are found on the MF-21, the straight-solid bar and the triangle. The straight bar besides a function means that function has been selected; the bar with the triangle means that function has been activated. By pressing the "PRN" button, the "PRINT" message will appear on the MF-21 screen and the current data will be imprinted on the film. Be aware of that message, as it can be set by accident and ruin a good photograph.

The **Interval Timer** on the MF-21, better known as an intervalometer, is an excellent tool applicable to many photographic problems. The MF-21 can be set to take a specific number of frames at specific intervals. That is, it can take two frames every five minutes to photograph the sunrise or one frame every two hours to document construction of a building. Access the interval timer by pressing the "FNC" button until the solid bar is right of the "INTERVAL" on the back of the MF-21. Then press the "MOD" button to access the other setting of the interval timer to obtain the correct setting for the situation. The "SEL" and "ADJ" are used to set the correct settings. Once all the information is set and the camera is ready to take the photograph, press the "S/S" button to activate the camera and start the interval timer. Remember to attach eyepiece cover, DK-8, to keep extra light from going into the eyepiece. Press the "S/R" button to cancel the function. It's very important to read Nikon's instruction book for correct operation of the interval timer. There are specific parameters in which the interval timer will not function.

The **Long Exposure** on the MF-21 operates the same as the Interval Timer but takes the same number of exposures at the same time every day. Setting of the back is the same as with the Interval Timer and uses the same parameters for correct operation. When setting this mode of operation, remember to have the eyepiece cover in place. Also, take into account the number of frames taken each day and how many days worth of film is in the camera in order to be able to return at the right time to replace the spent roll.

Nikon MF-21 Multi-Control Back.

The **Auto Exposure Bracketing** on the MF-21 is an excellent feature but cannot make up for bad photographic techniques. The MF-21 AEB can be set to fire 3 to 19 (at odd numbers) frames at increments of 0.3, 0.5, 0.7, 1.0, 1.3, 1.7, and 2.0 stops of compensation. The number of frames the camera will take is directly related to the bracketing compensation desired. If the improper number of frames or amount of compensation as they relate to each other is set, the camera will default to firing 3 frames. When the back is set to "AUTO BKT" and the "S/R" button is pressed, the triangle will blink that it's ready to go. With the N8008 film advance set to "CH or "CL", the camera will fire off the frames, counting the frames left to be fired by the AEB on the MF-21. Once finished, the AEB triangle will stop blinking to indicate is has completed the bracketing. If the N8008 film advance is set to "S", it must be fired one frame at a time until the set number of frames has been fired.

The **Freeze Focus Function** (Focus Priority) on the MF-21 is a brand new feature to be included into a camera back. The Freeze Focus is directly connected to the autofocus function in the N8008, and without the one there can't be the other. Once the Freeze Frame Function is selected on the MF-21, select either the "C", "S" or "M" focus mode ("M" is recommended) and focus on the subject. Remember the camera will be working off the two small autofocus brackets at the center of the camera screen and that's the point of focus where the subject must be to trip the camera. Press the shutter release to activate the system.

Recommendations for operation: when a number of exposures over a long period of time is desired, use the MC-12A cord to activate the system, and use of the lock on the MC-12A keeps the system activated for the entire time (otherwise a finger must be on the shutter release the whole time). The camera film advance needs to be set at either "CH or "CL" for this to work. With the MC-12A cord in use and set on "lock", the camera's electronic system will be activated and drawing on battery power. A word of warning, if the camera is left for eight hours or more in this mode, the batteries in the body could be drained and cancel all functions.

The F4 is the current Pro model camera body and with it comes a host of sophisticated, problem solving accessories never manufactured for a camera. There are three backs for the F4, the MF-22 Data Back, MF-23 Multi Control back and MF-24 250 exposure back. The **MF-22** is a basic data back with features similar to those of other units.

The **MF-23 Multi-Control Back** is the real jewel with many of the same basic features as the MF-21. The MF-23 has the following functions: Data Imprinting, Interval Timer, Exposure Delay, Long Time Exposure, Daily Alarm, Freeze Focus, Film Alarm, Film Stop, Auto Bracketing, and can combine these features. These functions are operated by a small control panel on the back of the MF-23 and setting the main date starts here. As on the MF-21, set the date and time properly to ensure correct operation for all other features. This description does not try to replace the instructions supplied with the MF-23, but does try to clarify and add to those instructions for easier operation.

The MF-23 has an indicator "bar" that moves around the display on the MF-23 as the function button is pressed. As with the MF-21, the MF-23 has a triangle that will be opposite the function that is currently in use.

The Auto Bracketing is activated by pressing the "BKT" button on the back of the MF-23 which causes a large, two part bar to come up on the display. A "+/−" compensation signal lights up inside the finder with its activation. The left bar has a "+" sign and the right bar has a "−" sign, indicating over or under exposure. The center "main" value of compensation as well as the amount of plus or minus compensation on either side of that "main" value can be set. The number of frames for either plus or minus can be set as well, two minus

Nikon F4s with MF-23 Multi-Control.

or three plus if desired for example, or any other combination. As with the MF-21, the number of frames that can be used is related to the amount of compensation set. With the MF-23, there is 0.0, 0.3, 0.7, 1.0 etc. to 7.7 positive and the same scale in negative compensation available. Once the desired compensation (pp. 92-96 in instruction book) is set, the bar will display the number of frames to be fired on both sides of zero compensation as well as the amount of compensation for the first frame and the compensation for the entire range.

The MF-23 can imprint data during any of these various functions, but careful reading of the instruction book is required to have data imprinting while a function is in use. The MF-23 has the ability to imprint the data on either the film frame itself or between the frames and like all other functions must be activated to operate. An extremely valuable tool is the possibility of having the shutter speed and aperture in use imprinted between the frames. Consult the instruction book for the numerous data sets that can be imprinted in the same manner.

The **Interval Timer Function** on the MF-23 operates basically the same as that on the MF-21. The specific interval between camera firings and the specific number of frames shot can be set to the photographer's requirements. There are a number of parameters which must be applied for proper operation of the Interval Timer (see the instruction manual). The **Exposure Delay Function** works like that of the MF-21, and takes the exact same number of frames at the exact same time each day. With either of these functions, make sure the eyepiece curtain is closed to avoid incorrect exposures.

Long Time Exposure permits extremely long exposures with an unattended camera for photographing things such as star trails where exposures of hours are required. The shutter speed must be set to "B" in the manual mode for this function to work. Exposures can be set for periods as long as 999 hours. With the MB-20, there are only 4 hours of battery life and only 6 hours with the MB-21.

The **Freeze Focus Function** (Focus Priority) on the MF-23 operates along the same lines as that on the MF-21. Push the "FNC" button until the bar is to the right of "FCS PRIOR". Next, make sure the focus mode is set to "M" and if using a lens with an "A" or "M" switch, that it too is set to "M". Now press the "S/R" button that activates the Freeze Focus and causes the triangle to be displayed.

Next, focus the lens manually remembering that the plane of focus must be broken for the camera to fire.

When trying to photograph a moving subject, the subject has to move through the center brackets in the finder for the camera to fire. Finally, all that is needed is to depress the shutter release button and the system is activated. As with the MF-21, the MC-12A can be utilized with its locking button to operate the F4s/MF-23 unmanned for long periods of time. With the F4s/MF-23 set up in this fashion and left unmanned, approximately seven hours of battery life are available with fresh batteries in the MB-21 or ten hours with the MB-20. If a 36 exposure roll will not be fired off in that period of time, use of a long life nicad hooked into the F4 with the MB-22 and MC-11A is advised.

The Freeze Focus Function is touchy, working off the electronic rangefinder in the F4s. Once the system is in place and operating, it should be checked to see that it will fire at the point desired. Use something with contrast, such as the instruction book (which should carried in case needed for review) and place it in front where the camera is set to fire. If the camera fires when this is done, it has been set correctly. If it does not, start the whole procedure over. When watching from a distance and the subject is seen going in front of an unresponsive camera, remember that the subject must go through the finder dead center at the brackets on the screen to make the camera fire. The F4 will be in this mode until the "S/R" button is pressed and the triangle on the display disappears. As long as the triangle is on, the camera cannot be fired manually. The camera must be back to manual to change film.

The **Film Alarm** can audibly warn the photographer when a preset amount of film is left to fire. The number at which the camera starts the warning is set by the photographer. For example: an audible warning can be set at 34 frames, informing the photographer that there are only 2 frames of film remaining. The **Film Stop** is a related function, letting the photographer set the number of frames he wants to fire during one burst of firing. Once the camera has fired that set burst, the shutter will lock and an audible alarm will notify the photographer.

The display on the back of the MF-23 provides a lot of information when activated. Once the shutter release button has been pressed, the back will

stay on for 16 seconds, going off when the F4 internal readout goes off. If the display on the MF-23 goes off sooner than that, especially within seconds, it means the batteries in the F4s are going dead rather than those in the MF-23. If that is the case, it can be easily determined by pressing the battery check on the MB-21.

The MF-23 displays 1) the shutter speed in use, 2) the f/stop in use if using a lens with a "CPU" that is directly connected to the body (an extension tube or teleconverter breaks the connection between the CPU and F4 so two dashes will replace the f/stop readout, 3)the number of frames fired, 4)the date, 5)the time. It will also display the functions that are in operation. Functions can be combined to do multiple functions at once, but careful reading of the instruction book is required. It's strongly suggested that the photographer study the function(s) before putting the back into use.

The **MF-24 250 Exposure Multi-Control Back** is the epitome of 250 exposure backs. It uses the same MZ-1 250 cassettes originally introduced with the F-250 and is powered by the MB-23. The MF-24 has all the multi-control functions descibed with the MF-23 making it an incredible tool for many applications.

All the remote firing devices, MC-12A, MW-2, MT-2, work with the F4s or F4e, but not with the F4 with the MB-20. The F4 does not have the electrical remote socket which is part of the MB-21 or MB-23 unit.

In 1990 the MB-23 Battery Pack and MN-20 Nicad were introduced to power the F4. The MB-23, MH-20, MN-20 are meant to completely replace the MB-21 power back.

The **MB-23** is a one piece unit with a battery clip that holds six AA batteries for quick and easy replacement of batteries. The MB-23 gives the F4 a higher profile and adds 4.1oz of weight compared to that of the F4 with the MB-21. The battery pack/handgrip (anatomical design) of the MB-23 is rubberized and attaches as one unit to the F4 with a thumb wheel. The battery tray has a button that must be pushed for removal. There is a detente to prevent the tray from dropping out when removing it from the MB-23. This wears out within a short period so be cautious of its prematurely falling out. It has a vertical firing button and a terminal for MC-12A, MF-24 and other remote firing devices. It has a centered 1/4-20 tripod socket.

The **MN-20 Nicad** and **MH-20 Charger** are for use in the MB-23. The MN-20 nicad fits in place of the battery tray in the MB-23, and provides more power and better performance at lower temperatures than AA batteries. The MH-20 is a high tech charger for the MN-20. It can charge two MN-20s, first charging one and, when completed, charging the second. The MN-20 is charged in 3 hours. After fully charging, the MH-20 goes into a trickle mode so batteries can be left on charge without damage to the nicad cells. When first introduced, the MH-20 was said to "discharge" the nicad before recharging. This has been found to be incorrect. The MH-20 has no facility for discharging the nicad.

The newest addition in remote firing devices, the **ML-2**, came in 1990. It's basically an autofocus version of the ML-1, a light-triggered, infrared emitting, remote control for motorized compatible cameras. Both transmitter and receiver run on four AA batteries. The transmitter can have as many as

Nikon F4s with MF-24 250 Exposure Multi-Control Back.

4500 flashes with alkaline batteries. The receiver can run up to 200 hours on standby. Recycling is 0.5 seconds. Unlike the ML-1, the ML-2 has three channels, capable of firing three separate cameras. Its range is 100 meters and it's possible to bounce its beam in operation. Shutter release lag time is 1 millisecond after triggering the transmitter. Light burst duration is 10 milliseconds.

Probably the one accessory that every Nikon owner buys is a lens shade. Nikon makes a wide variety of shades, custom fitting the lens angle-of-view and front element thread size to the maxi-

mum depth the shade can be without vignetting. Nikon is unique in that it manufactures metal lens shades (up until autofocus lenses) for its lenses. They are attached via screwing-in (HN), snapping-on (HS) or by clamping to the outside rim of the filter ring (HK). They also make a limited line of rubber (HR) shades. With the introduction of autofocus lenses, Nikon broke with tradition and introduced all plastic, bayonet style lens shades (HB). Other than certain exceptions, most shades must be used with the correct lens to get the maximum shading without vignetting.

Lens Shade Compatibility

Shade	Lenses
Screw-in	
HN-1 . . .	24f2.8, 24f2.8AF, 28f2, 35f2.8PC,
HN-2 . . .	28f2.8, 28f2.8AF, 28f3.5, 35-70f3.3-4.5, 35-70f3.3-4.5AF
HN-3 . . .	35f1.4, 35f2.8, 35f2, 35f2AF, 43-86f3.5, 55f2.8, 55f3.5,
HN-4* . .	45f2.8GN
HN-6* . .	55f1.2
HN-7* . .	85f1.8, 85f2, 80-200f4.5
HN-8* . .	105f2.5, 135f3.5
HN-9 . . .	28f3.5PC
HN-10* . .	200-600f9.5
HN-11* . .	50-300
HN-12 . .	52mm Polarizing Filter
HN-13 . .	72mm Polarizing Filter
HN-14* . .	20f4
HN-15* . .	18f4
HN-20 . .	85f1.4
HN-21* . .	75-150f3.5 E
HN-22 . .	35-70f3.5, (62mm)
HN-23 . .	85f1.8AF, 80-200f4,
HN-24 . .	70-210f4 E, 70-210f4-5.6AF, 75-300f4.505.6AF
HN-25* . .	80-200f2.8 ED,
HN-26 . .	62mm Polarizing Filter
HN-27 . .	500f8N
HN-28 . .	80-200f2.8AF

Shade	Lenses
Bayonet	
HB-1 . . .	28-85f3.5-4.5AF, 35-70f2.8AF, 35-135f3.5-4.5
HB-2 . . .	35-105f3.5-4.5AF
HB-3 . . .	24-50f3.3-4.5AF
HB-4 . . .	20f2.8AF
HB-6 . . .	28-70f3.5-4.5 AF

Shade	Lenses
EDIF "N" lens shade (repl)	
HE-1 . . .	300f2
HE-3 . . .	400f2.8, 800f5.6
HE-4 . . .	200f2, 300f2.8N, 600f5.6N
HE-5 . . .	600f4N
HE-6 . . .	300f2.8AF

Shade	Lenses
Slip-on	
HK-1* . . .	28-45f4.5
HK-2 . . .	24f2
HK-3* . . .	20f4
HK-4* . . .	35-70f3.5 (72mm)
HK-5 . . .	50-300f4.5, 50-300f4.5ED
HK-6* . . .	20f3.5 (52mm)
HK-7* . . .	25-50f4
HK-8* . . .	36-72f3.5 E
HK-9 . . .	18f3.5
HK-10* . .	50-135f3.5
HK-11* . .	35-105f3.5-4.5
HK-12* . .	28-50f3.5
HK-14 . . .	20f2.8
HK-15 . . .	35-200f3.5-4.5
HK-16* . .	28-85f3.5-4.5
HK-17 . . .	500f4P

Shade	Lenses
Snap-on	
HS-1* . . .	50f1.4
HS-2* . . .	50f2
HS-5* . . .	50f1.4
HS-6* . . .	50f2
HS-7* . . .	55f1.2
HS-8* . . .	105f2.5
HS-9	50f1.4
HS-10 . . .	85f2
HS-11* . .	50f1.8
HS-12 . . .	50f1.2
HS-14 . . .	105f2.8, 100-300f5.6

Shade	Lenses
Rubber (screw-in)	
HR-1 . . .	50f1.4, 50f1.8, 50f2
HR-2 . . .	55f1.2, 50f1.2
HR-3* . . .	R-10 Movie Camera
HR-4* . . .	50f1.8 E, 35f3.5 E
HR-5* . . .	100f2.8 E
HR-6* . . .	28f2.8 E

*=discontinued

There are other lens/shade combinations besides those recommended by Nikon that provide more protective shading for the front element without vignetting. One reason for changing shades from those recommended by Nikon could be a screw-in model is desired over a snap-on model. Often, retail stores do not have the exact shade Nikon recommends, and a substitution must be made. The following list comprises lens/shade combinations the author has tried and found to work without vignetting.

Lens	Shade	w/Filter	w/o Filter
24f2.8	HN-2	X	X
24f2.8	HN-3	X	X
24f2	HN-1	X	X
24f2	HN-2	X	X
28f2.8	HN-3	X	X
28f2	HN-3		X
35f2	HS-12	X	X
50f1.2	HS-9	X	X
50f1.4	HS-12	X	X
60f2.8AF	HN-23	X	X
35-70f2.8AF	HN-22	X	X

x = compatible

There are other possibilities that can be tried

with wide angle lenses but telephoto lenses do not have the same problem with vignetting because of their narrow angle of view. When selecting a shade not recommended, a simple procedure can insure the proper selection has been made.

Using a body with 100% viewing, attach the lens that needs the shade, making sure a filter is attached. Then attach the candidate shade. Close down the lens to the minimum f/stop and look at an even, bright light source. Now press in the depth-of-field button to close down the aperture and look at the four corners of the screen. If the shade attached vignettes, the corners will have dark shading. This means the shade itself is cutting into the picture. If this occurs, then that shade will not work with this lens. If working with a zoom, remember to try the shade at all focal lengths to guard against vignetting.

Many of the Nikon snap caps will attach to the shade so the lens and shade can be stored or used together with the protection of a cap. Some examples are the 77mm snap (which fits many shades) on the HN-23, or the 72mm snap on the HN-1, -2, -3. The slip-on cap for the 500f8N fits the shade for the 35-200 perfectly. Just give a cap a try on the shade to see if it fits.

Nikon Connecting Cords Nomenclature

Product #	Item Nomenclature	Description
*26	none	Connecting Cord F-36, 3'
*27	none	Connecting Cord F-36, 30'
*20	ME-3,	Basic Cord 3' household/household
*21	ME-6,	Basic Cord 6' household/household
*22	ME-15,	Basic Cord 15' household/household
*23	ME-30,	Basic Cord 30' household/household
*90	AE-1	Tripping Button
*91	AE-2	Alligator Clips
*92	AE-3	Twin Lugs
*94	AE-4	Mini Plugs
*95	AE-5	Banana Plugs
*41	none	Pistol Grip w/Microswitch (cord to F-36)
*24	MC-1, 10'	SC remote Cord, 10' long
*88	MC-1, 33'	SC remote Cord, 33' long
*89	MC-1, 66'	SC remote Cord, 66' long
*25	MC-2	Connecting Cord 8' MD-2 or 3 to MA-4
*28	MC-3	Coiled Cord Pistol Grip II to motor
*29	MC-4	Remote Cord 3' w/ Banana Plugs

* = discontinued

Product #	Item Nomenclature	Description
*77	MC-5	Connecting Cord motor - intervalometer
*95	MC-7	Connecting Cord Battery pack - MD-2 or 3
*75	MC-8	Connecting Cord Modulite to motor
	MC-9	Battery Grip Cord, between MA-3 to motor
131	MC-10	Remote Cord w/button release
*132	MC-11	External Power cord
*133	MC-12	Remote Cord f/MD-4 & 12
135	MC-14	Signal Cord MF-4
*130	MC-16	Connecting Cord MT-2
139	MC-18	Connecting Cord MW-2
4582	MC-3A	Coiled Cord f/Pistol Grip II
4583	MC-4A	Remote Cord w/Banana Plugs
4585	MC-8A	Connecting Cord ML-1 - motor
4586	MC-12A	Remote firing cord
4587	MC-16A	Connecting Cord f/MT-2

Cable Releases/Soft Releases

661	AR-1	Soft Shutter Release F/F2/Nikkormats
660	AR-2	9" cable release F/F2/Nikkormats
664	AR-3	9" cable release F3/FE2/FA/F4
2636	AR-4	Double cable release F/F2/Nikkormats
46	none	Pistol grip to F/F2/Nikkormats cable
667	AR-6	Pistol grip to F3/FE2/FA/F4 cable
668	AR-7	Double cable release F3/FE2/FA/F4
*669	AR-8	Converts F cable to fit standard socket
4417	AR-9	Soft shutter release FE2/FA/F3
2670	AR-10	Double cable release N8008/F4s/F3-MD4

Eyepiece Accessories

*2313	none	Rubber eyecup F/F2
*2316	DL-1	Photomic illuminator
*2320	DR-2	Right Angle finder
2388	DK-1	Converts HP eyepiece to standard thread
2406	DK-2	Rubber eyecup F3HP/F4
2362	DK-3	Rubber eyecup FE/FM/FE2/FM2/FA
2379	DK-4	Rubber eyecup F/F2/F3
2380	DK-5	Eyepiece shield N2000/N2020/N4004s
2393	DK-6	Rubber eyecup N8008
2394	DK-7	Converts HP eyepiece to standard thread
2395	DK-8	Eyepiece shield N8008
2939	none	Rubber eyecup N2000/N2020/N4004s
2355	DG-2	Eyepiece magnifier
2326	DR-3	Right angle finder

Miscellaneous Accessories

45	Pistol Grip 2	
635	AN-1	Leather neck strap
638	AN-4Y	Yellow nylon 1" wide neck strap
639	AN-4B	Black nylon 1" wide neck strap
4507	AN-6Y	Yellow nylon 2" wide neck strp
4508	AN-6W	Wine nylon 2" wide neck strp
2028	AP-2	Panaroma Head w/level & click stops 28mm-105mm
3062	DB-2	Anticold pack F3/FE/FE2/FA
2360	F-C	Adapts Nikon Bayonet F to C-type thread
2628	EL-F	Adapts Nikon Bayonet F to 39mm screw thread

* = discontinued

NIKON FLASH:
THE EVOLUTION

Nikon flash has evolved radically over its thirty years of manufacture. The tremendous technological growth in electronics can best be seen in its effect on flash photography. The design of electronic flash has been so influential that its operation has been integrated into camera body design. Its tremendous increase in use by photographers since 1959 directly affected the evolution of camera designs which now incorporate major features and new technologies just to accommodate flash.

The photographers of the sixties who used flash were true technicians of light. It was a must to make the old flash equipment deliver the lighting that their imaginations and job required. When the F came on the market, the flash bulb unit designed for use on the rangefinder cameras became its flash. The **BC-7 Flash Unit** uses glass flash bulbs and requires the camera's controls to be set for their use (refer to F chapter for setting to bulb use). This technology, though simplistic by today's standards, was a workable system that produced many photographs still admired today. The BC-7 employs features that directly relate to current designs such as tilting flash head and the angle of illuminance. The flash bulb was replaced when the SB-1 first came on the market in 1969.

The **SB-1 Speedlight** is a handle mount unit designed to deliver maximum power with a short recycling time. It can be powered by the D-cell **SD-2 Battery Pack**, the 510 volt **SD-3 Battery Pack**, the **SN-1 Nicad** charged by the **SA-1 Charger** (SH-1 is a quick charger) or use the SA-1 as an AC unit. It is simple in design and operation. The flash reflector has a 65 degree coverage, enough for a 35mm lens. Recycle time is 4 seconds with the SN-1 and 1.5 seconds with the SD-3. The bracket can tilt for bounce flash. Flash duration is 1/2000 second,

color temperature is 6000K, guide number of 125 with ASA 125 film. It was advertised with a flash bulb life of 30,000 flashes.

The power of the SB-1 is minimal by today's standards, but it performed well for that day's technology. It has an On/Off switch and an open flash button, an exposure-calculator disc, an extension socket, a ringlight socket and an AC socket. The SB-1 can power the **SR-1** ringlight (designed for magnifications less than 1:1) or the **SM-1** (designed for magnifications greater than 1:1 with a reversed lens). The SB-1 can be linked to fire as many as three SB-1's simultaneously with the **SE-2** cord. An **SF-1 Ready Light** provides the F cameras a ready light with the SB-1 and the **SC-4** connects to the ready light in the F2 prisms. The SB-1 was the only electronic flash available from Nikon until 1977 when a number of units were introduced.

The SB-2, SB-3, SB-4, and SB-5 are electronic flashes that were introduced at the same time, each with slightly different features and power. The **SB-2 Speedlight** and **SB-3 Speedlight** are basically the same unit. The SB-2 foot connects to the F2 hot shoe and activates the ready light in the F2 prism and the SB-3 has a standard ISO foot for use on Nikkormats (ISO foots). The units were advertised with state-of-the-art SCR (Silicon-controlled rectifier) which shuts off the flash when the correct amount of light (the same as Automatic on today's flash units) reaches the subject.

The Automatic provides accurate automatic control from 24 inches to 20 feet. The SB-2 and SB-3 also have the energy-saving thyristor system which conserves the limited power. Four AA batteries power the unit providing a guide number of 80 with ASA 100 film. They recycle in 1 to 8 seconds, depending on whether manual or automatic

mode is in use. The units can be positioned for vertical or horizontal photography and cover a 35mm lens. With the **SW-1** wide angle attachment either they can cover a 28mm lens. They also feature direct-reading calculator dials for manual operation and open flash button. The PC cord (**SC-7**) has a standard PC connection on one end and a parallel blade plug on the other. They will also accept the SF-1 and SC-4 cords.

The **SB-4** is Nikon's first compact flash. It has an ISO foot (but can work on the F2 with the **AS-1**) for use on Nikkormats. It's powered by two AA batteries to provide a guide number of 52 with ASA 100 film for up to 1000 flashes. It has single aperture automatic operation for reliable performance up to 13.1 feet. Its recycle time is 1 to 13 seconds in relation to the flash-to-subject distance. It provides hot shoe connection with ISO flash shoes and has a built-in PC cord for cameras not having a hot shoe.

The **SB-5 Speedlight** is a handle-mount unit with numerous remarkable features. Its main selling point is the versatile thyristor flash ideally suited for motor drive photography. It has variable power control. A selector switch permits operation at full power, at 1/4 power or at the special "MD" (motor drive) setting equivalent to 1/8th power. In "MD" mode, the SB-5 recycles in 0.25 seconds allowing motorized photography at speeds of 3.8 frames per second at a burst of up to 40 frames sequentially. The guide number is 105 with ASA 100 film and a guide number of 36 when in the "MD" mode. With the accessory **SU-1** Sensor, accurate automatic operation with three f/stops at distances up to 26.2 feet is possible. The sensor plugs into the flash for direct lighting or, with the **SC-9** cord, can be mounted on the camera accessory shoe for bounce flash. It can be adjusted in 30 degree increments on the mounting bracket for bounce photography. It is powered by the **SN-2 Nicad** (charged by **SH-2** charger) for up to 420 flashes or by the heavy duty **SD-4 Battery Pack** which uses two 240v batteries providing up to 4000 flashes. The SB-5 has coverage for a 28mm lens and a direct-reading exposure calculator with automatic guide number readout and open flash control.

In 1976 Nikon introduced the **SB-6 Repeating Flash**. This is a very specialized flash unit designed to deliver up to 40 flashes per second. The SB-6 has ratio capabilities providing a guide number of 147 with ASA 100 film on full, 104 at 1/2, 72 at 1/4, 52 at 1/8, 36 at 1/16 and 26 at 1/32 power setting. The SB-6 is powered by the **SA-3** AC unit connected via the **MC-9** cord. The **SD-5** DC unit with the **SN-3** nicad provides a portable power source. The stroboscopic capability of the SB-6 allows 5 to 40 flashes per second and can synchronize with a motorized camera firing as many as 3.8FPS. The SB-6 flash foot allows the unit to be attached to the F2 shoe.

In 1978 the **SB-7E** and **SB-8E Speedlights** were introduced. They are identical units except that the SB-7E fits the F2 accessory shoe, lighting up the ready light in the F2 prisms and the SB-8E has the standard ISO foot for Nikkormats. These units have a two f/stop automatic and a manual setting. On the top of the flash is the exposure calculator for manual use. They use four AA batteries to provide a recycle time of 1 to 8 seconds with a guide number of 25 with ASA 100 film. The angle of illuminance will cover a 35mm lens and with the **SW-2** wide angle attachment in place will cover a 28mm lens. The unit can be turned for vertical or horizontal shooting. These are the first electronic flashes to use special high efficiency flashtubes and they provide power in a compact design.

The **SB-9 Speedlight**, introduced in 1977, was designed to be a carry-along compact flash. It weighs three ounces without its two AA batteries and is only 24mm thick. It has an ISO shoe and was designed to work with the compact cameras. It has automatic operation with two f/stops and a guide number of 14 with ASA 100 film. The SB-9 also uses the special high efficiency flashtube.

The **SM-2** and **SR-2 Ringlights** were introduced in 1975 and are the same as the SM-1 (52mm mount) and SR-2 (reversed lens mount) but can be powered by the **LA-1** AC or the **LD-1** DC power sources. The flashtube is circular and provides "shadowless" lighting. Exposure is figured by using charts which calculate subject-to-flash distance.

The **SB-10 Speedlight** was introduced in 1978 primarily for use with the newly introduced FE. It has an ISO shoe and connects with the ready light in the FE. It's basically the same design as the SB-8E. It has the same guide number and uses four AA batteries with the same vertical and horizontal shooting positions. When attached, the SW-2 increases the angle of coverage but reduces the guide number to 18.

In 1980 the **SB-11 Speedlight** was Nikon's most powerful flash unit. It's a handle bar unit, weighs 30.3oz with a guide number of 118 with ASA 100 film and a guide number of 82 when the **SW-3** wide angle attachment is in place. It's powered by eight AA batteries or the **SD-7 Battery Pack** which uses six C batteries. Recycle time is up to eight seconds and it can provide up to 150 flashes. Although at the time the unit was the latest thing for Nikon, the flash now leaves a lot to be desired. It works TTL with the F3 via the **SC-12** cord, by plugging into the SU-1 socket and attaching to the F3 flash shoe or normal PC connection with the **SC-11** Sync Cord. The **SC-23** cord (a new accessory) lets the SB-11 work TTL with ISO shoe cameras. The **SC-13** Extension Cord takes the SU-2 Sensor (normally attached to the SB-11) off flash to attach to an ISO shoe for dedication. The SU-2 controls the automatic flash operation. The SU-2 also provides for a modulated burst of light to trigger a second flash attached to the Nikon ML-1.

The SB-11 hooks into the F3 TTL system, lighting the readylight inside the F3 prism when the SC-12 is in use. At the same time, the ready light on the SB-11 will indicate the correct exposure. If there is insufficient light for correct exposure or the cord is improperly connected, the ready light will blink rapidly. The head tilts 120 degrees for bounce flash photography. The light quality is quite harsh from the SB-11 because of the reflector and fresnel design and requires some type of diffusion to produce a pleasant light source. The technology, size, guide number, and lack of features, especially in the 1990's, make the SB-11 basically worthless.

The **SB-12 Speedlight**, also introduced in 1980, worked on the F3 only. It's the first compact flash Nikon designed and manufactured to work TTL with a camera and its metering system. The SB-12 has quite some power considering its compact size. It has a guide number of 82 with ASA 100 film (59 with the **SW-4** wide angle attachment) and coverage for a 35mm lens (28mm with the **SW-4**). It's powered by four AA batteries which provide up to 160 flashes. The entire flash head swivels for vertical and horizontal shooting. The SB-12 flash foot is designed to fit only on the F3 and engage with the F3 TTL system. When the flash is attached to the F3, it automatically sets the shutter speed to 1/80 for flash photography. It also activates the ready light in the finder to indicate proper or improper flash, or improper flash connection or charge for the next photograph.

The ready light, whether on the back of the flash or in the finder, indicates proper exposure by turning off after the exposure and coming back on when the flash is charged for the next exposure. It indicates improper exposure by blinking rapidly, then going off while recharging the flash unit. Proper exposure is a function of flash-to-subject distance and f/stop. If the flash indicates improper exposure, the flash-to-subject distance must be decreased, the f/stop opened or a combination of both used to achieve the correct exposure. The F3's exposure compensation dial can be utilized to change the exposure by plus or minus two stops.

The **SC-14** cord takes the SB-12 off camera a maximum of three feet while maintaining TTL/flash sync. It has a 1/4-20 thread for attaching to a bracket or tripod. The ASA dial on the SC-14 overrides the ASA dial on the body and must be set for correct exposure. The **AS-6** can convert the F3 foot of the SB-12 to work with an ISO mount, but all TTL functions are lost; the hot shoe connection remains.

In 1982 Nikon introduced the **SB-14**, a "compact" handle mount flash unit. It has a guide number of 105 with ASA 100 film and 72 with the **SW-5** wide angle attachment installed. It has the coverage for a 28mm and 24mm lens with the SW-5. It's powered by the SD-7 battery pack (connected via the **SC-16** cord) which uses six C batteries with a recycle time of up to 9.5 seconds and provides 270 flashes. It can work TTL with the F3 via the SC-12 cord or, as a dedicated unit with ISO shoes with the SC-13 cord. The **SC-23** cord lets the SB-14 work TTL with ISO shoe cameras. Like the SB-11, the SB-14 also utilizes the **SU-2** sensor which provides the same functions and features. The SB-14 is a harsh light source requiring some type of diffusion to make it a quality light source. This was a popular unit because of its size and guide number, but within a couple of years flash technology changed drastically making it obsolete.

In 1986 Nikon introduced a more sophisticated version of the SB-14, the **SB-140**. The SB-140 is for ultraviolet, visible and infrared photography. This is the same basic unit as the SB-14 with a different set of features. The SB-140 can work TTL (visible light only) with the F3 via the SC-12 cord or with an ISO shoe via the SC-23 cord. It comes with three special filters that are placed over the

flash head, the **SW-5V** Filter for visible light at 400-1100nm, the **SW-5UV** for UV light at 300-400nm and the **SW-5IR** for infrared light at 750-1100nm. Its guide number is rather low and changes depending on the filter in use: with ASA 100 film, a guide number of 32 with filter SW-5V, 22 with filter SW-5IR and 16 with filter SW-5UV. Like the SB-14, the SB-140 is powered by the SD-7 Battery Pack.

During this time Nikon released a newer pocket flash, the **SB-E**. Primarily designed for the EM camera, it was powered by four AAA batteries delivering a guide number of 56 with ASA 100 film. It has one mode, automatic. The photographer sets the f/stop for the desired flash-to-subject distance according to the scale on the back of the flash; the flash does the rest. It has an ISO foot.

In 1982 Nikon introduced the **SB-15 Speedlight**, a compact flash that will work TTL with ISO shoe cameras. The SB-15 is an excellent unit with more flexibility than any other Nikon flash up to this time. It has a guide number of 82 with ASA 100 film and 59 with the **SW-6** wide angle attachment. It has coverage for 35mm lens and 28mm lens with the SW-6. It's powered by four AA batteries which provide a recycle time of up to 8 seconds and deliver 160 flashes. The entire unit can be moved from vertical to horizontal shooting. The flash tube module tilts 15, 30, 60, and 90 degrees. It has a ready light on the back of the flash which activates the ready light in the finder. This provides TTL information as with the SB-11 and SB-14.

The SB-15 has two automatic functions and a manual mode for use on older cameras without TTL technology. It also has a Motordrive setting providing synchronization with a motorized camera capable of syncing up to 3.8FPS. This quick firing can be maintained for only short bursts which is determined by the flash-to-subject distance and f/stop in use. With its compact size, swiveling flash tube module, and TTL function, the SB-15 is an outstanding unit for close-up photography. Two units can be mated to work TTL with the **SC-17** Cord, **SC-18** Cord and **AS-10** and placed directly next to the lens for outstanding lighting.

In 1983 Nikon came out with the state-of-the-art flash, the **SB-16 Speedlight**. This flash can work TTL with both the F3 and ISO shoe cameras by just changing the lower module. The **AS-8** module (the SB-16A) works with the F3 and the **AS-9** module (the SB-16B) works with an ISO shoe. The SB-16 has a zoom head to change the angle of coverage of the light in relation to the lens in use. It zooms from 28mm to 85mm with a coverage for a 24mm with the **SW-7** wide angle attachment. The guide number changes depending on where the zoom head is set, from 105 at the 28mm setting to 138 at the 85mm setting with ASA 100 film. That's more power than the SB-11 in a much smaller package. The flash head can also be tilted for bounce photography and rotated 270 degrees to bounce off walls. It's powered by four AA batteries and provides 100 plus flashes. It's a battery eater and external power sources (not made by Nikon) are recommended for any type of commercial application.

The SB-16 has a built-in wink light that always points straight ahead and can place a catch light in the eye of the subject when using the flash in the bounce mode. The SB-16 hooks up to the ready light in the F3 and in ISO cameras just as the SB-15 (with the same indications concerning exposure). It also has two automatic settings, a motor drive setting, and a manual mode.

The dials on Nikon flash units are not connected to the cameras or flash computers. The big dial on the back of the SB-16 is strictly for manual flash operation and serves as a calculator to facilitate figuring correct flash exposure when in manual use. The SB-16 has two sockets on the lower modules, one for the standard PC off-camera sync and the other for TTL sync, and requires the SC-18 or SC-19 for coupling. At the time of its introduction it was one of the top flash units on the market, but that did not last long as many off brand companies specializing in just flash manufacture came out with more powerful, smaller units that will work TTL with Nikon bodies.

The **SB-17 Speedlight** was introduced in 1983, replacing the old SB-12. The SB-17 is the exact same unit as the SB-15 but works TTL with the F3 only. It's a vast improvement over the SB-12 and was a big hit with photographers at the time.

The **SB-18 Speedlight** is a small pocket flash that was sold as part of a promotional package and not sold separately. It's not a powerful flash. Powered by four AA batteries and delivering up to 250 flashes, it has a guide number of only 66 with ASA 100 film. It has only two settings, manual and TTL, and works with ISO flash shoes.

The **SB-19 Speedlight** is along the same lines

TTL MULTIPLE-FLASH SYSTEM

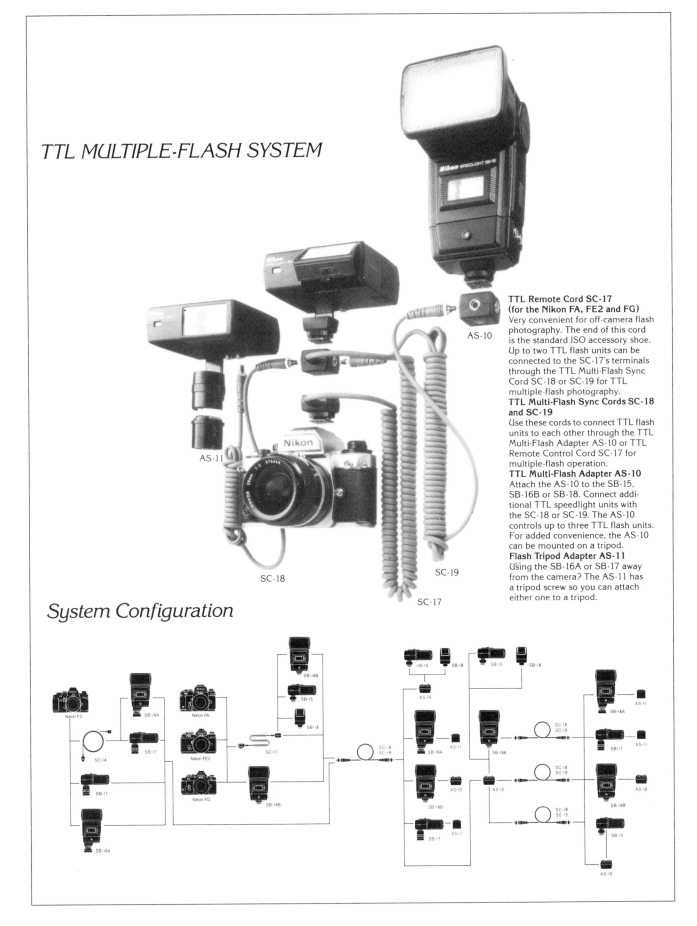

AS-10

AS-11

SC-18

SC-19

SC-17

**TTL Remote Cord SC-17
(for the Nikon FA, FE2 and FG)**
Very convenient for off-camera flash
photography. The end of this cord
is the standard ISO accessory shoe.
Up to two TTL flash units can be
connected to the SC-17's terminals
through the TTL Multi-Flash Sync
Cord SC-18 or SC-19 for TTL
multiple-flash photography.
**TTL Multi-Flash Sync Cords SC-18
and SC-19**
Use these cords to connect TTL flash
units to each other through the TTL
Multi-Flash Adapter AS-10 or TTL
Remote Control Cord SC-17 for
multiple-flash operation.
TTL Multi-Flash Adapter AS-10
Attach the AS-10 to the SB-15,
SB-16B or SB-18. Connect addi-
tional TTL speedlight units with
the SC-18 or SC-19. The AS-10
controls up to three TTL flash units.
For added convenience, the AS-10
can be mounted on a tripod.
Flash Tripod Adapter AS-11
Using the SB-16A or SB-17 away
from the camera? The AS-11 has
a tripod screw so you can attach
either one to a tripod.

System Configuration

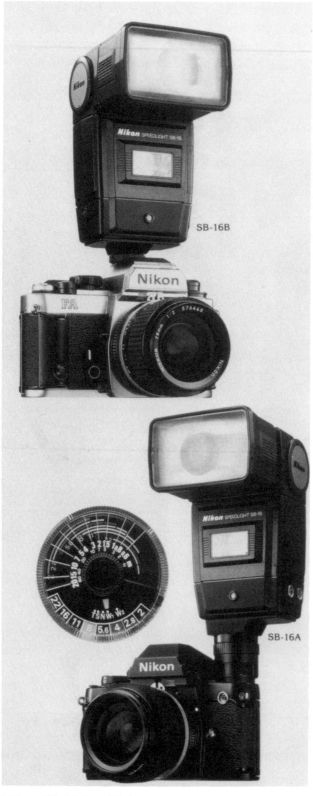

Nikon SB-16 Speedlights.

as the SB-18, but even smaller in size. It was designed to be a companion to the FG-20 and EM. It works with any ISO flash shoe and when used with an FG-20 or EM and a AIS or AI lens, provides six automatic settings. On any other body there is only one setting. It's powered by four AA batteries and delivers up to 250 flashes with a guide number of 66 with ASA 100 film.

The **SB-20 Speedlight**, introduced in 1986, was the first Nikon flash with autofocus assist. Many photographers have not taken full advantage of this flash and its outstanding features. Powered by four AA batteries, it provides up to 150 flashes with a recycle time of up to six seconds. It has a high voltage plug for use with the Nikon **SD-7** battery pack with the **SC-16** cord for a recycle time of up to four seconds. This same socket accepts Quantum's Turbo Battery (not recommended by Nikon), which provides instant recycle time with up to 300 flashes. The SB-20 has a rotating screen around the flash tube to change the angle of light to cover 28mm to 85mm lenses. When set at 28mm ("W" setting) it delivers a guide number of 72 and at the 85mm ("T" setting) it delivers a guide number of 118. The flash tube module can also be turned for bounce photography, still making use of the rotating flash screen. It has a number of new features for a Nikon flash. The power switch has "OFF", "STBY" (stand-by) and "ON" positions. The "ON" and "OFF" are self explanatory, but the "STBY" is new. When on this setting, the flash will turn itself off when hooked up to cameras that turn themselves off, but powers up the moment the shutter release on the camera is touched. Whenever using any Nikon flash as a slaved-TTL flash, the "STBY" function cannot be used. Make sure the SB-20 is set to "ON" when used as a slave.

The SB-20 has ratios available in the manual mode of 1/16, 1/8, 1/4, 1/2 and full. With the proper body connection, the ready light works the same as on all Nikon TTL flash units. On the SB-20 next to the "READY" light is a "BOUNCE" light. The "BOUNCE" light comes on when the flash head is in the bounce position, whether set to bounce up or at the 7 degree down bounce. The SB-20 has one external sync plug for PC connection only. To use off camera TTL, an SC-17 cord is required. And as a slave flash, an SC-18/19 and AS-10 is required.

The SB-20 was introduced with the N2020, Nikon's first autofocus camera, to work in conjunction with the N2020's autofocus system. The SB-20 has an illuminator that will, in dark situations,

Nikon SB-20 Speedlight.

come on and emit a red beam of light for the camera's autofocus sensor to lock on and focus. This illuminator will only function when the camera's autofocus selector switch is set to "S". It doesn't work at all with the "C" function. As with any beam of light, the illuminator's beam widens the farther it travels from the flash. Because of this, the photographer must look through the finder making sure the illuminator beam and the autofocus bracket in the camera's viewfinder line up to assure proper focus.

The **SB-21 Macro Speedlight** is an incredibly well designed macro flash. It's not a ringlight, but a macro flash that utilizes two parallel flashtubes for its light source. It's a two part unit, the flash consisting of the two flash tubes and focusing bulbs attached to the front element of a lens (via the lens filter thread) and the Controller Unit attaching to the camera's flash shoe. The **SB-21A** (using the AS-12 Controller) is for the F3 system, the **SB-21B** (using the AS-14 Controller) is for ISO flash shoe. The Controller is mounted where the TTL connection is made between the flash and camera and is where the batteries are housed. A power cord is used to get the power and computer-TTL connections from the controller unit to the flash head.

On the bottom of the flash assembly, between the two flash tubes are two focusing bulbs to illuminate the subject. These operate according to the power source in use. The Controller can use either four AA batteries to light up one focusing bulb for up to 200 flashes or the LD-2 Battery Pack

to provide the photographer both focusing bulbs and up to 300 flashes. By using an alternate power source (not recommended by Nikon) there is a big increase in the number of flashes, but only one focusing bulb will light up.

The Controller manages the operation of the flash. On the rear panel there is the "OFF", "M" and "TTL" switch. The "M" is for manual operation requiring the use of the calculator dial on top of the controller to figure out proper exposure. There is an "OVER EXP" and "FLASH/UNDER EXP" ready light on the back panel. They blink to indicate under or over exposure problems occurring during the exposure when the controller is set in TTL mode. The standard ready light for the SB-21 is the upper or "FLASH/UNDER EXP" light, which will come on when the flash is 90% charged for the next exposure and will stay on until the unit has been fired.

The flash tube assembly clips onto a ring (52 and 62mm rings come with unit) that is screwed into the lens' filter thread for mounting. On the back of the flash assembly there are two more control switches. One switch selects either the left tube, right tube or both tubes so that the photographer has control over the flash operation. The other switch operates the "M", "1/16" or "TTL" setting. These switches must be set to the proper mode for correct operation.

The SB-21 is not a powerful flash for general purpose photography, as it has only a guide number of 39 with ASA 100 film. This is plenty for its design as a macro flash, with enough power for f/22 at 1:1 magnification. For greater magnification, the SB-21 comes with a plastic adapter that increases the angle of illumination to light properly a subject that is close to the front element. When using the 60f2.8 AF Micro, the **UR-3** is required to attach the flash to the lens. The UR-3 fits on the barrel of the lens rather than to the filter ring. This prevents the autofocus motor in the camera from dealing with the weight of the flash when focusing. The SB-21 can be used with other flash units TTL via the SC-18 and SC-19 cords. It's possible to use a second flash to backlight a subject while using the SB-21.

When the DP-20 is removed from the F4 and the DW-20 or DW-21 are attached, the ISO hot shoe on the DP-20 is lost. The DW-20/21 do not have an ISO shoe as part of their design so Nikon provides a socket on the back of the DW-20/21 finders to

Nikon SB-23 Speedlight.

Nikon F4s with SB-24 Speedlight.

plug in the **SC-24** cord. It accepts the Controller Unit (or an ISO shoe) providing all TTL connections. One drawback is that there is no place to attach the Controller Unit because it now dangles at the end of a three foot coiled cord. A bracket (not manufactured by Nikon) attached to the body to which the Controller/SC-24 cord can be attached (via 1/4-20 thread on SC-24) is recommended when doing close-up work. This keeps the controller out of the way.

The **SB-22 Speedlight**, introduced in 1987, is an inexpensive autofocus flash. It uses four AA batteries and can deliver a guide number of 25 and with the wide angle diffuser (built into the unit, pulled into place) 18 with ASA 100 film. It delivers 200 flashes per set of batteries with a recycle time of up to four seconds. It has an autofocus illuminator and high voltage socket operating the same as that on the SB-20. The ready light also operates the same as those on all Nikon TTL flash units. The flash tube module pivots for bounce flash capability, up 90 degrees and down 7 degrees. It has "M", "MD" "A" and "TTL" settings that work as on other units. It has the "OFF", "ON" and "STBY" power switch that is incorporated into the SB-20.

In 1988 a unique little flash unit was introduced, the **SB-23 Speedlight**. This is a very compact autofocus flash powered by four AA batteries delivering a guide number of 66 with ASA 100 film. What is amazing about this unit is its recycle time of up to 1 second. This along with up to 400 flashes are on just one set of batteries. The electronic technology of the SB-23 is quite sophisticated for such a small unit. The one drawback of the SB-23 is that it cannot easily be used as a slaved unit. Nikon states that it cannot be used as a slaved unit at all because it has only "OFF" and "STBY". It can however, be used slaved, but the open flash button must be hit if the flash turns itself off before the exposure is made or it will not function. When slaved, the flash will not receive the signal from the camera when the shutter release button is touched, hence the need to hit the open flash button if it's to be used.

The **SB-24 Speedlight** took Nikon's flash technology a quantum leap with its introduction in 1988. This is a high powered flash with autofocus technology. It can be powered by four AA batteries or by the SD-7 or SD-8 battery packs via the high voltage socket. It can also be powered by remote power sources (not recommended by Nikon) via the AA battery drawer or the high voltage socket. The guide number with ASA 100 film is 98 to 164 depending on where the automatic zoom head is set. This written text on the SB-24 is not meant to replace the instruction book, but to explain or expand on functions of the SB-24 facilitating its use.

The SB-24 zoom head will automatically zoom to the correct angle of coverage when a lens with a CPU is attached to the N8008 or F4. When a zoom lens with a CPU is attached, the SB-24 zoom

USABLE FLASH MODES WITH YOUR CAMERA

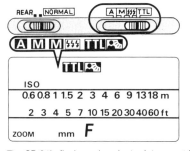

The SB-24's flash mode selector lets you select from four flash modes—TTL Auto **TTL**, Non-TTL Auto **A**, Manual **M** or Repeating-Flash **↯↯↯**. When the power switch is on, the flash mode indicator confirms your selection in the LCD panel.

TTL AUTO **TTL**

In this mode, the camera's TTL flash sensor measures all the light which passes through the camera's lens and reflects off the film surface. This includes both ambient light and light from the SB-24 flash. The flash shuts off at the moment the sensor detects the correct exposure. Because the sensor detects light passing through the lens, it automatically adjusts for most flash shooting situations, including bounce flash, diffusion filters and colored or neutral-density filters used on the lens or on the flash head.

The SB-24's automatic flash operation depends on the Nikon SLR model used. The chart on the following page indicates the automatic modes available for each SLR model shown. Subsequent sections of this instruction manual explain each of the different automatic modes.

Available flash features also vary depending upon the type of Nikon lens used and camera on which it is used. The newest AF Nikkor lenses include built-in computers, and used with the newest Nikon SLR models (F4, F-801/N8008, F-401s/N4004s)—which incorporate a computer and multi-segment light meter—provide the most advanced flash operation, known as Matrix Balanced Fill-Flash.

head will operate in concert with the zoom during zooming for the correct angle of coverage. The zoom head covers 24mm to 85mm automatically. It can be set manually by an override feature when using a non-CPU lens.

The flash head itself can tilt up or sideways for bounce photography and simultaneously maintain the automatic zoom. The light source itself has a special quality not normally found in a flash. Much of the harsh light is not present because of the reflector and diffuser built into the flash head.

One important setting must be made before use of the SB-24 and that is the distance scale. Inside the battery compartment the distance scale can be set for feet or meters (comes from the factory in meters). Select the method desired for distance readout on the LCD panel.

This flash is specifically designed to interface with the N8008/N8008s and F4/F4s/F4e which make full use of all the SB-24's features. It will work in the TTL mode on all cameras accepting an ISO shoe flash but all other functions of the SB-24 are not available. The rear panel of the flash is the heart of its operation. How one initializes the settings on the back of the flash determines whether the SB-24 will do all, part, or none of the exposure calculations for the photographer.

At the top of the flash are two switches that need to be set, the Flash Sync Mode, and Flash Mode Selector. The SB-24 provides "REAR" curtain sync and "NORMAL" curtain sync. In "REAR" sync mode, the flash will fire as the shutter is closing which is the opposite of normal flash unit operation. This allows the photographer to make the exposure and freeze the subject after the movement has been recorded. With the N8008/N8008s/F4/F4s/F4e in any exposure mode except "M", rear curtain sync enables the camera to expose ambient light accurately from 30 seconds to 1/250 while maintaining accurate TTL flash exposure.

In "NORMAL" mode the flash is fired as soon as the shutter is opened. Most flash units are used this way 99% of the time. In "NORMAL" mode, the flash instantly records the action present as the shutter is opened. The N8008/F4 will sync only at shutter speeds 1/60-1/250 when the flash is set in "NORMAL." If the ambient light requires a shutter speed slower than 1/60, the camera will underexpose the ambient light.

The second switch is the Flash Mode Selector and provides "A", "M", "three lightning bolt symbol" and "TTL". The **"A"** is an automatic mode in which the small port below the autofocus illumin-

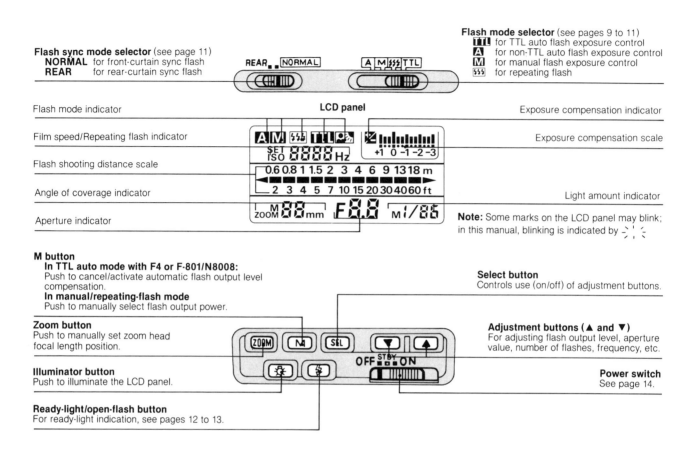

Flash sync mode selector (see page 11)
NORMAL for front-curtain sync flash
REAR for rear-curtain sync flash

Flash mode selector (see pages 9 to 11)
TTL for TTL auto flash exposure control
A for non-TTL auto flash exposure control
M for manual flash exposure control
for repeating flash

Flash mode indicator

LCD panel

Exposure compensation indicator

Film speed/Repeating flash indicator

Exposure compensation scale

Flash shooting distance scale

Angle of coverage indicator

Light amount indicator

Aperture indicator

Note: Some marks on the LCD panel may blink; in this manual, blinking is indicated by

M button
In TTL auto mode with F4 or F-801/N8008:
Push to cancel/activate automatic flash output level compensation.
In manual/repeating-flash mode
Push to manually select flash output power.

Select button
Controls use (on/off) of adjustment buttons.

Zoom button
Push to manually set zoom head focal length position.

Adjustment buttons (▲ and ▼)
For adjusting flash output level, aperture value, number of flashes, frequency, etc.

Illuminator button
Push to illuminate the LCD panel.

Power switch
See page 14.

Ready-light/open-flash button
For ready-light indication, see pages 12 to 13.

ator reads the light bouncing off the subject and turns off the flash when the correct exposure is reached. The adjustment buttons (the two arrows) to change the f/stop are on the rear panel. The f/stop selected must be within the range the distance readout on the flash prescribes. The aperture on the lens must be set to the same f/stop that has been selected on the flash panel for correct exposure.

The "M" mode puts the photographer in complete control of the exposure, providing ratio options of 1/16, 1/8, 1/4, 1/2 and full power. Exposure is calculated by the photographer according to flash-to-subject distance. When the SB-24 is attached to an N8008 or F4s with a lens with a CPU in use, the flash information panel will relay the f/stop at which the aperture has been set to facilitate manual operation. The distance scale right above the selected f/stop will indicate the correct flash-to-subject distance for proper exposure. The scale changes as the f/stop changes.

The "Three Lightning Bolts" is the Repeating Flash permitting the subject to be flashed up to

eight times consecutively on the same frame of film. This feature works only in "M" mode and the camera should be set to Bulb or a shutter speed long enough to accept the exposure. For example: if the flash is set to 6 times (the number of flashes) at 8Hz (the speed of the flashes) then it will take 6/8 or 0.75 second for correct exposure. The closest setting is 1 second for this situation.

The number of flashes for the desired effect is selected via the adjustment arrow. The "M" button selects the power setting between 1/8 and 1/16. Choosing 1/8 or 1/16 allows the photographer to vary the subject distance which is displayed on the distance scale on the information panel. Correct exposure is determined by the same method as in manual mode for flash-to-subject distance. The lower power setting of 1/16 allows more flashes per firing. This is a feature of the SB-24 that must be experimented with to completely understand and use. Reading the instruction book twenty times also helps.

The "TTL" mode is the setting that brings the SB-24 to life for the photographer. The SB-24 has

an "OFF", "STBY" and "ON" switch that operates like that on the SB-20. When the flash is switched to "ON", the information panel displays a number of features. At the top of the panel is a LCD readout "TTL" and next to that is a graphic of a "man/sun". This is the "AUTO/COMP" indicator. When this indicator is displayed (not blinking) and the F4/N8008 metering system is on either matrix or center-weighted, the flash automatically flash fills. The ratio that is set by the flash can be from 1:1 to 2/3 stops under-exposed, as calculated by the camera and flash computers.

If the "man/sun" is blinking ("MAN-UAL/COMP"), the compensation dialed by the photographer will be the same for each exposure, overriding the flashes' computed ratio. Pressing the "M" sets the "MANUAL/COMP" to blinking, pressing the "SEL" calls up the analog scale and pressing the arrows sets the compensation desired. If the "M" is hit again and the "AUTO/COMP" stops blinking, then the compensation that has been dialed will be added to the amount the camera's computer has calculated. If "MAN-UAL/COMP" has been dialed, the plus/minus compensation warning symbol in the viewfinder of the camera will light to inform the photographer of the compensation in use.

This procedure combined with Rear Curtain Sync basically guaranties correct flash/ambient light exposure in any situation. Remember to look at the shutter speed setting to see if a tripod is required for a long shutter speed. This all works whether one of five flash units are linked TTL.

The SB-24 works in concert with the N8008 and F4 for Matrix Balanced and Center-weighted flash fill. When in TTL mode, whether the camera is set to "P", "PH", "PD", or "S", the camera's computer (in concert with the flash) will determine the correct exposure for the f/stop selected. The camera goes as far as setting the correct shutter speed for correct exposure of the ambient light. The ready light in the viewfinder will indicate the correct exposure for TTL exposures just as with all other Nikon flash units.

If the lens in use does not have a CPU, or a lens with a CPU is used and the contacts are broken by an extension tube or teleconverter, the LCD panel will no longer display the f/stop. The distance scale, aperture, and focal length information on the LCD panel go off after 16 seconds to conserve power, and come back on once the shutter

release button is touched. Next to the ready light on the back panel there is a button with a light symbol. When pressed it illuminates the LCD panel for seven seconds or shuts off when the camera is fired.

The SB-24 can be taken off camera via the SC-17 cord and still maintain full TTL and computer connections. The SB-24 has two connections on the side of the unit, one for a standard PC connection and one for TTL connection via SC-18 and SC-19 cords. When the SB-24 is used as a second or slaved unit via an SC-18 or SC-19 cord, all functions on the SB-24 are lost except TTL exposure. Zoom, ISO, and TTL setting are the only functions which must be set on the slaved unit. All other features of the master SB-24 are transferred to the slaved unit.

If the power is interrupted, all functions are reset to factory settings and have to be reset. Any custom settings which have been dialed in will be present when flash is turned on if turned off while connected to the camera's TTL shoe directly or via the SC-17 cord. The dialed functions will be erased if the flash slips off the flash foot while the power is on. The SB-24 has a microcomputer and since the unit is not grounded static electricity can cause the flash to stop functioning. This can be fixed by removing and reinserting the batteries, thus breaking the static charge.

The SB-24 operates with each camera body differently. A thorough reading of the instruction book is required for use of the SB-24 with other bodies for accurate operation. When used with the N6006/N6006, all the above functions are no longer applicable. There has been a revision of the instruction book since the first SB-24's were released. On page 24, the current and most accurate instruction book shows a three part system for use with different camera systems.

In the summer of 1990 Nikon introduced the **SD-8 High Performance Battery Pack** for use with the SB-24. It can work with the SB-11, SB-20, SB-22 and SB-24, all of which have the high voltage power socket. The SD-8 requires six AA batteries; the four batteries in the flash must still be in place for proper operation. The purpose behind the SD-8 is a faster recycle time and a greater number of flashes with its ten AA batteries. The SD-8 has two cords, the first is the power lead and the second a PC cord. It's important to plug or unplug the PC cord before the power cord. The PC cord is

plugged into the PC socket on the flash and not the one on the body.

As mentioned before, there are alternative power sources for the flash units with high voltage sockets which can work quite effectively. These units are not recommended by Nikon and their use voids the flashes' warranty. Thousands of photographers use alternative power sources successfully and safely day in and day out on their Nikon flash units, especially the SB-24, so some discussion is warranted.

The SB-24 is the first flash to successfully knock the Vivitar out as the principal flash employed by photojournalists using Nikon equipment. These photographers were used to having the super fast recycle time the Quantum Battery provided the Vivitar. Quantum has a module designed especially for the SB-24 and the Quantum Battery 1. It's called the MKE and works great.

The SB-24 can use the Turbo Battery via its high voltage socket with the Quantum cord. When using the Turbo with the SB-24, there must still be four AA batteries in the flash (that holds true for any high voltage Nikon flash) for proper operation. The AA batteries operate the LCD panel on the flash while the external pack charges the flashes' capacitor, the power that runs the flash-tube.

Working TTL

All Nikon's bodies that have TTL flash metering can work with as many as five flash units TTL at one time. When in use with an ISO camera (such as the N8008 or F4), these flash units are hooked together with either the SC-17, SC-18, or SC-19 cords. Although this is the best system currently on the market, there are still some holes in the technology that the photographer must be aware of in order to make the best use of the system.

TTL multiple flash photography starts with one "Master" flash attached to the camera's hot shoe and slaved units being triggered from it via the SC-18 or 19 cords. Usually the "Master" flash is taken off the camera via the SC-17 cord. The SC-17 cord is the heart of off-camera TTL work. It's the only cord with five wire leads built into the cord, relaying all information between the computers of the camera and the flash. When using the

SC-17, all features available when the flash is directly attached to the camera are still present and available.

When attaching the SC-17, it's recommended that it be attached to the camera body first, then to the flash. The foot on the SC-17 to which the flash is attached must have a flash attached to complete the circuit. There is no way to plug the cord into the foot of the SC-17 for a slaved flash without a "Master" flash being in the foot to complete the circuit. On the bottom of that flash foot there is a 1/4-20 threaded socket to allow attachment of the foot assembly to a bracket or stand. As many as three SC-17 cords can be connected together for 9-15 feet of extension and still have proper TTL operation; any more and the resistance in the line can cause improper exposure.

There are two sockets on the foot of the SC-17 cord. These are for connecting either the SC-18 or SC-19 cords for additional slaved TTL flash units. Slaved TTL flash units work only TTL, losing all other functions the flash has when used as a "Master" flash. That's because the SC-18 and SC-19 are three lead wire cords and carry only the TTL exposure information. All slaved units must be set to "ON" and not "STBY" because they do not receive the impulse from the shutter release when it is pressed. When the exposure is made they will not have been activated. It's advisable to have all TTL sockets covered with a PC cap (not done at the factory) when not in use to avoid foreign material getting in and shorting out the TTL system. This especially holds true for the flash units themselves.

When coupling multiple flash units together for TTL operation, it's recommended that the TTL sockets be used that are on the flash units if they are available before using the sockets on the SC-17 or AS-10. The AS-10 has three sockets that accept the SC-18 or 19 cords and a 1/4-20 thread on the base permitting attachment to a bracket or stand. Since the SC-18 and SC-19 are only three lead cords, as many as three SC-19s (a total of 30' of extension) or six SC-18s (a total of 30') can be coupled together for TTL operation. These cords are joined by the AS-10 which has a TTL socket to accept a flash but does not need a flash in the socket to close the circuit. The SC-18 can be cut down in length (not recommended by Nikon) to accommodate special brackets so the excess cord is not in the way.

Flash Accessories

Item	Description
AS-1	F2 to ISO flash shoe, provides hot shoe use of ISO flash on an F2 body.
AS-2	ISO to F2 flash shoe, converts F2 flash shoe to work on ISO shoe.
AS-3	F3 to F2 flash shoe, converts F3 hot shoe to work on F2 shoe.
AS-4	F3 to ISO flash shoe, provides hot shot use of ISO flash on an F3 body.
AS-5	F2 to F3 flash shoe, converts F2 shoe to work on F3 shoe.
AS-6	ISO foot to F3 flash shoe, converts ISO shoe to work on F3 body.
AS-7	Allows flash to be moved out from F3 body, maintaining TTL connection and allowing the film rewind lever to be lifted to open back. Also has ISO foot, non-TTL.
AS-8	SB-16 foot for F3 body.
AS-9	SB-16 foot for ISO shoe.
AS-10	TTL Multi-Flash adapter, allows two TTL cords to be connected, has 1/4-20 thread for tripod mounting.
AS-11	Permits F3 foot flash to be mounted to a 1/4-20 thread.
AS-12	Controller unit for F3 shoe.
AS-14	Controller unit for ISO shoe.
AS-15	PC sync terminal adapter for ISO shoe.

Flash Wide Angle Adapters

Item	Description
SW-1	for SB-2, -3
SW-2	for SB-7E, -8E, -10
SW-3	for SB-11
SW-4	for SB-12-17
SW-5	for SB-14
SW-6	for SB-15
SW-7	for SB-16A or B

Flash Cords

Item	Description
MC-9	Connecting cord F-36 to SB-6
SF-1	Eyepiece Pilot Lamp
*SC-4	Ready light adapter for F2 with Nikon flash
*SC-5	Sync cord for SB-5
SC-6	Screw-on Coiled Cord
*SC-7	Sync Cord, SB-2, -3, -7E, 8E, 10
*SC-8	Sync Cord SB-4
SC-9	Extension cord for SU-1
*SC-10	Sync cord for SB-9
SC-11	Sync cord for SB-11
SC-12	TTL cord for F3 and SB-11, 14, -140
SC-13	Extension cord for SU-2 and ISO foot
SC-14	TTL off-camera cord for F3
SC-15	Coiled PC to PC cord
SC-16	Power cord for SD-7
SC-17	ISO TTL remote cord to flash, 3' long
SC-18	TTL to TTL connecting cord, 5' long
SC-19	TTL to TTL connecting cord, 10' long
SC-20	Sync cord for 120 medical
SC-21	Power connecting cord for 120 medical
SC-22	Sync cord for 120 medical
SC-23	TTL to ISO connecting cord for SB-11, -14, -140

*=discontinued

Item	Description

Flash Power Sources

*SU-1 Sensor unit for SB-5, -6
SU-2 Sensor unit for SB-11, -14, -140
*SA-2 AC adapter for SB-2, SB-3
SA-3 AC power unit for SB-6
*SN-1 Nicad for SB-1
*SN-2 Nicad for SB-5
SN-3 Nicad for SD-5
*SH-1 Charger for SN-1
*SH-2 Charger for SN-2
SH-3 Charger for SN-3
*SD-4 480V Battery Pack for SB-5
SD-7 C-Cell power source for SB-11, -14, -140, -20, -22, -24
SD-8 Power source for SB-24
*LD-1 DC battery pack for 200 medical, SM-2, SR-2
*LA-1 AC battery pack for 200 medical, SM-2, SR-2
LD-2 DC battery pack for 120 medical
LA-2 AC battery pack for 120 medical, SB-21
*MS-2 AA Battery holder for SB-7E, -8E, -10
MS-5 AA Battery holder for SB-16
MS-6 AA Battery holder for SB-15, -17

*=discontinued

NIKON CLOSE-UP:
THE EVOLUTION

Before Nikon began to produce cameras, they made microscopes. It did not take them long to combine their two fields of expertise, as they became the major innovator in close-up photography. Their rangefinders were Nikon's first forum for close-up photography and they manufactured a number of accessories to accomplish close-up work, such as the Bellows 1. It was not until the SLR came on the market that the world of close-up photography was explored by the everyday photographer. Their equipment demands instantly grew and Nikon did not hesitate to meet their demands.

Photography in its raw form is a play on physics. Optics manipulate light, bending it so it will hit the film at a set distance to create a sharp image. Close-up, macro photography is photography taken to the extreme, and places great demands on both the photographer and the equipment. This is why there are more mathematical formulas, exposure calculations, and rules of thumb in close-up photography than in basic photography. There are two rules that must be grasped to understand the basics of close-up equipment: required amount of extension to reach a given magnification, and exposure compensation for that extension.

Two terms in close-up photography relate directly to extension, macro and micro. Macro is working at magnifications as great as 1:1 (life size) and micro is working at magnifications greater than 1:1. The ratio of 1:1 is the symbol or formula signifying life size magnification, where the size of the object in life is the exact size of the image on the film. If a penny were photographed at 1:1 and the photograph of that penny were laid on a light table on top of an actual penny, the penny and the image of the penny would be exactly the same.

To reach 1:1 magnification with a lens an equal amount of extension must be added to the focal length. With a 50mm lens, 50mm of extension is required to reach 1:1 magnification. 1:1 magnification can easily be calculated by this rule of thumb for any lens. When extension is added, light takes longer to reach the film plane for which one must compensate by increased exposure time.

Increasing the magnification to 1:2, one stop of light is lost. When increasing the magnification of any lens to 1:1, 2 stops of light are lost. This is true for 24mm of extension with a 24mm lens or 200mm of extension with a 200m lens. In either case, only two stops of light are lost. As with all rules of thumbs though, there are exceptions.

When using special lenses such as the 60f2.8AF or 105f2.8AF Micro, the added amount of extension is not equal to the focal length of the lens. By adding a PK-13 to a 400f5.6, the minimum focusing distance is drastically reduced, but the exposure is not affected. So with each situation in close-up photography, considerations of the equipment and methods employed must be factored in to achieve the perfect photograph.

Nikon equipment offers a number of options to achieve close-up photography, the best known of which are the bellows. The first bellows introduced for the F was the **Bellows 2**. There are actually two models of the Bellows 2, both using a single, twin-rail system. With the first model, the Photomic and Photomic T finders had to be removed before the F could be mounted to the bellows. That was fixed on the second version by the simple addition of 3mm on the mounting flange. The Bellows 2 is the only bellows to receive a serial number, which is the only way the two models can be distinguished. The modified bellows is #106700 and greater.

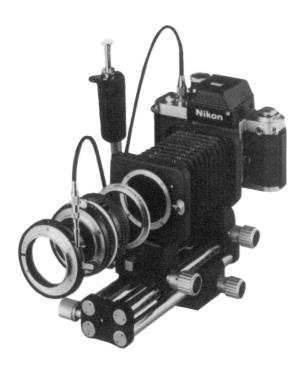

Nikon Bellows PB-4.

With a 50mm lens the magnification range of the Bellows 2 is 1x to 3.6x. With the bellows completely closed, there is still 51.6mm of extension, which is why it starts at 1:1. There are engraved steps on the Bellows 2 corresponding to the 50f2 and the 135f4 Bellows lens. The marks provide accurate magnification information when the lens standard is set to that mark. With the 50mm lens reversed (requiring the BR-2 ring), the magnification range increases to 1.7x to 5.1x.

The Bellows 2 tripod socket is at the end of the bellows where the lens standard extends. Both the rear standard, where the body connects with the bellows, and the front standard can be moved. This provides the means to work at a set magnification. If working at a set magnification, focus is achieved by moving the entire bellows/body/lens assembly toward or away from the subject. With the tripod socket permanently mounted to the front of the bellows, the Bellows 2 doesn't lend itself to this requirement.

The body standard allows for vertical and horizontal shooting. By pressing a lever on the side of the bellows body mount, the body is released to pivot 90 degrees. The Bellows 2 will accept the **Slide Copier** which attaches to the front standard and holds a 35mm slide. It has two trays, one on

each side of the holder. This is for use in duplicating an uncut roll of film. The Slide Copier will work only on the Bellows 2 and the Bellows 2 will only accept the Slide Copier. All other copiers have the wrong rail and height for proper operation.

The **PB-3 Bellows** (known also as Bellows 3) is a marvelous little bellows for field work. It's a dovetailed-grooved, single-rail bellows with a range of extension from 35-142mm. It's physically the smallest of the Nikon bellows and is the only one with a octagon shaped bellows. Magnification of 0.6x to 2.8x can be attained with a 50mm lens and 1.4x to 3.5x with the 50mm reversed. The rear standard of the bellows is locked in place. The tripod socket thread is located here. This supports the bellows and body quite well when attached to a tripod. Because the construction of the rear standard doesn't allow the body mount to turn horizontally or vertically, the F4 and N8008 cannot mount to this bellows. There are millimeter markings on the rail that when divided by the millimeters of the lens in use will provide the magnification. The PB-3 bellows does not accept any slide copying attachment.

The **PB-4 Bellows** was the most sophisticated bellows unit manufactured by Nikon. Its dual twin-rail bellows allow independent movement of the body/lens standards and of the entire assembly. It has 43mm to 185mm of extension. With a 50mm lens magnification of 0.83x to 3.6x is possible. With the 50mm reversed, 0.6x to 4.4x is possible. The upper rail has millimeter markings like all bellows, from 0 to 192 and figuring magnification is the same as described above.

The lens, body, and the tripod head assembly have geared focusing for extreme accuracy in magnification and focusing. The geared tripod head makes it possible to set up the body/lens at a specific magnification and focus the whole assembly while it's attached to a tripod. Focusing of the entire bellows assembly is done by a simple turn of the knob. The two standards and the tripod head can be locked into place to prevent slippage or accidental changes.

What distinguishes the PB-4 from all other bellows is a lens standard. It has 25 degrees of swing and 10mm of lateral shift. This aids in control of the depth-of-field. There are two levers on the lens standard that when released permit these movements. When the lens standard is swung to control depth-of-field, the subject can be swung off

the frame. The lateral shift corrects this by moving the subject back into the picture, like raising the front of a 4x5 camera. Though unique features in a bellows, its effect on the 35mm film format is limited and its problem solving possibilities slim.

The body standard permits the camera to be rotated for horizontal and vertical shooting. The PB-4 accepts the **PS-4** slide copying attachment which works on the same principle as the Slide Copier. The one difference is that the PS-4 has 9mm of horizontal shift and 6mm of vertical shift. The PS-4 has an accordion leather bellows that attaches to the front of the lens and prevents stray light from hitting the front of the lens and causing flare. The PB-4 will also accept the PS-5 slide copier.

With any of these slide copying attachments, it should be remembered that they are an add-on accessory. They are not capable of producing a high quality duplicate slide or negative. In duplicating film, the contrast of the original normally doubles unless the film is flashed by a second method. These slide copying attachments do not allow for such flashing and consequently do not produce a high quality duplicate.

The **PB-5 Bellows** is a simplified version of the PB-4 with single twin-rail construction. It has the exact same extension and magnification ranges as the PB-4. Its lens standard does not have the swings or shifts and it does not have an independent tripod socket. There is a tripod socket on the front and rear standard, but no means of mounting it in the center for stability. As with the Bellows 2, it does allow the body to be rotated for horizontal and vertical shooting by pressing a lever. It accepts the PS-4 or **PS-5** slide copier, the PS-5 being the same as the PS-4 but without the slide trays.

Making these bellows easier, simpler, and quicker to use is possible with the addition of specialized accessories. When the lens is removed from the body and attached to the front bellows' standard, the automatic diaphragm and meter coupling are lost. The meter coupling cannot be recoupled, but semi-automatic diaphragm operation can be regained with the **BR-4** ring. When a lens is normally on a camera, the body keeps the diaphragm open for bright viewing when focusing, then closes down to the selected f/stop when the camera is fired. If it did not operate this way, viewing would be extremely dark with the lens stopped down. The same problem occurs when the lens is removed from the body and attached to the

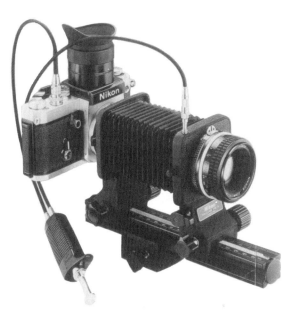

Nikon Bellows PB-6.

front of the bellows, as the automatic diaphragm and meter coupling are lost, the meter coupling cannot easily be recoupled, but semi-automatic diaphragm operation can be regained with the BR-4 ring. It keeps the diaphragm open for bright viewing by closes the diaphragm to the selected f/stop when the camera is fired. The BR-4 requires a double cable release to trigger it when the camera is fired. Nikon makes three such releases. The **AR-4** double cable release for the old release sockets of the F and Nikkormat, the **AR-7** for standard cable release sockets, and the **AR-10** for motorized cameras such as the N8008 or F4s. When the plunger is pressed on the double cable release, it fires the camera and simultaneously stops down the lens.

Introduced in 1977, the **PB-6 Bellows** is still the state-of-the-art in bellows from Nikon. It's part of a modular system, making it one the most flexible bellows on the market. The PB-6 is a double-dovetail rail design which allows independent operation of the body/lens standards and of the entire assembly. The rail has a variable extension of 48mm to 208mm for magnification of 1.1x to 4x with a 50mm lens. The top rail has two scales for accurate measurement. The body and lens standards have a geared focusing knob that can be locked in place for precision work.

The tripod head of the PB-6 is like that of the PB-4. The assembly is on the bottom section of rail

all by itself. It has full use of the bottom rail, thereby affording exact unit balance and stability. The body mount can be turned for vertical or horizontal photography. The PB-6 bellows has a number of built-in accessories that are add on's to other bellows. The lens standard has a built-in semi-automatic diaphragm (BR-4 on other bellows) that by pressing a lever, manually closes down the diaphragm. It requires a double cable to activate it when taking a photograph. The lens standard can also be reversed when on the rail, reversing the lens attached for greater magnification. This eliminates the need of a BR-2/2A reversing ring which performs the same function on other bellows.

The **PB-6E Extension Bellows** can be added to the PB-6 for a maximum of 438mm of extension. When the PB-6E is attached, the tripod mount mobility is lost and with it the ability to focus by moving the entire assembly. The PB-6E comes with a large connecting plate to which the rails of the two units are joined. This plate has a tripod mount. It also comes with a bellows and standard that connects with the actual bellows of the PB-6. The lens standard is removed when assembling the two units, and is reattached to the bellows section that is part of the PB-6E. With a 20mm lens reversed, a magnification of 23x is possible requiring 46 stops of compensation to get an image on the film!

The **PB-6M Macro Copy Stand** is a small stand that attaches to the end of the PB-6. It's 90x144mm in size with a white, opaque acrylic disc at the center which allows direct or transillumination of the subject. It also comes with a gray painted aluminum disc that can be used as an 18% gray card. If working with a small object that could be enhanced by backlighting, this is excellent.

The **PS-6 Slide Copier** attaches to the PB-6 allowing slide duplication. It's an updated PS-4.

Bellows are not the only method Nikon has to offer to move the lens away from the film plane for close-up work. The first extension tubes were non meter-coupling, referred to as manual extension tubes because exposure had to be figured out manually. The **K-Tubes** are a set of tubes that can be mixed and matched for various amounts of extension or stacked together for a total of 46.6mm of extension. These tubes are quite dated and are more trouble than they are worth. When the 55f3.5 Micro was originally sold it came with a 27.5mm extension tube permitting the lens to focus to 1:1.

The first tube was the **M Ring** which was later replaced by the **M2 Ring**. Neither were capable of meter coupling.

The first meter coupled extension tubes were the **PK-1**, **PK-2** and the **PK-3**. They worked with the non-AI coupling system. Each tube has a different amount of extension: the PK-1=8mm, PK-2=14mm and the PK-3=27.5mm. These can be mixed and matched to achieve the amount of extension needed to do the job. There is no limit to the number that can be stacked. As they all maintain meter-coupling between the body and lens, exposure compensation is easier to figure out.

The PK-1 and 2 are odd amounts of extension not related any one lens. PK-3 is the exact amount of extension required by the 55 Micro for 1:1 magnification. Nikon offers one other meter-coupled extension tube, the **PN-1**. Its 52.5mm of extension couples with the 105 Micro for 1:1 magnification. When the AI meter coupling system was introduced, the extension tubes were updated to permit meter-coupling with the new system. The exact same extension tubes were produced except they were now fitted with the AI coupling. They are **PK-11**, **PK-12** and **PK-13**. The PN-1 was also updated to an AI version, the **PN-11**.

As yet there are no autofocus extension tubes, the only option remains the AI extension tubes. They all work fine on the autofocus equipment except the PK-11, so Nikon made a small modification and came out with the **PK-11A**. It has the same amount of extension as the PK-1/11, but it has a small part of the mounting flange removed to prevent interference with the autofocus contacts in the body. None of the other tubes have this problem so no other new versions were necessary.

Close-up photography can be achieved through the use of Micro lenses such as the 55f2.8, 60f2.8AF, 105f2.8AF, and the 200f4IF Micro. But any Nikon lens can be used with an extension tube, altering the minimum focusing distance and permitting close focusing. An example would be the use of the 300f4AF with the PN-11 which changes the minimum focusing distance from nine feet to 4.7 feet with a magnification of 0.18x with 1/4 stop light loss.

Long telephotos lend themselves to the application of extension tubes quite readily to shorten their minimum focusing distance. For example, the 500f4P has a minimum focusing distance of 20 feet. This changes to 17.5 feet by adding the PK-11A

with no light loss. This option allows for tighter cropping and greater image size while decreasing the depth-of-field. Infinity focus is no longer present because the lens has been moved away from the film plane, but this is no handicap since the lens is being used for close-up focusing.

There are other options to modify a lens for close-up photography. Nikon makes the **Close-up Attachment No. 0, No. 1** and **No. 2**. These are basically filters designed to work with lenses up to 55mm. They can be stacked together for greater magnification but this causes a loss in overall quality. The refractive power of the No. 0 = 0.7, the No. 1 = 1.5 and the No. 2 = 3. These are an inexpensive investment for a first venture into close-up photography, testing the waters before getting heavily into the very expensive lenses and attachments.

Nikon makes four other close-up attachments that are on a totally different level of quality without a big price. The **Close-up Attachments No. 3T, No. 4T, No. 5T** and **No. 6T** are two element, achromatic attachments. This means they are corrected pieces of optical magnifying glass delivering outstanding quality. The 3T and 4T are 52mm and the 5T and 6T are 62mm. The 3T and 5T have a refractive power of 1.5; the 4T and 6T have a power of 2.9. The greater the refractive value the closer the camera can be to the subject and hence the greater the image size.

The "T" after the numbers signify that these attachments are designed to work with telephoto lenses (85mm to 200mm range) to increase their magnification, which they do quite handily. For example, the 4T on a 200mm lens provides 1.2-1.7x, the 6T on the 35-70f2.8AF (great combo) provides 1.7-2.1x. Any of these attachments can be used in multiples for greater magnification without light loss. These can be excellent problem solving tools for working in close when nothing else will work.

Close-up Attachments no.3T, no.4T, no.5T and no.6T.

A very popular method of working close-up is by reversing a lens. Nikon makes the **BR-2A** ring (originally the BR-2) and **BR-5** ring for just this application. The BR-2/BR-2A attach to 52mm threads, the BR-5 attaches to 62mm threads. The BR-2A must be used with autofocus bodies (and works just fine with other bodies). It has a small notch removed from its mounting flange so it won't harm the autofocus contacts in the body.

These rings permit 52mm and 62mm lenses to be mounted reversed onto a body, extension tube, or bellows for greater magnification. The most popular lenses to be reversed are the 20f3.5, 20f2.8, 35f2, and 50f2 because of their excellent edge to edge quality. When a lens is reversed, the optical formula designed by the engineers is completely altered; the light travels in reverse of its original path. Some lenses can be excellent when used normally but perform poorly when reversed. Trial and error is necessary to test the performance of a reversed lens.

When the lens is reversed, all meter and automatic diaphragm connections are lost. As with a bellows, automatic diaphragm control can be regained with the BR-4 or with the new **BR-6** ring which is used in conjunction with the BR-2A ring. With the lens reversed, the filter threads are lost. The rear element is also extremely exposed. The **BR-3** ring attaches to the lens mounting flange and provides 52mm threads for attaching a protective filter (including close-up filters) to a reversed lens. The BR-3 can work on any reversed lens without vignetting because of the inherent magnification of the set up.

When working close-up to a subject with a camera and lens set up at a fixed magnification, focusing can be difficult at best without some type of aid. When working with extension tubes, macro lens or another set system, photography is a lot easier with the aid of the **PG-2 Focusing Stage**.

The PG-2 permits a motorized camera set up to be used vertically or horizontally, and permits the whole camera assembly to be moved for fine focus. It works on the same double-dovetail rail as the PB-6. The top rail works the camera assembly; the bottom rail is the track for moving the whole stage. The **PG-1** is a version that works with a body only, no motor drive. When cameras with built-in motor drives came on the market it was discontinued. These units provide 360mm of tracking which accommodates almost any close-up set up requirement.

NIKON PRICE GUIDE

The second hardest thing about getting the right piece of photographic equipment is finding it at a good price. But what is a good price? The selling price of equipment, by law, cannot be set by the manufacturer. Nikon publishes a "Suggested List" price for equipment, the price normally quoted in technical articles concerning a particular product, which is rarely the actual selling price. Retailers are able to set their selling price according to their own profit structure, selling new equipment as low as 1% above their buying price and as high as 33% or more. It can get quite confusing when shopping around for the right price when there are as many different prices as there are stores.

Nikon products, bodies, lenses, accessories, etc., are imported into the United States by Nikon Inc., and are wholly owned by The Nikon Corporation, Japan. Nikon's dealerships are set up into two categories: **NCP** (**N**ikon **C**onsumer **P**roducts) and **NAS** (**N**ikon **A**dvanced **S**ystems). The NCP dealer is able to stock and sell the lower priced, basic consumer photo equipment whereas the NAS dealer can sell those same photo products as well as the professional lines (F4S, ED lenses, etc.).

Products with serial numbers have a written one year USA and World Wide Warranty from Nikon. The product is the same whether it's bought in Japan, Europe or the USA; a 105f2.8AF Micro for example is a 105f2.8AF Micro. The only difference is the paperwork that comes in the box with the product. Nikon USA warranty's only products they import into the country, and they will not repair under warranty products privately imported. Grey market is the private import of Nikon products into the USA. They are the same products that can be purchased in the USA, but they have no warranty privileges from Nikon USA.

The price guide that follows is a sampling of prices from stores around the country, averaged to come up with one figure. What price a photographer pays is up to what the photographer requires for his dollar. Since the product is the same, what is gained or lost by paying higher or lower prices? The stereotyped "New York" stores have the reputation of great low prices but poor service, poor business tactics, and slow delivery. But that's not a fair summation, because there are many stores operating in New York that provide great prices, service, and delivery.

Other big city camera stores offer the same price right in the photographer's backyard (but state sales tax is applicable) with the advantage of talking to a salesperson one on one and the ability of walking out the door with the product when the bill is paid. Extended warranties are currently quite the craze, but photographers beware, what is purchased is not necessarily what is obtained. For example, Nikon Inc. is the only facility that can properly repair an F4, N8008 or N6006 at this time. The computers and software needed to repair these units are not available to independent repair facilities.

Being an educated buyer makes the photographer a successful buyer! If the photographer knows his photographic needs prior to shopping, products not needed won't be bought. And an idea of what a product might cost should have already been determined to make the buying trip successful. Use a credit card to pay for the product. If taken in by a bad deal, the credit card company will protect your money until the transaction is cleared up.

Pay the extra money and have the product shipped by Fed Ex Standard Air or UPS 2nd Day Air so a precise arrival date can be set before the transaction is completed. If the product is not delivered on the date promised, make a call and get the tracking number and have it traced. The photographer will know very quickly if it's a sour deal.

If in the market for a newly released product or one that is hard to come by and it's needed for a project, when calling around to find that product and one piece is found, buy it on the spot regardless of the price. Nikon is physically a small company, production is slow and precise and supply is normally in limited quantity. If a photographer needs a certain piece of equipment and he finds it, he shouldn't take the chance of losing the product while calling around to find a better price.

The parameters concerning buying used equipment are quite different, with product and price being very different around the county. The price for used equipment depends on many factors: original selling price, quantity manufactured and purchased, age and obsolescences, black or chrome, cosmetic and mechanical operation, and most importantly, current demand for the product.

Many outstanding lenses such as the 800f8 EDIF, 1200f11 EDIF, 80-200f2.8 ED sold for $2,000 to $5,000 when new, but on the used market, they sell for only $800 to $2,500. This is a reflection of their lack of popularity and not optical quality which is outstanding. On the other hand, mint (like new condition) black "F" and "F2" bodies can go for as much as suggested list because of their popularity with buyers.

The 300f2.8 EDIF has always commanded a high price, new or used, with great low prices usually reflecting severe cosmetic, mechanical, or optical problems. When buying used equipment, make sure it comes with a return privilege of 30 to 45 days and some type of in-store warranty (Nikon does not warranty used or second hand equipment).

One factor not normally considered by photographers when buying equipment concerns basic business. Buying new equipment from the urge to increase the camera bag's inventory usually results in the loss of income and lack of satisfaction from the equipment. Purchasing a piece of equipment that solves a particular photographic problem or opens up a new venture in a photographer's field on the other hand will usually mean years of satisfaction and the equipment will make money. Use the information in this book to make that educated assessment of your photographic equipment needs, then buy the equipment that will solve those problems, making the photographer successful, both financially and photographically.

The Prices

Item	Suggested List*	Mail Order	National Average	Mint Used**
NIKON BODIES				
F (blk), body only	355	90		350
F (chr), body only	375	40	75	300
Nikon FTn (blk)	494	170	140	450
Nikon FTn (chr)	474	110	100	395
FT	N.N.A.	0	75	85
FS	N.N.A.	0	0	65
FTn	N.N.A.	45	70	185
EL (blk)	460	80	80	245
EL (chr)	478	60	45	265
FT2 (blk)	297	60	45	235
FT2 (chr)	287	25	25	205
ELw (blk)	499	125	140	285
FT3 (blk)	307	100	80	245
FT3 (chr)	297	80	80	225
EL2 (blk)	530	175	175	265
EL2 (chr)	510	140	100	225
F2 w/DE-1 (blk)	539	160	110	295-465
F2 w/DE-1 (chr)	519	140	100	250-435
F2 Phot (blk)	649	180	125	345-495
F2 Phot (chr)	629	100	100	295-395
F2S (blk)	765	150	100	315-435
F2S (chr)	745	130	100	265-385
F2SB (blk)	815	345	300	555-695
F2SB (chr)	795	300	270	525-650
F2A (blk)	669	325	290	450-575
F2A (chr)	649	290	290	400-525
F2AS (blk)	830	390	340	650-885
F2AS (chr)	810	320	300	600-825
FM (blk)	313	125	125	185
FM (chr)	301	90	100	175
FE (blk)	420	140	100	225
FE (chr)	399	100	75	185
EM (blk)	231	25	25	75
FM2 (blk)	380	170	125	255
FM2 (chr)	364	130	90	235
FG (blk)	355	55	60	125
FG (chr)	338	35	35	105
FE2 (blk)	550	260	250	385
FE2 (chr)	530	225	210	355
FA (blk)	790	295	270	385
FA (chr)	765	250	250	350
FM2n (blk)	575	345	370	385
FM2n (chr)	555	240	270	285
FG-20 (chr)	354	25	25	95
F3	810	470	500	400
F3HP	1360	825	899	750
F3AF	1710	500	600	600
F3T	1675	1050	1100	850
N2000	440	250	250	190

* = Suggested List Price, last published price

** = Mint-used, looks like new out of the box

N.A. = Data Not Available

N.N.A. = No National Average

Item	Suggested List*	Mail Order	National Average	Mint Used**
N2020	602	125	90	235
N4004	414	190	150	180
N4004s	485	269	305	245
N8008	858	475	400	500
N8008s	899	679	649	700
N6006	648	450	429	490
N6000	510	365	340	400
F4s	2550	1495	1650	1450

NIKON LENSES

Item	Suggested List*	Mail Order	National Average	Mint Used**
6f2.8 Fisheye	14,300	8800	10,000	6500
6f5.6	1425	145	N.N.A.	350
7.5f5.6 Fisheye	N.N.A.	100	N.N.A.	365
8f2.8 Fisheye	1960	1100	1200	890
8f8 Fisheye	N.N.A.	190	N.N.A.	250
10f5.6 OP Fisheye	1279	600	N.N.A.	650
13f5.6	12,270	7700	8440	6000
15f3.5	2315	1385	1490	1250
15f5.6	1249	500	N.N.A.	850
16f2.8 Fisheye	908	549	579	469
16f3.5 Fisheye	569	325	N.N.A.	390
18f3.5	1355	794	859	695
18f4	649	300	N.N.A.	400
20f2.8 AF	680	439	489	425
20f2.8	635	429	469	402
20f3.5 (72mm)	N.N.A.	170	N.N.A.	325
20f3.5	361	225	N.N.A.	325
20f4	399	190	N.N.A.	290
21f4 w/fndr	N.N.A.	250	N.N.A.	250
24f2	838	480	539	409
24f2.8	442	290	360	280
24f2.8 AF	430.5	284	299	269
28f2	732	458	525	390
28f2.8 AF	260	184	199	169
28f2.8	442	329	349	289
28f2.8 E	138	40	N.N.A.	79
28f3.5	215	25	N.N.A.	135
28f3.5 PC	1310	819	875	710
28f4 PC	759	290	N.N.A.	550
35f1.4	921	419	454	390
35f2	410	265	302	225
35f2 AF	438.5	290	290	250
35f2.5 E	113	29	N.N.A.	69
35f2.8	180	25	N.N.A.	135
35f2.8 PC	789	365	340	390
35f2.8N PC	856	439	525	405
35f3.5 PC	N.N.A.	210	N.N.A.	225
45f2.8 GN	148	90	N.N.A.	125
50f1.2	570	338	379	290
50f1.4 AF	323	215	225	186
50f1.4	372	125	125	195
50f1.8N AF	108	62	65	49
50f1.8 AF	90	25	40	39

* = Suggested List Price, last published price

** = Mint-used, looks like new out of the box

N.A. = Data Not Available

N.N.A. = No National Average

Item	Suggested List*	Mail Order	National Average	Mint Used**
50f1.8	159	25	40	50
50f1.8N	117	15	20	69
50f1.8 E	97	0	N.N.A.	39
50f2	124	0	N.N.A.	65
55f1.2	321	90	N.N.A.	125
55f3.5 Micro, Comp	N.N.A.	90	N.N.A.	100
55f3.5 Micro	275	90	N.N.A.	125
55f2.8 Micro	407	210	190	269
55f2.8 Micro AF	447	190	N.N.A.	260
58f1.2 Noct	1845	1099	1240	950
58f1.4	N.N.A.	125	N.N.A.	105
60f2.8 Micro AF	519	299	345	290
80f2.8 AF	550	125	N.N.A.	225
85f1.4	1015	560	825	509
85f1.8	299	210	N.N.A.	175
85f1.8 AF	446.5	349	369	309
100f2.8 E	N.N.A.	90	N.N.A.	99
105f1.8	838	475	525	409
105f2.5	430.5	170	150	205
105f2.8 Micro AF	819	589	650	545
105f2.8 Micro	740	450	505	410
105f4 Preset	N.N.A.	70	N.N.A.	135
105f4 Bellows	N.N.A.	175	N.N.A.	280
105f4 Micro AIS	456	190	170	400
105f4.5 UV	3200	special order only		
120f4 Medical	1740	879	1100	750
135f2	1100	625	819	575
135f2 AF DF	1295	880	825	N.N.A.
135f2.8	410	279	308	185
135f2.8 E	160	80	N.N.A.	100
135f3.5	197	15	N.N.A.	79
180f2.5 Shrt Mnt	N.N.A.	N.N.A.	N.N.A.	350
180f2.8	673	290	300	410
180f2.8ED	925	700	675	725
180f2.8 EDIF AF	770	410	450	510
180f2.8N EDIF AF	971	579	645	525
200f2 EDIF	4910	2640	3100	1900
200f3.5 EDIF AF	1475	225	N.N.A.	485
200f4 Micro	995	639	689	535
200f4	462	90	N.N.A.	210
200f5.6 Medical	1055	N.N.A.	N.N.A.	350
250f4 Shrt Mnt	N.N.A.	N.N.A.	N.N.A.	375
300f2 EDIF w/TC-14C	22,000	11,000	12,500	17,000
300f2.8 EDIF	4195	1800	1650	2700
300f2.8 EDIF AF	3695	2000	2000	2350
300f2.8N EDIF AF	4750	3149	3450	3050
300f4 EDIF AF	1215	949	995	850
300f4.5	730	175	175	365
300f4.5 EDIF	1175	849	899	720
350f4.5 Shrt Mnt	N.N.A.	N.N.A.	N.N.A.	410
400f2.8 EDIF	7980	5000	5800	4800
400f3.5 EDIF	5050	3150	3300	2750
400f5.6 ED	1499	490	N.N.A.	850
400f5.6 EDIF	2420	1285	1400	1100

* = Suggested List Price, last published price

** = Mint-used, looks like new out of the box

N.A. = Data Not Available

N.N.A. = No National Average

Item	Suggested List*	Mail Order	National Average	Mint Used**
500f4 P	5460	3190	3350	2980
500f5 Shrt Mnt	N.N.A.	N.N.A.	N.N.A.	390
500f5 Mirror	N.N.A.	200	N.N.A.	375
500f8N Mirror	911	529	590	490
500f8 Mirror	492	175	N.N.A.	250
600f4N EDIF	8135	4900	5150	4300
600f5.6 ED	2059	N.N.A.	N.N.A.	850
600f5.6N EDIF	5350	3350	3600	2950
800f5.6 EDIF	6800	4190	4450	3800
800f8 ED	2530	N.N.A.	N.N.A.	600
800f8 EDIF	4987	1900	N.N.A.	2500
1000f6.3 Shrt Mnt	N.N.A.	N.N.A.	N.N.A.	850
1000f11N Mirror	1980	1050	1360	900
1200f11 ED	3159	N.N.A.	N.N.A.	900
1200f11 EDIF	6295	1350	N.N.A.	2800
2000f11 Mirror	9500	N.N.A.	N.N.A.	7000
24-50f3.3-4.5 AF	510	329	349	290
25-50f4	762	200	N.N.A.	410
28-45f4.5	659	160	N.N.A.	280
28-50f3.5	388	225	N.N.A.	280
28-85f3.5	637	290	250	385
28-85f3.5-4.5 AF	500	354	385	310
28-85f3.5-4.5N AF	525	390	365	410
35-70f2.8 AF	838	529	550	490
35-70f3.5	725	190	N.N.A.	360
35-70f3.3-4.5N AF	233.5	139	154	109
35-70f3.3-4.5 AF	210	90	N.N.A.	109
35-70f3.3-4.5	227	249	179	129
35-105f3.5-4.5	520	289	325	250
35-105f3.5-4.5 AF	510	324	369	290
35-105f3.5-4.5N AF	535	329	359	375
35-135f3.5-4.5N AF	570	384	409	369
35-135f3.5-4.5 AF	485	399	435	342
35-135f3.5-4.5	645	225	N.N.A.	340
35-200f3.5-4.5	1065	589	619	559
36-72f3.5E	290	125	N.N.A.	138
43-86f3.5	299	70	N.N.A.	100
50-135f3.5	540	190	N.N.A.	275
50-300f4.5	1579	400	N.N.A.	595
50-300f4.5 ED	3300	1700	1900	1650
70-210f2E	452	110	N.N.A.	130
70-210f4 AF	315	120	N.N.A.	190
70-210f4-5.6N AF	352	199	210	169
75-150f3.5 E	316	110	N.N.A.	139
75-300f4.5-5.6 AF	690	459	490	425
80-200f2.8 ED AF	1210	979	999	850
80-200f2.8 ED	3525	900	N.N.A.	1200
80-200f4	877	310	N.N.A.	425
80-200f4.5	749	225	240	403
85-250f4-4.5	N.N.A.	100	N.N.A.	125
100-300f5.6	565	300	275	275
180-600f8 ED	10,340	4000	3900	4800
200-600f9.5	1439	410	N.N.A.	395
200-400f4 ED	5600	3250	N.N.A.	2800

* = Suggested List Price, last published price

** = Mint-used, looks like new out of the box

N.A. = Data Not Available

N.N.A. = No National Average

Item	Suggested List*	Mail Order	National Average	Mint Used**
360-1200f11 ED	7318	N.N.A.	N.N.A.	5800
TC-1	199	190	N.N.A.	280
TC-2	520	90	N.N.A.	225
TC-14	417	295	N.N.A.	325
TC-14A	339	189	225	175
TC-14B	706	449	479	419
TC-16A AF	227	129	149	95
TC-200	188	125	N.N.A.	160
TC-201	339	198	225	175
TC-300	417	290	N.N.A.	325
TC-301	706	389	449	325

NIKON ACCESSORIES

Item	Suggested List*	Mail Order	National Average	Mint Used**
F-36 w/Batt pack	587	110	N.N.A.	225
F-36 Cordless	675	290	250	360
F-250	867	90	N.N.A.	125
AW-1	179	10	N.N.A.	45
MD-1/MB-1	N.N.A.	125	125	290
MD-2/MB-1	1079	210	190	475
MD-3/MB-2	462	175	175	335
MF-1	726	190	190	160
MF-2	5131	3500	N.N.A.	4100
MF-10	1612	900	N.N.A.	1100
MF-11	1625	1100	N.N.A.	1300
MD-12	417.5	160	160	155
MDE	108	N.N.A.	N.N.A.	90
MD-14	185	N.N.A.	N.N.A.	190
MD-15	295	N.N.A.	N.N.A.	225
MD-4	510	294	325	236
MF-4	1190	N.N.A.	800	550
MW-2	1885	1199	1300	900
MF-19	235	N.N.A.	N.N.A.	108
MF-20	99	60	75	45
MF-21	235	139	159	120
MF-22	180	140	129	100
MF-23	630	310	419	380
MF-24	6100	N.N.A.	N.N.A.	5800
MT-2	1105	N.N.A.	N.N.A.	300
MB-23	420	N.N.A.	350	300

NIKON FLASH

Item	Suggested List*	Mail Order	National Average	Mint Used**
SB-1	N.N.A.	N.N.A.	N.N.A.	180
SB-2	129	N.N.A.	N.N.A.	79
SB-3	124	N.N.A.	N.N.A.	79
SB-4	79	N.N.A.	N.N.A.	110
SB-5	569	N.N.A.	N.N.A.	225
SB-7E	N.N.A.	N.N.A.	N.N.A.	105
SB-8E	N.N.A.	N.N.A.	N.N.A.	115
SB-9	59	N.N.A.	N.N.A.	25
SB-10	N.N.A.	N.N.A.	N.N.A.	25
SB-11	455	N.N.A.	N.N.A.	95
SB-12	144	N.N.A.	N.N.A.	69

* = Suggested List Price, last published price

** = Mint-used, looks like new out of the box

N.A. = Data Not Available

N.N.A. = No National Average

Item	Suggested List*	Mail Order	National Average	Mint Used**
SB-14	580	N.N.A.	N.N.A.	115
SB-140	670	N.N.A.	N.N.A.	200
SB-E	56	N.N.A.	N.N.A.	10
SB-15	135	N.N.A.	N.N.A.	90
SB-16A	375	217	235	160
SB-16B	350	201	215	180
SB-17	220	134	155	160
SB-18	N.N.A.	N.N.A.	N.N.A.	60
SB-19	79	N.N.A.	N.N.A.	50
SB-20	270	154	179	115
SB-21B	525	309	335	290
SB-21A	550	314	325	265
SB-22	175	99	109	69
SB-23	136	77	83	59
SB-24	390	219	259	200

NIKON CLOSE-UP

Item	Suggested List*	Mail Order	National Average	Mint Used**
Bellows 2	N.N.A.	N.N.A.	N.N.A.	69
Slide Copier	N.N.A.	N.N.A.	N.N.A.	109
Bellows 3	N.N.A.	N.N.A.	N.N.A.	130
PB-4	214	N.N.A.	N.N.A.	240
PS-4	147	N.N.A.	N.N.A.	50
PS-5	56	N.N.A.	N.N.A.	15
PB-5	142	N.N.A.	N.N.A.	135
PB-6	349	169	225	150
PB-6E	233.5	111	156	109
PB-6M	60.5	29	39	25
PS-6	210	113	147	110
K tubes	43	N.N.A.	N.N.A.	45
PN-1	91	N.N.A.	N.N.A.	90
PK-11	70	N.N.A.	N.N.A.	45
PK-11A	73.5	38	45	29
PK-12	76	38	45	29
PK-13	79	42	55	39
PN-11	160	70	109	89
PG-1	125	N.N.A.	N.N.A.	105
PG-2	233.5	N.N.A.	150	120

* = Suggested List Price, last published price

** = Mint-used, looks like new out of the box

N.A. = Data Not Available

N.N.A. = No National Average

INDEX

PHOTOGRAPHY BEST SELLERS. By Ong.

The one hundred images in this book have sold for more than two million dollars: A fascinating look into the stock photo business, a real eye-opener: An insider's view of the stock photography business showing exactly what sells.

Originally H $29.95 **Special H $14.95**

THE PHOTOGRAPHER'S BUSINESS AND LEGAL HANDBOOK. By Leonard Duboff, lawyer.

How do you protect yourself legally as a photographer? What you don't know can hurt you. This new authoritative book deals with copyright, your rights, tax tips, legal forms, contracts, reproduction fee prices, etc. **Only $18.95**

THE PHOTO GALLERY AND WORKSHOP HANDBOOK. By Jeff Cason.

U.S. & International gallery guide and workshop directory. Detailed listings, interviews w/ gallery and workshop directors, photo investing, price guides of collectible photo art, auctions, and how to present your photographs to galleries. **Only $19.95**

WINNING PHOTO CONTESTS.
By Jeanne Stallman.

Your guide to entering and cashing in on contests of all kinds. Included are:
• Prize-winning photos from various contests.
• Detailed contest listings with information on entry requirements and awards.
• Interviews with judges and prize winners.
• Advice on graphic impact, timing, composition, and color.
Expert advice is offered to the reader on:
• Finding the right contest for your photos.
• How to make your entry stand out.
• Model releases.
• Editing and presentation of photos.
• Contests to avoid.

Only $14.95

THE PHOTOMARKETING HANDBOOK - SECOND EDITION. By Cason & Lawrence.

• Detailed market listings, publishers, paper product companies, domestic and foreign agencies, telling you exactly what editors and agents are looking for.
• In depth profiles with professional photographers, editors and agents, telling you what it takes to succeed.
• Sample business forms, photographer-agency agreement, and book publishing contracts.
• A chapter on how to publish a photo book detailing the process of both commercial and self-publishing.
• Newspaper listings worldwide.
• Reproduction fee chart.

Only $19.95

PHOTOGRAPHER'S PUBLISHING HANDBOOK.
By Harold Davis.

Comprehensive reference on all aspects of publishing photographic imagery, including photo books and paper products. How to:
• Create publishable imagery.
• Publish self-promotion pieces.
• Market stock photos to publishers.
• Self-publish.
• Create a reputation as a photographer.

Only $19.95

Ask for these Images Books at your local camera shop, bookstore, or order directly from:
Images Press • 7 East 17th Street, New York, NY 10003 • 800-367- 4854 or 212-243-2306.